Exhibit Handbook for the Small Museum

Exhibits for the Small Museum

A Handbook

ARMINTA NEAL

With an Introductory Essay by
H. J. Swinney

4319

American Association for State and Local History

Nashville

Publication of this book was made possible through the cooperation of the Smithsonian Institution and their aid is gratefully acknowledged

Library of Congress Cataloging in Publication Data
Neal, Arminta.
 Exhibits for the small museum.

 1. Museum techniques. I. Title.
AM151.N37 069'.5 76-21812
ISBN 0-910050-23-6

Contents

Preface

By the time this handbook appears, the United States will be in the midst of the Bicentennial era. This celebration has spawned an expected rash of "cute" souveniers—one bearing the slogan "Buy American, Celebrate the Bicentennial, Made in Japan." The Bicentennial should be the stimulus for projects of more than passing interest and casual concern.

It is appropriate during this celebration, to reassess ourselves and the relationships our museums (which reflect our society) have with our local and surrounding communities. Who are we? Where are we? Where are we going? What can we do about it? Do we acknowledge not only the *existence* of others in this land before the arrival of Western European culture, but the *contributions* of the native Americans? Do we, in our exhibits and publications, relate past achievements and contributions of all ethnic groups to our contemporary culture? Do we ask the active participation of all groups in the development of many of our projects? Do we explore the richness both of natural and ethnic resources? Do we present the pros and cons of current issues in a fair and equal way? Do we present exhibits so that the public may make up its own mind about controversial questions?

Museums today must be more than traditional holders of collections. Increasingly popular, museums can and should be one of the foremost means of communication between specialists (historians, artists, scientists, industrialists, politicians, etc.) and the ordinary citizen. Museums in larger communities (100,000 or more population) will find that people in some areas may never visit the central museum. They may not be made to feel comfortable. It may not be possible, because of transportation difficulties, for some to get to the museum. In these communities, museums have a responsibility to develop "satellite" exhibits to place in store and bank windows, shopping centers, airline terminals, and other high traffic areas. It is time for museums to become one with their communities.

This "how-to-do-it" manual basically is a continuation and expansion of an earlier handbook *Help! for the Small Museum*. In this manual, reference will be made to the earlier publication rather than duplicating information already available. As with the earlier handbook, it is my earnest hope that through these suggestions, staff members and volunteers of small museums may gain the confidence to try improving their exhibits through a "do-it-yourself" approach. It is still true that good design and interesting, attention-getting exhibits are more a matter of common sense, creativity, and ingenuity than of great amounts of money.

Arminta Neal

Acknowledgments

No work of this kind can be achieved without the generous cooperation of museums across the country, and the organizations and individuals who have helped supply photographs and information. For their much appreciated help I wish to thank Per Guldbeck, formerly with the New York State Historical Association, author of *The Care of Historical Collections*; Yvonne Lange, Museum of International Folk Art, *Lore*, and the Milwaukee Public Museum; Fred Pruett of Pruett Press, Inc.; the Social Science Research Council; Budd Sherrick, Steinfeld's of Tucson; H. J. Swinney, Margaret Woodbury Strong Museum; Davis Thomas, Executive Editor, *Travel and Leisure* Magazine; and Gilbert Wright, Office of Exhibits Central, Smithsonian Institution.

I am most particularly indebted to Bill Alderson, Director of the American Association for State and Local History, who first asked me to prepare the book and waited patiently through its over-long incubation period.

Exhibit Handbook for the Small Museum

Introductory Essay

H. J. Swinney

When any museum begins to consider its role and its plans in and for a commemoration or celebration, it must establish some point of departure. That point ought to be an understanding of what a museum is. Without that understanding, no museum can go on to a sound analysis of its own capabilities and then to sound planning.

At first glance, it seems simple: a museum that is in existence, that is operating, that is admitting visitors and carrying on its regular programs, must know what it is. Yet the Accreditation Committee of the American Association of Museums, composed of experienced museum professionals, needed nearly a year of the most searching kind of consideration and debate to hammer out a basic definition of a museum. Surprisingly few individual museums have ever seriously come to grips with this sort of thinking.

Beginning with the dictionary definition of a museum would seem obvious, but it is too easy. Webster has said for many years that a *museum* is "a place or building where objects of aesthetic, historical or scientific importance are preserved," and the new American Heritage Dictionary, basing its definition on Webster, calls it "a place or building in which works of artistic, historical, and scientific value are cared for and exhibited." These definitions are good enough as far as they go, but they are inadequate because they omit any reason for the preservation and exhibition of objects. To go farther, we need a step-by-step consideration of the basic purposes of a museum.

We can begin by agreeing with the definitions that a museum is an institution which possesses collections of objects of artistic, historical, or scientific virtue—or of virtue in some related field. Of course, there are also private collections, not possessed by an institution. They are usually formed by more or less knowledgeable people along more or less organized lines, and they may range from the milk-bottle tops and matchbook covers that enthusiastic youngsters collect to the splendid assemblies of antiques or works of art collected by connoisseurs over long lifetimes. Despite the scholarship demonstrated by at least some collectors, the most usual reason for the formation of private collections is the pleasure that the possession of these objects brings to the collector. This is perfectly valid. Why should an individual not choose to surround himself with beautiful or intriguing things, to which he brings intelligence, taste, and understanding, and from which he derives a variety of continuing satisfactions? It would be unreasonable and unfair to suggest that there is something wrong with individual collecting for the pleasure of possession.

But a museum is not an individual, and it cannot experience pleasure from the possession of collections. There must be some further reason. Is it the preservation of its things? No; preservation is clearly an important component of a museum's function, but it cannot be the end purpose. If it were, it could best be accomplished not by the construction of galleries, but of carefully-designed warehouses, with little or no light, with controlled temperature and humidity, and with opportunities for damage or deterioration minimized. In storage of this kind, under the inspection of skilled conservators, objects would be exposed to the least possible danger, and would thus be

1

preserved for the longest possible time. But this would scarcely be a museum, particularly since there would be no exhibition to the public.

Exhibition is the key. It is only when a museum organizes its material into exhibitions and throws open the doors of its galleries to the public that its character is finally formed. Here is the crux of the whole matter: the material has been collected and preserved in order to exhibit it to the public.

But one may still ask a further question: why exhibit? The mere installation of exhibitions cannot be the end purpose of the museum—why does the museum expect the public to come? Is the purpose the entertainment of the visitor? Certainly entertainment is a part of the pattern; if a visitor does not have a good time in a modern museum, something is wrong, and it is wrong with the museum, not with the visitor. But entertainment is not the main purpose of modern museums either—they are far too complex and expensive for that alone. Disneyland is an institution which uses many museum techniques and is intended for entertainment, and it is a very clever and successful job, but it is not a museum. It is, so to speak, a work of fiction, whereas a museum is fundamentally factual.

A museum ordinarily collects and chooses its materials and arranges them into exhibitions because it has something to say— because it wishes to present an idea, a concept, a fact or some combination of these goals. It is a teaching institution, whose students are its visitors and whose teachers are its collections, aided by the knowledge and skill of curators, researchers, and interpretive staff. It seems impossible to escape the conclusion that a museum is by nature an educational institution, and that the standard dictionary definitions are flawed because they omit the idea of education.

It is important to realize here that many art museums prefer not to use the word "education" in stating their purposes. Quite reasonably, they try to avoid being didactic with their visitors; they feel that it is their proper job to display aesthetically significant objects in the best possible setting, so that each visitor may have his own personal experience with them. Nevertheless, responsible art museums do not display their collections at random in their galleries; they choose works that are in some way complementary. Paintings or drawings by a single artist or from a single period or school are chosen, or works are selected because they relate to each other in a variety of more complex ways—but a relationship of some sort is normally present, and thus a statement is made which the museum intends the visitor to grasp. In this sense, most art museums are teaching institutions, and a certain measure of didacticism is probably inescapable.

This educational nature of museums is widely accepted. In New York state, for example, museums are chartered by the State Education Department and live under its mildly regulatory eye. Legitimate museums everywhere have presumably earned their eligibility for tax exemption because of their educational status, too, and there are a variety of other indications that society generally classifies museums as educational institutions. The concept has certain implications that must be explored by any museum.

Semantic difficulties get in the way of our understanding of museums in comparison with other sorts of educational institutions. In discussing schools, it is not much of a problem to distinguish between the schoolhouse, which is that imposing brick building with the word "School" over its door, and the school itself, which is the educational enterprise carried on by the teachers, administrators, and other people who work within the schoolhouse. But it is easy to confuse various meanings of the word "museum": too often, it is taken to mean the building itself ("The John Jones Memorial Museum at Main Street and First Avenue") when it really ought to be understood as the function carried on within that building by a staff. It is in that last sense that we must now use

the word in analyzing the strengths and weaknesses of a museum.

A museum is one distinct type of educational institution. Among other types, we might list libraries, classrooms, laboratories, field trips, motion pictures, television, and probably others. All of these are devices for the transmission of information in some way or another, and each of them has its own strengths and weaknesses. Each can efficiently transmit certain kinds of information or ideas in certain ways, and each becomes less efficient when it deals with other kinds of ideas and other methods of transmission to which it is less well adapted.

Take a classroom as an example. A classroom is not merely a hollow space with rows of desks and a chalkboard. It is a rather sophisticated device, developed on the basis of centuries of experience and intended to provide an optimum format in which a lecturer can talk to a class of not fewer than about ten and not more than about thirty five students. The efficiency of a classroom drops off as the minimum and maximum numbers of students are approached (ask any schoolteacher if you doubt that); if the minimum and maximum numbers are passed, some other kind of educational device works much better. A classroom cannot be simply doubled in size in order to accommodate seventy students as opposed to thirty-five, because communication becomes very poor between the lecturer and the rear-row students in a room that big. Nor is it efficient to use a classroom to teach, say, four or five students; a seminar room in which teacher and students can sit together around a table is far better.

An ordinary classroom does not work very well for the use of slides and movies, and it is very hard to show actual objects in a classroom, because they are almost impossible to see beyond the second or third row. A classroom does not work well for experiments, for art work, or for similar participatory tasks; a specially equipped laboratory or studio is required. A classroom is, finally, at its best as a format for a lecture; it does not work well for the transmission of ideas by most other methods.

Thus with the other kinds of educational devices: they work well for the kinds of teaching for which they have been designed —libraries for the storage and retrieval of books, laboratories for teaching by experiment, and so on—and they are all liable to partial or complete failure when they are used for something they were not designed to do. A museum shares this characteristic. It can do certain things well, and it does other things less well or even badly. An understanding of its capabilities is essential to all museum planning.

A museum is the best device our culture has developed for the transmission of ideas to large numbers of people through the exhibition of genuine objects. This is a museum's strength. This is what it can do better than any other kind of institution yet devised.

This ability to use actual, genuine objects is fundamental in the consideration of museums. It is, in fact, so fundamental that it is commonly taken for granted or left out of the analysis, and thus not clearly understood. Yet this ability identifies museums among· all other institutions. Objects cannot be nearly so well shown in or by any other kind of institution. A collector sitting in his own living room can display a few of his treasures to his friends by merely handing them around, and a teacher in a seminar room or an archaeologist in a laboratory can show specimens to a few students in the same way. But only a small number of people are involved here, and the objects themselves are under the immediate supervision of the responsible person. When either large numbers of people or lack of personal supervision—or both—are involved, something like the traditional concept of the museum inevitably has to develop.

Like the other kinds of institutions, the museum has both strengths and weaknesses; if it abandons its strong ability to exhibit genuine objects and moves toward the province of some other sort of institution, its success in transmitting its ideas

inexorably decreases. One of the clearest examples of this lies in labeling. If the museum attempts to transmit a large quantity of information through lengthy labels, the label itself gradually becomes the exhibit and the object becomes an illustration for the label. (An old professional joke say that a museum is a large group of labels illustrated by a small group of specimens.) Failure threatens an exhibition with long labels simply because a museum is not the right device for the transmission of the written word. A museum is not a book.

Transmitting information through writing is a two-way process, requiring not only a writer but also a reader. A book is successful because it can be read at leisure while sitting in a chair, as it almost always is. The reader can pause to reflect, can reread, can take his own time. But extensive labels on the walls of a museum are self-defeating, because practically nobody will read them. Only very rarely will visitors read a label longer than about sixty or sixty five words, and fifty words is a better limit. Brief museum labels will work, but the museum that writes lengthy labels is invading the province of the book —and its labels will not work.

Another example: it is perfectly possible to build a motion picture theater in a museum complex, and to have it work quite successfully in a variety of ways. The visitor center at Colonial Williamsburg is only one of many such examples. But when a museum tries to use motion pictures as the main (or a major) method of transmitting information within its galleries—within the true museum setting, that is—trouble is likely to begin. Movies require low light levels which are difficult to achieve while still leaving light enough to see objects on exhibition; the sound tracks are distracting; people come and go during the film; and perhaps most important of all, visitors become very uncomfortable when asked to stand for long periods of time on the typical terrazzo or tile floor. Films of two or three minutes duration have been used with success in museums to explain some complex object or process, but this is an interpretive technique in which the film is clearly subsidiary to, rather than a replacement for, the object displayed. When the film becomes the display, the museum becomes less successful, because museums don't work well as theaters.

The same analogy can readily be made for a variety of other information-transmitting devices. About any of them, it is necessary to ask whether it will work well with large numbers of people who come at random times and who have varying amounts of interest in and foreknowledge of the subject at hand; that is, it is necessary to ask whether it can be used in a typical museum context. There is no need to examine all of these various analogies and devices here. The end result is still clear. The exhibition of objects is the thing a museum does best, and is its special province and job. In fact, this idea is what that word *museum* means in standard English, and a long list of quotations and definitions can be assembled to support the point. In his article under "Museums" in recent editions of *Encyclopaedia Brittanica*, Ralph Lewis says

Museums are the institutions developed by modern society to stave off for as long as possible the deterioration and loss of objects treasured for their cultural value. Museums do for objects what libraries do for books, and archives for official documents.

Later on he says that bona fide museums are distinguished

. . . on one hand from institutions such as art centers that hold public exhibitions of borrowed objects but maintain no collections of their own, and on the other from entertainment enterprises that call themselves museums to gain prestige.

Carl Guthe's *The Management of Small History Museums* says (at the opening of the chapter called "The Collections")

A museum is judged by its collections. Their possession accounts for its existence; their character determines its worth . . .

4

(and) reveals the policies and objectives of the museum.

The fundamental definition of a museum, which we referred to earlier and which is the cornerstone of the accreditation system of the American Association of Museums, says

For purposes of the accreditation program of the American Association of Museums, a museum is defined as an organized and permanent non-profit institution, essentially educational or aesthetic in purpose, with professional staff, which owns and utilizes tangible objects, cares for them, and exhibits them to the public on some regular schedule.

In 1971, the American Association of Art Museum Directors promulgated *Professional Practices in Art Museums*. This report repeats the AAM definition of a museum practically word for word, except that it says "which acquires objects" in place of the AAM phrase "which owns and utilizes tangible objects."

This repeated insistence on the possession of objects reflects a strong professional consensus that objects are fundamental to museums. Now, if we can at last agree on this premise, it follows that museums work well only with certain classes of ideas. These might be called "artifactual" ideas—that is, ideas that are capable of being transmitted and interpreted through the use of objects.

Traditional works of visual art form a useful example. For convenience, the history of art is taught largely through the use of pictures and slides, but there is no getting around the fact that the ideas the artist intended to transmit (ideas which an art museum also intends to transmit when it displays the work of art, though it may also have added ideas of its own in arranging its exhibition) are far more inherent in the original works of art than in any form of reproduction. A genuine Old Master drawing or Winslow Homer painting is simply a much better thing than a reproduction of it. Of course a bronze statue is in a certain sense a reproduction

of the clay model which the sculptor actually worked on with his own hands, but it can also be said that the statue is the final result the sculptor had in mind, just as the performance of a symphony, not the musical manuscript, is the composer's intended result.

An original work of art has a presence of its own which is inescapable, and this quality of genuineness is the great advantage of the museum. Many ideas depend on it. A demonstration of an actual spinning wheel is far more comprehensible than pages of print about how to spin, and it is nearly impossible to describe a spiral staircase in simple words, whereas the real staircase is immediately understandable. These are simple examples of artifactual ideas. On the other hand, interconnected ideas about some form of philosophy, say existentialism, cannot be readily transmitted by a museum. These are abstract ideas, necessarily expressed in words—often a great many words—and sometimes requiring the use of an extended vocabulary for their explanation. This must be done through a book or lecture; it is not a practical museum job.

In planning for a commemoration or special program, a historical museum must carefully make this distinction between artifactual and non-artifactual ideas. It is perfectly possible, for example, to discuss the development of the boundaries of an American state in a museum exhibition, using maps, perhaps photographs and graphics, and a variety of other flat exhibition objects. Such exhibitions have often been mounted. But in doing so, a museum is working at a disadvantage because it is trying to use objects to expound essentially a non-artifactual idea. It can be successful only by surmounting inherent disadvantages, and it can never hope to surmount them entirely. A discussion of boundary development would better be done in a book, even though museums sometimes have to tackle this sort of thing for reasons beyond their control. It is only when the museum begins to deal with ideas that are solidly based on objects that it truly comes

into its own, especially when the objects are cleverly interpreted through graphics, brief movies, and comparable modern techniques. In its planning, a museum must seek out the ideas which can be thus expounded with objects, and must avoid—as much as its story will allow—non-artifactual ideas.

If these are the internal strengths of a museum, what are its external strengths? In planning its programs a museum needs a clear grasp of its position in its own community. This is by no means the same for all museums. The historical society of a remote county in the mountain West may have quite a different role to play from that of an eastern county historical society which is very near a huge and highly professional state historical museum. Each museum needs to think about its own relationships to its own people.

If it is kept in mind that a museum is an educational institution, and that its business is to teach, the process of self-analysis becomes simpler. Realizing that museums must deal with artifactual ideas clarifies the matter still further. Finally, if we assume that we are dealing with history museums (as distinct from art, science, and natural history museums) we have progressed a long way.

Let us take up in reverse order (history, artifacts, and teaching) the way these factors affect a museum in its community.

It is widely accepted that the profitable study of history demands more than just knowledge of what took place in the past. We have to combine the various things we know about the past (what the academic historian calls "synthesis"); discover what the combination means (the academic historian calls this "analysis"); and finally explain it all (museum people say "interpret" it all) for the students we are trying to teach, that is, our visitors. This needs a certain perspective, a certain long view. Not only is it hard to put recent events into their proper relationship to one another, but often we know only part of what has recently happened; the rest has not yet come to light. What we know, or think we know, about recent events has a way of changing. As our perspective gets longer, as more sources become available and as more scholars study them and publish about them, our knowledge becomes firmer. This is not to suggest that we can ever be absolutely certain we are right about history, any more than any teacher can hope to be absolutely right about anything —but it is certain that events of several years or more ago are easier to deal with than the recent past.

Partly because of this need for perspective, it is harder to appraise the significance of the objects of today than it is of objects of the past. Take, for example, some relatively revolutionary invention. If it was invented, say, a century ago, we now know fairly accurately whether it was a technical or a commercial or a social success, or perhaps all three—but if it was invented only a few weeks ago, we have no way of knowing whether or not it is going to work. A simple change of fashion, like short skirts for women, may turn out to be the beginning of a movement with complex and lasting effects—or it may be a mere fad, forgotten in a few years. The associated objects (in this case, the skirts themselves) may help teach a historically important set of ideas, or may be hardly worth keeping. It is only as we gain the perspective of time that we know.

The need for perspective has even more important overtones for a history museum than it would have for an individual classroom teacher. A teacher can discuss ideas in depth, helping a class to distinguish among the various probabilities involved, and contrasting clearly the personal opinions and research-based conclusions. But a museum must deal with large and changing groups of people for brief intervals of time, and there are sharp limits on the amount of explanation and discussion it can present. Furthermore, it is perceived by its visitors as an institution, not as a person, and thus it speaks with a weight of authority that an individual teacher rarely has. This imposes special obligations on museum curators and de-

signers. Because it is so hard to change what a museum says when the evidence changes, museum staff members need to be as certain of their ground as their colleagues in classrooms.

All of this suggests the outlines of a special sort of relationship between a history museum and the community it serves. A history museum tends to be the arbiter and teacher of a specialized and local form of history, and in serving its community it needs to remember the limitations as well as the advantages of the sort of institution it is. Because of a history museum's need for perspective, it is not a very useful instrument for the promotion of social change; it is hard for a history museum to identify practical and permanent facts about the future in the welter of ideas presented to us today. When it begins to expound the opinions of its staff in the guise of fact, it is getting dangerously close to being an instrument for propaganda rather than a museum. A history museum can effectively teach and interpret the patterns of the past, but it ought to leave the future application of those patterns to the judgment of its visitors—that is, to the members of its own community.

The bicentennial era offers both opportunities and perils for history museums. By involving qualified historians and modern sources and methods in the development of exhibitions, a local history museum has a wonderful chance to provide new understanding and also correction for the unhappy old legends about its area. It can bring fresh facts to the synthesis and fresh skills to the analysis which it offers to the community. Just for example, careful study of the Federal census records, now available on microfilm for all of the country in much of the nineteenth century, might provide a local museum with all kinds of new information about immigration to its community, about the trades and skills represented in its population, about the economy and products of the area, about growth or the lack of it and all sort of other things. By choosing those aspects of

this new information that can be interpreted through the use of objects—the artifactual ideas we have been talking about—a museum can add something new and valid to its community's knowledge of how it got to where it is. This kind of review of a community's past (and other kinds that can readily be imagined) provides self-evident opportunities for real and responsible community service.

But a history museum in a modest community (probably in large one, too) will not find it possible to correct the social injustices of our day, no matter how much its staff members would like to do so. To try that without success is a peril that can only be turned into an opportunity by realistic use of a museum's strengths. A museum in a Northwestern mining town, for example, might produce a real effect on the community consciousness of general social injustice by a new study of the bitter prejudice against Chinese immigrants that was so common a century ago. There is now a good deal of evidence about the existence of a substantial Chinese cultural pattern that went practically unrecognized by the white Americans of that day. A good historian could uncover these sources and cast a fresh light on the matter, and with luck and hard searching, the objects that would tell the story could probably be acquired. Necessary translations might be obtained today from the state university where they would have been very difficult to get forty or fifty years ago. In many another way, we are equipped as never before to restudy the history of these immigrants, and best of all, the prejudices and the uncertainties that surrounded the position of the Chinese in American society at that time that have now pretty much evaporated. The perspective of history makes it possible for us to judge with new accuracy what was going on. A carefully conceived, researched, and mounted exhibition about this phase of our history would carry parallels with today's circumstances that would be so clear that they could probably be left to the understanding of visitors without pointing them out.

Every community's history offers opportunities like this for the restudy of the past, the recasting of our opinions about it, and the reapplication of our knowledge of history to the uncertainties of the future. But when people who staff history museums begin to assume that their special competence about the past makes them specially competent to foretell the future, the perils of enthusiasm begin to gape widely. Our visitors are entitled to draw their own conclusions about the present and the future if they have been given the results of historical scholarship and museological skill. A history museum's opportunity lies not in being all things to all people, but in doing an improved job in its own natural role—a job that necessarily involves a clear concept of its strengths and a recognition of its weaknesses, a determination to bring better scholarship to better exhibitions, and above all an acceptance of its responsibility to teach what it can be sure is sound.

To accomplish the practical result of good plans is not something open only to affluent museums. There are big museums with big budgets that turn out exhibitions that are pedestrian or worse—and there are plenty of small museums that consistently mount thoughtfully conceived and effectively presented shows with very little money. The secret is not money, but skill and care intelligently combined. The techniques of simple but good museum work are not at all beyond the reach of small museums, and it is to these techniques that the second part of this book is addressed.

1 Getting Started

Getting Started: Organize!

There are a number of projects with which a small museum can become involved in any celebration. Whatever projects are to be considered, the first and most important step is the organization of a working committee. Membership should include representatives from local industries and businesses, newspapers, radio and television stations, ethnic groups, and schools, as well as from the museum. From the work of such a committee, cooperative and mutually reinforcing plans can develop. As an example, a particular exhibit might be designed by high-school or college level art students, built by industrial design students or in the shops of a state prison; the exhibit materials provided by the local museum, with history students or historical society members doing research for labels, and English or journalism students writing the labels.

The committee should be involved not only with the planning of the physical exhibit, but also with developing the necessary community financial support to make the project possible. Suggestions should be solicited from the entire community by making presentations to church organizations, minority groups, PTAs, and community service clubs. And care should be taken to avoid calendar competition with neighboring communities. An entire area will benefit if adjacent communities plan sequences of events—openings of exhibits, ethnic fairs, etc.—all keyed to a common calendar rather than being scheduled at competing times.

What *specific* things can be done? The following list may give you a "jumping-off" place.

Temporary projects

> *Student and adult essay contests,*
> *Art and photo contests, followed by*
> *Art and photo displays*
> *Exhibits for store windows*

Permanent projects

> *Publish a booklet, a history "map"*
> *Establish a "history trail"*
> *Walking tours in town*
> *Self-guided (from the history map)*
> * auto tours of surrounding areas*
> *Install outdoor interpretive panels*
> * (such as those in various National*
> * Parks and Monuments)*
> *Build a new exhibit*
> *Build a new gallery*
> *Build traveling school loan exhibit*
> * kits*
> *Send out a Museumobile*
> *Create a small museum*
> * using an existing structure (store,*
> * residence, railroad station)*
> *build a new structure (investigate*
> * pre-built units manufactured for*
> * modular home, store, and factory*
> * construction)*

Getting Started: Publicize!

As progress is made on your project, let people know about it. Prepare news releases for your local newspapers, radio and television stations (see Technical Leaflets nos. 26 and 45 published by the American Association for State and Local History.) Once your project is complete and is open to the public, get the word to "outsiders." Let them know you exist by sending regular announcements not only to your local media but to the broadcasting stations and newspapers in surrounding areas. Submit articles to national club newspapers and

magazines such as the *American Legion* magazine or to such "house" publications as those put out by the major airlines. Prepare a brochure or leaflet about your project. This can be a single legal-size sheet printed on both sides and folded to road-map dimensions. In these brochures be certain that, in addition to describing your project, you include a simple map showing exactly where you are (indicating *accurate* distances from main highways,) and an *accurate* listing of the days and hours you are open. In addition, list other facilities you may have available—ample parking, a shaded picnic area, nearby snack shop, a gift shop. Mimeograph or print the brochure and ask every motel on highways leading to town (as far away as 60 to 80 miles) and every motel in town for permission to place a stack on their registration desks. Ask the managers of highway service areas with service stations and adjacent restaurants and gift shops, such as Stuckey's and Nickerson Farms, for permission to place the brochures on the cashier's counter. Once you have secured this permission, keep the supply of brochures current. Sponsor a poster contest and place the best entries in service stations, banks, and stores in town. Then, when you are open, make sure that *nothing* changes your published notices about the hours you are open. Few things are more infuriating to a motoring visitor than planning to see something, driving a little out of his way, only to find the attraction closed. If your volunteer staff is so small your exhibit must be closed for a lunch hour, *say so* in your brochure!

Now, on to exhibit specifics!

2 Exhibit Specifics

It cannot be emphasized enough that out-of-town *or* local visitors are most interested in *your local story.* Comments made by Alistaire Cooke about the planning and making of his 13-week television series on American history are well worth noting here. He denies the existence of the *collective* "American people," saying ". . . in a continent of (then) forty-eight governments, a half-dozen radically different climates, a score of separate economies, and a goulash of ethnic ingredients, nothing that you say about the *whole* country is going to be true. . . ." He continues, ". . . the chronic problem . . . was to find precious landmarks that have not been obliterated or dolled up since their moment of history. . . . Across the whole American landscape what defeated us all the time was the gaudy litter of housing developments, burger stands, bingo palaces, the flapping penants of secondhand car lots, and always the interminable platoons of billboards that make the airport-downtown trip identically hideous in a thousand towns that once had their own trees, architecture, taste, smell, look—in a word, character."[1]

What to Exhibit

To apply Cooke's comments to the museum situation, recall the many, many history museum exhibits you may have seen —rooms crammed full of unsorted, uninterpreted artifacts and determine right now that *yours* is *not* going to be "identically hideous."

You do not need to feel that because your area may not have had "the" definitive battle of the Revolution, the Civil War, or

1. Cooke, Alistaire, *Travel and Leisure* Magazine, 3:2 (April/May 1973) pp. 29-32.

any other significant skirmish, that your story is any less interesting. People—*all people*—Native Americans, Spanish-Americans, Mexican, English, Irish, Scandinavian, Central European, Oriental —all people and the way they met the challenge of the environment and developed a pattern of living within that environment provide you with the most interesting stories that can be told. Start with your natural setting as it existed when prehistoric people exploited it. Describe for your visitors the important natural features—the mountains or hills, plateaus or basins, valleys, rivers and streams. Relate the climate to the growing season and the native plants and how they were used both by Native Americans and by early non-Indian settlers. Show how the topography, climate and available plants influenced the varieties of animals that were available for food or that posed a danger. Display the mineral wealth that may have been significant in your history and relate it to your economic development. (For more on the development of your local story, see pp. 8—10 in *Help.*)

The next pages show you some techniques that may help in the actual planning of your exhibit or series of exhibits.

A great planning aid is the story board for the developing of a written outline. Whether your exhibit project is a single panel, a single case, a sequence of cases in a room, or an entire building, your first step again, must be to organize!

Planning or Story Board

Producers of filmstrips and television commercials often make use of a "story"

board (Fig. 2-1) on which index cards with various captions and indications of "visuals" may be placed and sorted. Use of such a story board may help you to organize your thoughts. Construction is very simple and inexpensive.

Flat screen molding (3/4″ x 1/4″ x 6′) is cut to lengths to fit on a piece of 1/4″ thick scrap plyboard at least 20″ x 27″. Strips of lightweight cardboard (similar in weight to dress boxes from department stores) are cut 1/4″ wide and glued with white glue along one long side of each strip of screen molding. Clothespins make fine clamps for this (Fig. 2-2a).

The strips of screen molding are then attached 2″ apart to the sheet of plyboard with white glue and 18-gauge, 1/2″ long wire nails similar to cigar-box nails, with the lightweight cardboard strip positioned along the bottom edge. This thickness holds the screen molding just far enough away from the plyboard sheet to make it possible to slip a 3 x 5 index card into place (Fig. 2-2b).

Index cards are made out for topics and sub-topics. After they have received a final sort, a written outline can be typed.

Another approach to developing a written outline for the organization of single panels and independent cases might be to fill in forms similar to those shown in Figs. 2-3, 2-4, and 2-5. (For a detailed discussion of labels, see pp. 95—99 in *Help!*.)

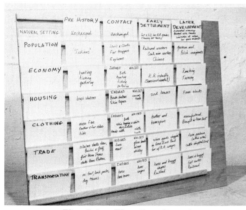

Fig. 2-1. The story board

Fig. 2-2a. Cardboard glued on screen molding

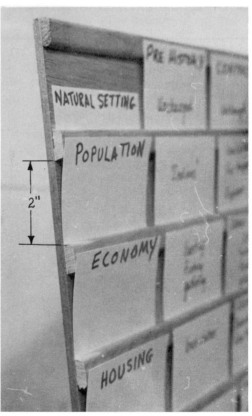

Fig. 2-2b. Cards are slipped behind the molding

EXTERIOR EXHIBIT PANEL

Location: _____

Purpose: _____

Main Headline Label: _____

Secondary (Subhead) Label: _____

Visual materials available for use: (List each, with reference sources, e.g. pages, name of publication, publisher and date, catalogue number (if a specimen).
(Suggested items: maps, photographs, drawings, manuscripts, journals, newspaper articles)

1._____ 4._____
2._____ 5._____
3._____ 6._____

Fig. 2-3. Exterior exhibit panel

INTERIOR EXHIBIT PANEL

Location: _____

Method of Lighting: _____

Purpose: _____

Main Headline Label: _____

Secondary (Subhead) Label: _____

Visual materials available for use: (List each, with reference sources; list catalogue numbers of artifacts or specimens to be used.) Suggested items: maps, manuscripts, journals, newspaper articles, photographs, drawings, artifacts.

1._____ 4._____
2._____ 5._____
3._____ 6._____

Fig. 2-4. Interior exhibit panel

INDEPENDENT CASE EXHIBIT (not part of a sequence)

Type (floor, wall): _____

Location: _____

Method of Lighting: _____

Purpose: _____

Main Headline Label: _____

Secondary (Subhead) Label: _____

Group Label No. 1 (if needed) _____

Group Label No. 2 (if needed) _____

Group Label No. 3 (if needed) _____

Visual materials available for use (list each, with reference sources; list catalogue numbers of all artifacts or specimens to be used; indicate use in case—e.g. with headline or subhead label, or grouped with labels no. 1, 2, 3, etc.) Suggested items: maps, manuscripts, journals, newspaper clippings, photographs, drawings, artifacts (include approximate dimensions and whether light, medium or heavy weight).

1. _____ 7. _____

2. _____ 8. _____

3. _____ 9. _____

4. _____ 10. _____

5. _____ 11. _____

6. _____ 12. _____

Fig. 2-5. Independent case exhibit

Converting the Written Outline Into an Exhibit Plan

An exhibit plan can be developed by filling in a three-column chart. You may find your story board useful for this or you may want to develop the plan on long strips of shelf paper tacked to the wall or to a bulletin board. The written outline (worked out on the story board) is used for the first column. The second column is a list of objects which are in the collections or may be secured from other sources, which are correlated with the written outline. The third column suggests the exhibit structures on or in which these objects can be shown. It will include such things as wall and free-standing panels, wall and free-standing cases, platforms for large objects and floor-space to be occupied by the largest objects.

The following outline suggests topics, objects, and exhibit methods and may be helpful in planning your own exhibit sequence. Some subjects may better be handled by some means other than an exhibit and this is to be indicated in this listing. The first column is adapted from an outline in Donald Dean Parker's *Local History: How to Gather It, Write It, and Publish It.*[2] Detailed discussions of the topics are given in this publication and are well worth reading. This book is now out of print but many local libraries probably have copies. For most purposes, Parker's book has been replaced by Thomas E. Felt's *Researching, Writing and Publishing Local History*, AASLH, 1976.

Once this three-part outline has been completed, it will be easy to determine the *physical requirements* for your exhibit: how much space will be required; how many free-standing panels, how many wall panels, how many small cases, how many large cases, how many platforms, etc.

2. Parker, Donald Dean, *Local History: How to Gather It, Write It, and Publish It*, New York: Social Science Research Council, 1944.

TOPIC	OBJECTS	EXHIBIT METHOD
I. The NATURAL SETTING		
1. Location 　Ecological setting: boreal forest, desert, grassland, etc. 　Size of town area 　Physical characteristics: flat, hilly, mountainous; natural passes between this area and neighboring areas	Maps, photos, aerial photos, relief maps	Panels
2. Climate 　Amount of moisture annually through rain and/or snow 　Length of growing season		
3. Soil 　Kind and quality 　Relationship to plant cover and effect on agriculture (e.g. plains and prairie -- relatively easy clearing; rocky soil -- poor farming; forests -- must be cleared of trees)		
4. Plants	Dried plants, pressed flowers, line engravings copied from books, photographs, watercolors slides	Panels, small shallow cases Automatic slide projector (Carousel or similar type)
5. Animals (mammals, fish, amphibians, reptiles, birds)	Photographs, drawings, paintings, miniature models, mounted specimens	Panels, miniature dioramas, free-standing floor cases, platforms with panels
6. Minerals	Mineral specimens, photos of old mines, photos of mine interiors	Panels with small cases, shallow wall cases, free-standing cases

16

TOPIC	OBJECTS	EXHIBIT METHOD
II. PREHISTORIC and EARLY HISTORIC INHABITANTS		
1. Native American Cultures		
Food: how obtained, prepared, preserved	Dried corn, beans, photos, drawings, scale models	Shallow cases, panels
Shelter: need for, how made and from what, how influenced by way of life (nomadic, semi-nomadic, settled)	Photos, drawings, models of house types, full-size tepee, wickiup, longhouse, etc.	Panels, cases, interior floor space or outdoor space to set up full-size houses
Clothing: how made and from what	Fibre skirts, shirts, leather skirts, shirts, leggings, mocassins, sandals, headgear	Cases, floor and wall space (behind protective railing), mannikins
Tools and weapons	Stone projectile points, spear thrower and spear, bows and arrows, knives, guns, stone scrapers, metal scrapers, mauls, awls, baskets, pottery, parfleches, wooden boxes, hide containers, bark containers, pouches	Cases
2. Native American Sites		
Mounds, camp sites, village sites, rock carvings and paintings	Maps, photos, "tabletop" miniature models, rubbings (of petroglyphs)	Panels and cases
III. EXPLORATION		
1. Purpose of the exploration	Headline label	Panel or wall
2. By whom, at what time of year (year span, seasons), military, fur trappers and traders	Photos, drawings, paintings, steel engravings, etchings	Panel
3. Difficulties: climate, personalities, failure of equipment	Label	Panel, or inside case
4. Routes followed: natural barriers, encounters with Native Americans, other Europeans	Flat map, relief map	Panel or wall, free-standing platform

TOPIC	OBJECTS	EXHIBIT METHOD
5. Means of transportation: foot, horseback, pack animals, wagon, boat	Backpacks (for transport of supplies), pack saddles, saddlebags, hide boat, bark boat, wooden boat, sled	Case, Case, or on back of cut-out animal Floor space (for platform)
6. Types of equipment	Guns, powderhorns, powder flasks, knives, compass, sextant, journals, maps, clothing	Panels and cases (labels might be taken from journals) Mannikin
IV. The FIRST EUROPEAN-AMERICAN SETTLERS		
1. WHO were they: WHERE did they come from; WHY? Character and composition Nationality by birth and by parentage (traditions brought into the area) Homes of settlers immediately preceding their coming; route followed from old to new home Motives which led to their coming Old-home occupations of settlers compared with new-home activities Special characteristics of the early settlers Relations between different ethnic (racial or national) groups (e.g. Indian/white, black/white, Oriental/white, French/ British/Dutch, etc.)	Photos, maps showing routes into area; personal items brought by earliest settlers	Panels, cases
2. Conditions which made the area desireable as a home: Indians: absent or still present when settlement began: Indian/white relationships during early years of settlement Land: desert, plains, prairie, wooded, forested Transportation: difficult or relatively easy	Photos, diaries	Panels with portions of diaries reproduced and enlarged

18

TOPIC	OBJECTS	EXHIBIT METHOD
Sources of income: immediate or to be developed		
Markets: nearby or far away; means by which goods transported		
3. Biographical sketches of outstanding pioneers		Panels and cases
The "founders"		
Their chief supporters and advisors		
V. ECONOMIC DEVELOPMENT		
1. Transportation, trade, communications:	Fur pelts, glass beads, steel knives, sacks of grain, maps of roads and canals, telephones and telegraph keys and batteries, timetables (ships, stage lines, railroads), model ships, models or full-size wagons, stagecoaches, antique autos, bicycles, train, airplane	Floor space or outdoor area with protective roof; shallow pool for boats; Panels (indoors and out), cases
General relations to other communities, sections, counties		
Frontier trade: furs, etc		
Roads, rivers, and canals		
Maritime trade		
Railroads		
Telegraph and telephone		
Automobiles and highways		
Air routes, terminals		
Mail services		
2. Agriculture:	Farm equipment, photos, "American primitive" paintings, models or miniature dioramas of changing farm patterns	Floor space or outdoor area with protective roof; panels, cases
General ideas and methods		
Subsistence farming		
Lumbering and forestry		
Money crops, relation to trade		
Machinery and implements		
Rotation and fertilization		
Animal husbandry		
Capital -- owning, mortgages, renting, share-cropping		
3. Manufacturing	Spinning wheel, industrial machines, early	Platforms, floor space, panels, cases
Early handcrafts		

TOPIC	OBJECT	EXHIBIT METHOD
Inventions and machinery The factory system Private business and corporations Banking and finance Labor and the unions General business relations	typewriters, ledgers, cash books, receipts, photographs of buildings and early factory interiors	Platforms, floor space, panels, cases
4. Maritime activities Fisheries Shipbuilding	Photos, anchors, lobster pots, fish nets, whaling equipment, model ships, ship drawings, paintings, figureheads, chains, knot boards, personal gear of sailros	Platforms, floor space, panels, cases
5. Extractive industries Mining, oil, lumbering (if done with no effort at reforestration)	Miners' candlehoders, lamps, picks, ore buckets, ore cars, drilling equipment	Cases, panels, flobr space for platforms
	model oil well, drill bits, core samples	Miniature diorama, case, panel
	Cross-cut double-handed saws, axes, spikes, logging "dogs", photos	Panels, wall space, floor space
6. Present-day economic base for community or area. Problems with pollution and environmental quality	Photos, Science-Fair exhibits	Panels, cases, wall space
VI. POLITICAL ACTIVITIES		
1. Original form of local government	Photostats of legal documents	Panels
2. Changes in charters, boundaries, status	Maps, charts	Panels
3. Prominent officials		

20

TOPIC	OBJECT	EXHIBIT METHOD
4. Rise and progress of political parties, their local programs, elections	Campaign buttons, posters, flyers, photos	Panels (with protection over posters)
5. Degree of efficiency and honesty in local government, financial policies		
6. Relation of government to other intitutions (churches, schools, social problems, etc.)		
7. Civic services: Water Sewerage Gas and electricity Fire and police protection (from volunteer to paid), vigilantes	Fire fighting equipment, early hand-cuffs, leg irons, sheriff's badge, guns, "Wanted" posters, newspaper clippings	Floor space, platforms, cases, panels, outdoor space with protective roof
Public relation facilities (chambers of commerce) City planning		
8. Civic reform movements		
VII. RELIGIOUS DEVELOPMENT		
1. Early religious life (circuit riders, itinerant preachers)	Saddlebags, bibles, map (of circuit rider's route), religious statues, santos, photos of early churches	Cases Panels, wall space, floor space behind a railing
2. Development of the major denominations: doctrines, government, ritual, morals		
3. Minor groups		
4. Interdenominational relations		
5. Moral attitudes in churches and their relation to social problems, law and order, civic reform, etc.		

21

TOPIC	OBJECTS	EXHIBIT METHOD
VIII. POPULATION HISTORY		
1. Birth and death rates	Probably treated easier in a pamphlet than an exhibit. However, might be shown with maps, census reports, enlarged newspaper headlines	Panel
2. Growth or decline of total population		
3. Migrations: Immigration: Statistics Racial or national groups Treatment of immigrants "Americanization" Influence of immigrants Emigration Causes and destinations Selective influences Results (viable town today? ghost town?)	Materials brought from former homes	Cases and panels
IX. The FAMILY		
1. Courtship, marriage, remarriage and divorce	Objects connected with daily life: clothing, books, family portraits, cooking ware, tableware, eyeglasses, fans, stickpins, lamps, furniture, toys	Panels, platforms, cases, wall space, mannikins, "period" rooms, cases behind "false" fronts
2. Moral standards		
3. Personal and property rights of husbands, wives, and children		
4. Birth rates, status of children		
5. Special phases of family life -- religious, educational, recreational, economic, etc.		

TOPIC	OBJECTS	EXHIBIT METHOD
X. EDUCATION		
1. The first schools	Schoolbooks, slates, desks, black-boards, photographs, drawings, one-room schoolhouse	Panels, cases, platforms with back panels, "period" room, outdoor space for building
2. Church and other private schools		
3. Public schools: Elementary and secondary Curriculum: extracurricular activities Teachers and teacher training Methods of teaching School administration School financing School building and facilities Special schools		
4. Higher education Church colleges City or state universities		
5. Adult education		
6. General influence of schools on the community and vice-versa		
XI. The NEWSPAPERS, PERIODICALS and LIBRARIES, RADIO and TELEVISION		
1. Early newspapers, their origin, growth, influence, political affiliations and part played in local politics	Early newspapers, hand presses, machine powered presses, early radio and television sets, photographs	Panels (perhaps some built along a wall like pages in a book), cases, floor space for platforms
2. Discontinued newspapers: origin, growth, influence, political affiliations, reasons for discontinuance		
3. Present newspapers: origin, growth, influence, political affiliations, policies for local community		

23

TOPIC	OBJECTS	EXHIBIT METHOD
4. Periodicals, magazines and journals, origin, growth, influence		
5. Libraries: public and private		
6. Radio stations: first one, growth, influence		
7. Television stations: growth, influence		
XII. SOCIAL and FRATERNAL ORGANIZATIONS		
1. Origin and growth of each	Costumes and uniforms, club publications paraphernalia, photos	Cases, mannikins, panels
2. Purpose and special field of activity		
3. Relation to whole community		
(Organizations to consider: Masons, Knights of Columbus, Knights of Pythias, Odd Fellows, Grange, DAR, American Legion, VFW, Parent-Teachers' Association, Women's clubs, Ku Klux Klan, Chamber of Commerce, Rotary, etc.)		
XIII. OTHER CULTURAL ACTIVITIES: The Arts		
1. Household arts: cookery, wines, textiles	Pottery, pewter, wooden utensils needlework, spinning wheel, loom, potter's wheel	Cases, with techniques shown in drawings or photos on panels in case or adjacent panels; floor space for platform with panel back or adjacent panel
2. Minor arts: costumes, furniture, silver, glass,		
3. Fine arts: music (folk songs, singing societies orchestras), dancing, painting and sculpture, architecture (old houses, construction, styles)	Musical instruments, scores, music stands, photos, paintings, sculptures models of buildings	cases, panels, floor stands addition of sound by tape recording activated by push button
4. Literature Taste in reading: relation to libraries, periodicals Literary societies Original work	Better in a pamphlet rather than exhibit	

TOPIC	OBJECTS	EXHIBIT METHOD
5. Professional groups and schools		
6. The stage Amateur theatricals Pageants Theatres, vaudeville Minstrel shows "Movies" Opera	Costumes, props, posters, programs, handbills, photos	Panels and cases; perhaps floor space for platform reminiscent of stage with "wing" panels
7. Museums: origin, growth, changing exhibit techniques, programs		
XIV. SCIENCE and TECHNOLOGY		
1. Local inventors	Photos of local inventors, groups, models of inventions, equipment, work-bench, patent drawings and applications	Panels and cases, "period" room,
2. Technological developments in factories, transportation, agriculture	Tools, machines	Panels, cases, platforms
3. Original work in "pure" science		
4. Scientific institutions and professional groups (engineers, chemists, etc.)		
XV. LAW		
1. Civil law Common law – civil Statute law (local, state, and federal)	Probably better in a pamphlet than exhibit	
2. Criminal law (see above)		
3. Court organization and procedures		
4. The legal profession: training, place in community, in politics		

25

TOPIC	OBJECTS	EXHIBIT METHOD
XVI. SOCIAL PROBLEMS and REFORM		
1. Poverty and poor relief	Photographs, enlargements of newspaper stories, some actual objects	Combined panel and shallow cases
2. Crime and punishment Crime conditions and moral attitudes Types of punishment Penology and institutions	Guns, clubs, hypodermic needles, etc.	Investigate posters and loan exhibits from federal, state, and local agencies. Write AASLH for list of sources of travelling or loan exhibits.
3. Drunkenness and drug addiction		
4. Prostitution	Photographs, early handbills, brass tokens,	
5. Slavery		
6. Handicapped classes Orphans and aged The insane and feeble-minded The deaf, dumb, blind, and crippled		
7. Health and disease Medicine and doctors Hospitals Disease conditions Public health control Folk medicine and practice Quackery and medical sects Relations to regular medicine Public medical services		
8. Social reform movements Anti-slavery, temperance, women's rights, civil rights (each of these can be treated in relation to a particular problem above)		
XVII. RECREATION		
1. Utilitarian recreation: corn husking, house raisings, spelling bees, etc.	Models, dioramas, sports equipment (fishing tackle, skis, snowshoes, canoes),	Cases, panels

26

TOPIC	OBJECTS	EXHIBIT METHODS
2. Indoor games	photographs, posters, newspaper clippings, maps	
3. Outdoor sports: amateur and professional		Free map/folders locating nearby parks, camping and recreational areas
4. (See also: literature, libraries, theatres, movies, radio, television)		
5. Vacations: public resorts, amusement parks, federal, state and local parks		
6. Immigrant contributions (e.g. jaialai, soccer, lacrosse)		
XVIII. FOLKLORE		
1. Superstitions	Probably handled better by popular-style publication than by exhibit (see Foxfire by).	
2. Local beliefs about births, deaths, weddings, funerals		
3. Ghosts, charms, haunted houses, hidden stair-ways, secret closets	However, a PANEL exhibit of gravestone rubbings with short history of individuals involved, would be of interest.	Panel
4. Strange and unaccounted-for happenings		
5. Eccentric characters -- inventors, cranks, prophets, gamblers, murderers, spies		
6. Spite fences, churches, school, towns, and railroads		
7. Odd decisions made by the flipping of a coin		
8. Irreverent, odd and interesting jingles on tombstones		
9. Odd and obsolete punishments, ordinances		
10. Local sayins, maxims, proverbs, ballads		
11. Dialect and words peculiar to the neighborhood		
12. Local sports, feasts, fairs		

27

3 Exhibit Specifics: Scale Models

Whether you are planning an independent panel or case or an entire gallery sequence of panels and cases, your task will be made much easier by the use of a scale model.

Developing A Scale Model From the Exhibit Plan

A "planning base" is made first by attaching 1/4" graph paper to a corrugated cardboard support. Sheets of double-coated adhesive paper (such as Redimount) are used in the following sequence:

1. Flip a corner of the double-coated paper back and forth with a finger tip until you can separate one side of the protective paper. Peel this paper back a few inches (Fig. 3-1a) and crease it down on a diagonal (Fig. 3-1b) so that one corner extends beyond the side of the sheet.

2. Hold the exposed sticky sheet up away from the graph paper and line up the remaining corners with the corners of the graph paper (Fig. 3-1c).

3. Holding the graph paper and adhesive paper in register, smooth down the sticky portion of adhesive sheet to graph paper (Fig. 3-1d).

4. Remove remaining protective sheet by pulling on corner of protective sheet exposed by diagonal fold in step 1 above (Fig. 3-1e). Smooth down thus exposed sticky side to graph paper as the protective paper is pulled away. It may be necessary to apply several adhesive sheets to fully cover the back of the graph paper.

5. When the back of the graph paper is completely covered with the adhesive sheets, pull away the remaining protective sheet from half of the graph paper (Fig. 3-2a).

6. Holding the exposed sticky back of the graph paper away from the supporting corrugated cardboard, line up one edge of the graph paper with the cardboard (Fig. 3-2b) then hold the graph paper and cardboard firmly in register while you slowly lower the sticky side of the graph paper. Smooth the sticky side down firmly to the cardboard.

7. Peel the remaining protective paper from the back of the graph paper (Fig. 3-2c) and smooth the remaining sticky side of the graph paper down onto the cardboard (Fig. 3-2d). Trim the edges of the cardboard even with the border graph paper lines.

This base may be used to develop a full room or gallery exhibit or a floor plan for an entire building. It may also be covered with a protective sheet of waxed paper and used in designing structures for panels or cases.

Fig. 3-1a.

28

Fig. 3-1b.

Fig. 3-1c.

Fig. 3-1d.

Fig. 3-1e.

Fig. 3-2a.

Fig. 3-2b.

Fig. 3-2c.

Fig. 3-2d.

29

Scale Model Exhibit Rooms

In building a scale model of an exhibit room, use the planning base. In the examples shown here, one-quarter of an inch is equal to one foot.

Most 1/4" graph paper will show heavier blue lines every fourth line. This helps in counting off squares. An additional help will be to start at a common corner and, using a fine tip fibre-tipped black pen (such as Flair) count off and prenumber the lines along two sides (these numbers are shown clearly in Fig. 3-4c). Most tools and materials you will need are shown in Fig. 3-3 and include: a small size T-square, 3/4" masking or drafting tape, a copy of the blueprint of your floor plan, some white glue, an architect's scale, a No. 1 X-Acto knife with a No. 11 blade (you will want several spare blades), a metal-edged ruler, a triangle, and some straight pins. Not shown, but useful, are a small pair of pliers (to use with the pins), a piece of 1/4" plate glass about one foot square (to use as base against which to cut with the X-Acto knife and metal-edge ruler), a paper cutter of at least 15" capacity (for cutting long parallel strips of "pebble" or mat board), and a supply of "pebble" or mat board. Assorted pieces of balsa wood and a miniature mitre box and razor-backed saw (available from hobby or model railroad shops) also are useful.

Steps in making the scale model room

1. Transfer the floor plan from the blueprint to the graph paper planning base. Many times the blueprint will already be

Fig. 3-3.

drawn in a 1/4" to 1')" scale. If not, use the dimensions written along the sides of walls shown on the print or, if none are shown but the scale is given (e.g. 1/8" = 1')") use the corresponding scale on the architect's ruler or scale to measure the blueprint. Remember to allow for the thickness of walls in transferring your drawing. It is a good idea to do the drawing on the graph paper first with a comparatively soft pencil (No. 2 or No. 1) so that mistakes may be erased easily.

If you have an existing room but no blueprint of the floor plan, you will have to measure that room then make the drawing on the graph paper.

Remember, each:

 1/4" equals 1 foot;
 1/8" equals 6 inches;
 1/16" equals 3 inches
and so on.

2. When you have outlined the floor plan on the graph paper base, cut strips of pebble board or mat board to use in making the walls of your model. If the walls of your room are actually 8 feet high these strips should be 2" wide; if the walls are 10 feet high the strips should be 2 1/2" wide; 12 feet walls should be represented by 3" wide strips.

3. Place one of these strips on your floor plan; line up one end with a corner of the room and measure the length of the wall at the opposite corner (Fig. 3-4a).

4. Use the T-square to mark the end of the wall across the strip (Fig. 3-4b). Trim the strip with the paper cutter or the X-Acto knife. Do this for each of the four outside walls. *Remember* to allow for the thickness of the cardboard on two opposite sides (either *both* long walls or *both* short walls).

5. Measure the length of interior walls in the same way and trim to length. Place the trimmed wall strips on the floor plan and mark the places for door and window openings (Fig. 3-4c).

6. Use the T-square again to get a true right-angle line, then use the architect's scale to measure the correct height of the door (shown as 7 feet in Fig. 3-4d). For

windows, both the top and bottom should be marked.

7. Place the marked strip on a large piece of 1/4″ thick plate glass, use the metal-edged ruler and X-Acto knife to cut out the door opening (Fig. 3-4e). Cutting against the glass will give a cleaner cut and edge than cutting against a softer material.

8. Exposed supporting columns may be shown by measuring and cutting balsa wood sticks (Fig. 3-4f). These sticks are available from hobby stores in a variety of sizes from as small as 1/16″ square to 1″ square, all three feet long.

Remember, in the scale we are using:

a 1/8″ square stick will represent a 6″ square column;

a 1/4″ square stick will represent a 12″ square column;

a 3/8″ square stick will represent an 18″ square column.

Dowels are also available for representing round columns.

Fig. 3-4a.

Fig. 3-4b.

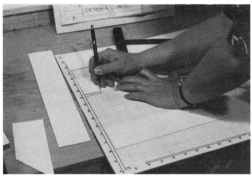

Fig. 3-4c.

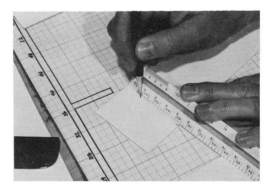

Fig. 3-4d.

Fig. 3-4e.

Fig. 3-4f.

Fig. 3-4g.

9. Glue all exterior and interior walls and columns in place. Push pins through the pebbleboard into the corrugated cardboard base along both sides of the pebbleboard strips to hold the scale walls in a straight line (Fig. 3-4g).

Steps in making scale model cases for the scale model room

Figure 3-5a shows patterns for scale model cases. The following steps may be followed:

1. Cut strips of pebbleboard the height of the scale model cases:

 1 3/4″ strips represent 7 feet high cases

 2″ strips represent 8 feet high cases.

2. Use the architect's scale to measure the depth and width of the case along one edge of the strip. Measure the width of the viewing window at the same time (Fig. 3-5b).

3. Use the T-square to mark true right angles for the corners of the case (Fig. 3-5c).

4. Score along these lines (cut only halfway through the pebbleboard) using the metal-edged ruler and X-Acto knife (Fig. 3-5d).

5. Cut out the window opening, then fold the scored lines to form the scale case. Glue the corner together and hold with pins until the glue dries (Fig. 3-5e).

6. Make a number of scale model cases of different sizes and cut a number of pieces of pebbleboard to represent panels of different widths.

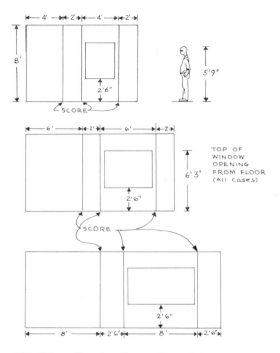

Fig. 3-5a. Constructing scale-model cases.

7. With a supply of scale model cases and panels, the model of the room, and the typed outline of the exhibit, you should be able to begin development of a floor plan (Fig. 3-5f) to provide a definite traffic pattern or flow for your visitors to follow.

8. *Remember* to plan floor space for benches for your visitors' comfort.

Scale Model Design-Case Construction

There are almost as many ideas about exhibit cases as there are museum exhibit designers. There are "cases" which actually are architectural structures large enough for the visitor to enter which are built within an existing room and there are cases designed to show one isolated, tiny specimen which may require a built-in magnifying glass for the visitor's use. Most cases, however, can be "catalogued" as one of the following (Fig. 3-6):

 a. hanging wall

 b. flat, table

 c. floor

 d. built-in

Fig. 3-5b.

Fig. 3-5c.

Fig. 3-5d.

Most commercially available cases, no matter how attractively advertised and no matter the listed "big" museum in which they may be used, are not well suited for most museum purposes. Too often they are "slick" constructions of chrome and formica with viewing glass that is not slanted and with interiors equipped with glass shelves. Often one can build two or even three cases for the same amount of money required for the purchase of one commercial unit. Be wary of industrial designs and of designers who approach museum exhibit problems as they do trade fairs. The "biggest," "brightest," and most expensive is not necessarily the best.

As with the planning of a gallery layout, use of a scale model while planning exhibit case construction will help to solve many problems in the preliminary stages. Use of the scale model also makes it possible to anticipate material needs (and costs) very closely.

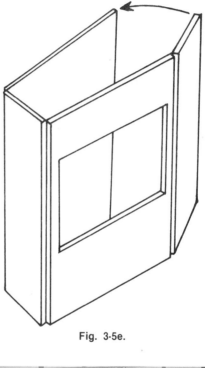

Fig. 3-5e.

Fig. 3-5f.

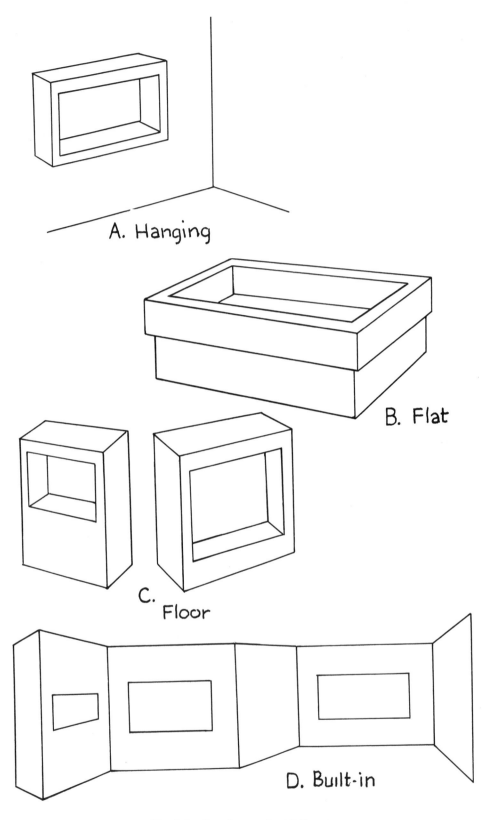

A. Hanging

B. Flat

C. Floor

D. Built-in

Fig. 3-6. Four types of exhibit cases

34

A scale of 1 1/2″ = 1′0″ will permit using many commercially available balsa wood strips and is large enough actually to plan just which way boards will meet, whether joints are to be lap or butt, how many framing members will be required, etc.

With a 1 1/2″ to 1′0″ scale, the following are equivalent measures:

Scale size	equals	Actual size
1 1/2″		1 foot
3/4″		6″
1/2″		4″
3/8″		3″
1/4″		2″
1/8″		1″
3/32″		3/4″
1/16″		1/2″
1/32″		1/4″

Some balsa wood strips that are available are shown below with their equivalent sizes:

Scale size	equals	Actual size
1/8″ x 1/2″		1 x 4 pine board
1/4″ x 1/2″		2 x 4 pine or fir board
1/8″ x 1 1/4″		1 x 10 pine board

Sheets of balsa wood that range from 1/32″ thick and 3″ or 6″ wide to 1/4″ thick and 3″ or 6″ wide can be purchased from hobby shops. All sheets are 36″ long. These sheets and equivalent sizes are shown here:

Scale size	equals	Actual size
1/32″ x 6″ cut 12″ long		1/4″ x 4′ x 8′ plyboard sheet
1/16″ x 6″ cut 12″ long		1/2″ x 4′ x 8′ plyboard
3/32″ x 6″ cut 12″ long		3/4″ x 4′ x 8′ plyboard

One of the sides of an architect's scale will include the 1 1/2″ scale. Use of this scale will permit relatively close planning on material cuts.

To build a scale model case to represent an actual case 4 feet wide, 2 feet deep, and 7 feet high, you will need the graph paper planning base, sheets of tracing paper, masking tape, an architect's scale, triangles (for ease in drawing true right angles), waxed paper, pins, balsa wood, and white (Elmer's) glue. The following step-by-step description of construction of the case will demonstrate typical procedures for both scale and actual construction.

1. Tape a sheet of tracing paper to a graph paper planning base (Fig. 3-7a) and draw the framing for the front of the case. Protect the final drawing by taping a sheet of waxed paper over it.

2. Cut balsa wood strips (here 1/8″ x 1/2″ to equal 1 x 4 pine boards and one 1/4″ x 1/2″ to indicate a 2 x 4) and glue them *not* to the planning base but to each other (Fig. 3-7b), using the protected drawing as a guide. Use pins to hold the pieces together until the glue dries. Extra pins, pushed into the planning base, hold the strips of balsa straight along the lines of the drawing.

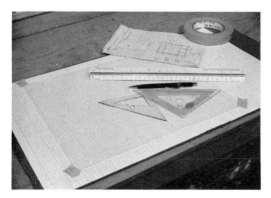

Fig. 3-7a.

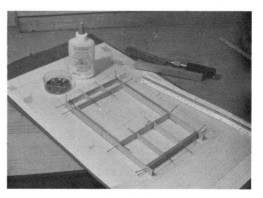

Fig. 3-7b.

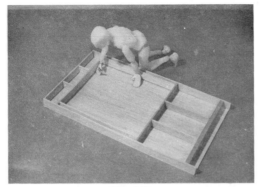

Fig. 3-7c.

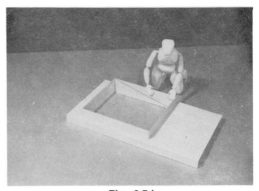

Fig. 3-7d.

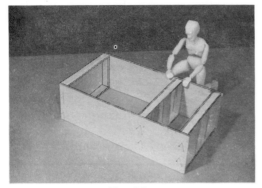

Fig. 3-7e.

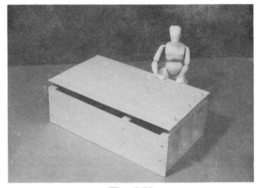

Fig. 3-7f.

3. When this unit is dry remove it from the waxed paper and glue it to a sheet of balsa 1/32″ x 6″ x 10 1/2″ (representing a sheet of plyboard) (Fig. 3-7c).

4. Cut out the opening for the window then make a frame of balsa strips 3/32″ x 1 1/8″ (representing pine boards) for the "shadow box" for the glass. Put this shadow box into the opening from the *front* (plyboard) side of the framed front so that all boards are flush on what will be the inside of the case front (Fig. 3-7d).

5. Tape a fresh piece of tracing paper to the planning board and draw the framing for one of the two required "shelf" units. Again, protect the drawing with waxed paper, glue the framing together, glue a sheet of balsa (representing plyboard) to the framing. Remove this first unit from the waxed paper and make the second. These will form the bottom and exhibit shelf of the case. Use the same drawing to make the outside framing for the case top, eliminating the two inside framing pieces so that the final top resembles an upside-down tray (see Fig. 3-7e).

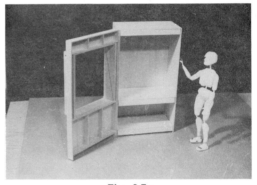

Fig. 3-7g.

6. Cut two sheets of balsa 3/32″ x 2 1/2″ x 10 1/2″ (which represents plyboard sides of 3/4″ x 21″ x 7′). Use glue and pins to assemble sides to top, shelf, and bottom (Fig. 3-7e).

7. Cut a sheet of balsa wood 1/16″ x 6″ x 10 1/2″ to represent a case back 1/2″ x 4′ x 7′ plyboard and glue this to the assembled sides, top, shelf, and bottom (Fig. 3-7f).

8. A strip of drafting tape fastens the front to the assembled case and represents either a piano hinge or other hinges on the final full-scale case (Fig. 3-7g).

36

Photographs of the full-size case with construction details and scale drawings of the case are shown in Figs. 3-8, 3-9, and 3-10.

A variation on this "theme" is shown in Fig. 3-11 which represents an exhibit case 6 feet wide. The essential differences are:

Two 2 x 4s are used for framing uprights for additional strength on the hinged case front. Because it is difficult to hammer nails through a 2 x 4 into a 1 x 4, extra "nailing blocks" ("H" in Fig. 3-11a) are used.

A 1/2″ T/G (tongue-and-groove) plyboard, normally used for sheathing or subflooring, is used for the front and back

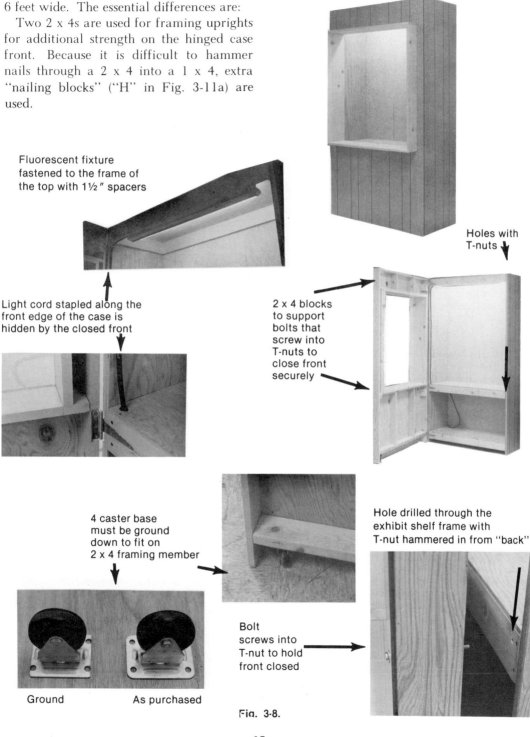

Fluorescent fixture fastened to the frame of the top with 1½″ spacers

Light cord stapled along the front edge of the case is hidden by the closed front

Holes with T-nuts

2 x 4 blocks to support bolts that screw into T-nuts to close front securely

4 caster base must be ground down to fit on 2 x 4 framing member

Hole drilled through the exhibit shelf frame with T-nut hammered in from "back"

Ground As purchased

Bolt screws into T-nut to hold front closed

Fig. 3-8.

37

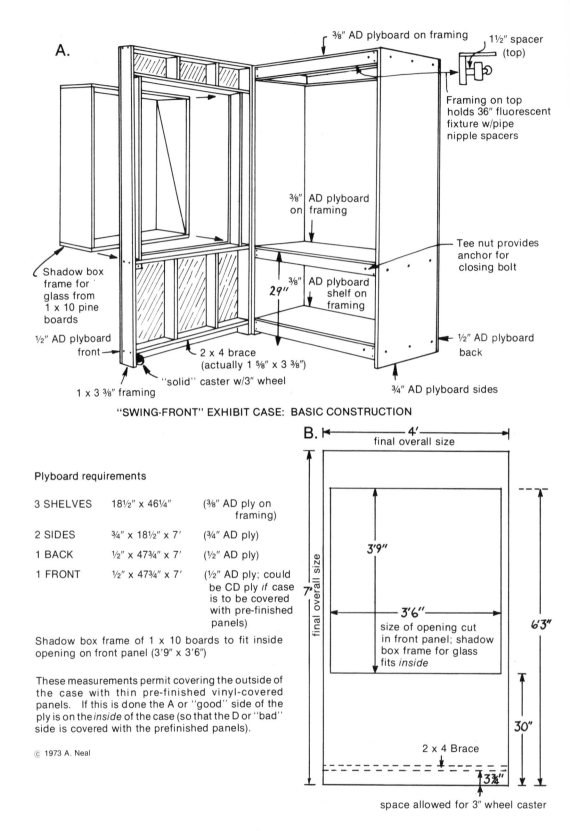

A.

⅜" AD plyboard on framing

1½" spacer (top)

Framing on top holds 36" fluorescent fixture w/pipe nipple spacers

⅜" AD plyboard on framing

Shadow box frame for glass from 1 x 10 pine boards

½" AD plyboard front

⅜" AD plyboard shelf on framing

29"

Tee nut provides anchor for closing bolt

½" AD plyboard back

2 x 4 brace (actually 1 ⅝" x 3 ⅜")

1 x 3 ⅜" framing

"solid" caster w/3" wheel

¾" AD plyboard sides

"SWING-FRONT" EXHIBIT CASE: BASIC CONSTRUCTION

Plyboard requirements

3 SHELVES	18½" x 46¼"	(⅜" AD ply on framing)
2 SIDES	¾" x 18½" x 7'	(¾" AD ply)
1 BACK	½" x 47¾" x 7'	(½" AD ply)
1 FRONT	½" x 47¾" x 7'	(½" AD ply; could be CD ply *if* case is to be covered with pre-finished panels)

Shadow box frame of 1 x 10 boards to fit inside opening on front panel (3'9" x 3'6")

These measurements permit covering the outside of the case with thin pre-finished vinyl-covered panels. If this is done the A or "good" side of the ply is on the *inside* of the case (so that the D or "bad" side is covered with the prefinished panels).

B.

4' final overall size

7' final overall size

3'9"

3'6"

size of opening cut in front panel; shadow box frame for glass fits *inside*

6'3"

30"

2 x 4 Brace

3¾"

space allowed for 3" wheel caster

Fig. 3-9. Constructing a swing-front exhibit case

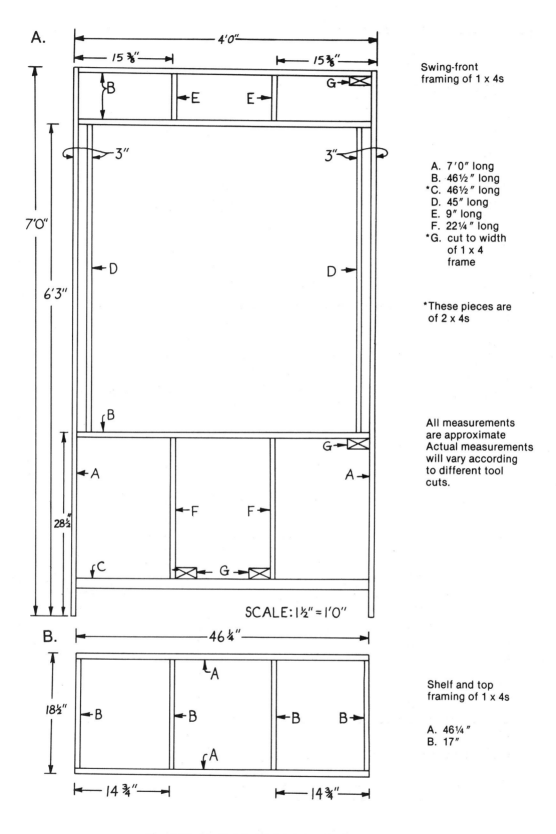

A.

4'0"

15⅜" 15⅜"

B
E E G

Swing-front
framing of 1 x 4s

3" 3"

A. 7'0" long
B. 46½" long
*C. 46½" long
D. 45" long
E. 9" long
F. 22¼" long
*G. cut to width
of 1 x 4
frame

7'0"

6'3"

D D

*These pieces are
of 2 x 4s

B

A G A

All measurements
are approximate
Actual measurements
will vary according
to different tool
cuts.

28½"

F F

C G

SCALE: 1½" = 1'0"

B.

46¼"

A

18½"

B B B B

Shelf and top
framing of 1 x 4s

A

A. 46¼"
B. 17"

14¾" 14¾"

Fig. 3-10a,b. Details of the swing-front case

39

C.

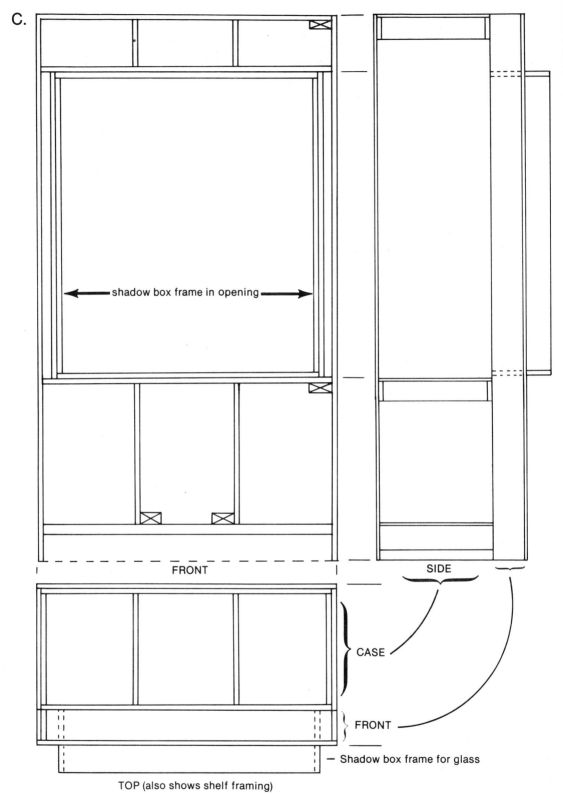

shadow box frame in opening

FRONT

SIDE

CASE

FRONT

Shadow box frame for glass

TOP (also shows shelf framing)

Fig. 3-10c. Detail of the swing-front case

40

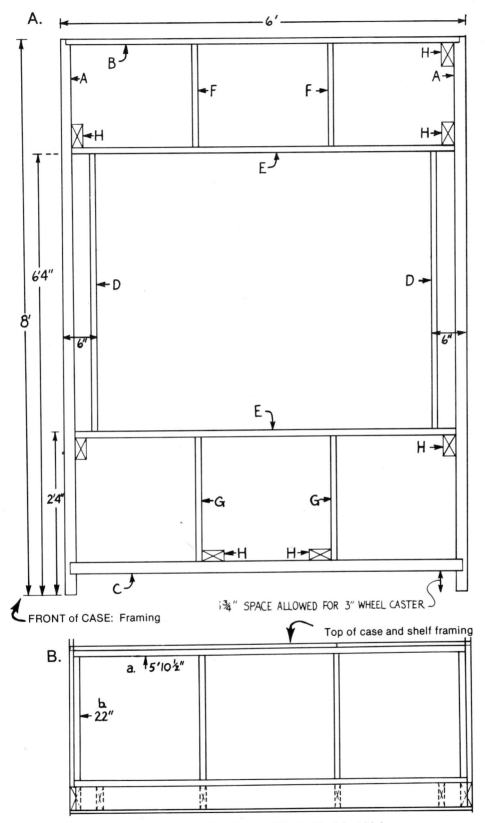

A.

B.

a. 5'10½"

b. 22"

¾" SPACE ALLOWED FOR 3" WHEEL CASTER

FRONT of CASE: Framing

Top of case and shelf framing

Fig. 3-11a,b. Details of a case 6 feet wide, 8 feet high

C.

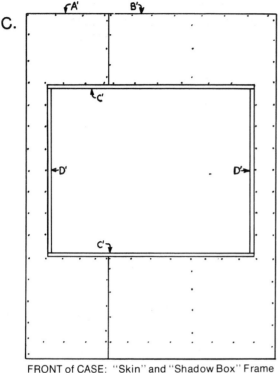

FRONT of CASE: "Skin" and "Shadow Box" Frame
for glass

Fig. 3-11c. Detail

"skins." The 6 foot wide dimension requires a vertical seam. While the front ply would be supported by vertical framing elements (F and G in Fig. 3-11a), the seam on the back has no framing member and, without the tongue-and-groove, might easily buckle, creating a crack in the completed case back.

The groove should be loaded with white glue when the front and back "skins" are nailed in place.

This T/G plyboard is quite rough on both sides with many knots and splints (usually a C-D grade). The interior back of the case can be lined with 3/16″ Upson board, 1/2″ Cellotex or similar material to provide a smooth exhibit surface. The outside may be covered with thin (3/32″) pre-finished, random-grooved, vinyl-clad panels or, if a rough lumber effect is appropriate for the exhibit story, may be grooved into a random-width plank pattern by using a "V" cutter in a router, then stained and finished.

Framing measurements for case six feet wide and eight feet high:

A	2 req.	2″x4″x96″
B	1 req.	1′x4′x69¾″
C	1 req.	2′x4′x69¾″
D	2 req.	1′x4′x48′
E	2 req.	1′x4′x68½″
F	2 req.	1′x4′x18½″
G	2 req.	1′x4′x22½″
H		nailing blocks of 2 x 4s cut to width of framing

These measurements are approximate. Actual measurements will vary according to different tool cuts.

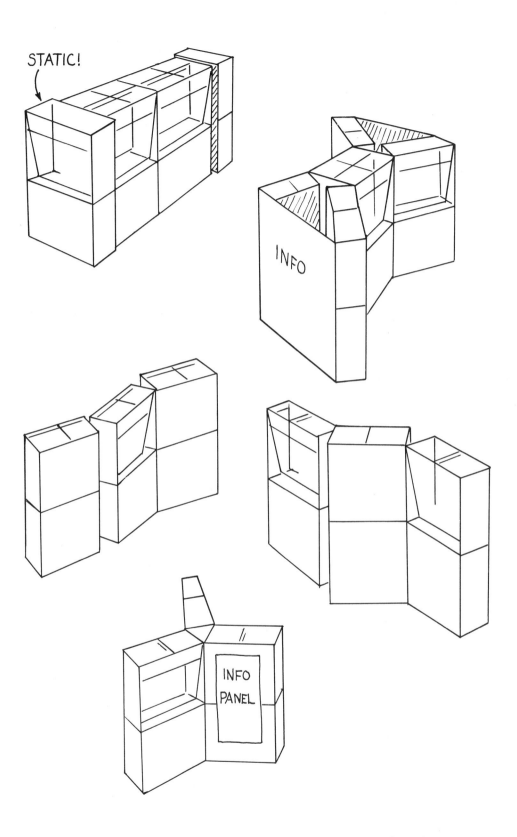

STATIC!

INFO

INFO PANEL

Fig. 3-12. Some suggested floor arrangements for free-standing units

43

4 This Old House

Historical societies sometimes fall heir to, or are able to acquire, school buildings, stores, or huge old residences which may not quite fulfill the requirements to be designated historical landmarks and are not significant enough in local history to require preservation as an historic house. Such properties, if architecturally sound, may lend themselves to becoming a combination society headquarters and small exhibit facility. Before accepting or acquiring such a building, you should ask your local building code inspectors to go over the house completely to determine what necessary repairs and additions must be made to bring the building up to code for public (as opposed to private) use. Such things as modernized plumbing, with the possible addition of first-floor toilets for public use, and up-dated wiring must be considered. It is possible the entire structure would need new wiring. It is almost certain that additional wiring for exhibit purposes would be required. It might be necessary to cut additional outside doors to provide emergency exits. List all these requirements, then ask for bids from your contractors. In addition, try to arrive at a realistic estimate of annual operating expenses—heating, lighting, water, etc. Once your estimates are complete, you can decide if the house can be accepted (even as a gift) or if it is worth raising money to purchase.

As an exhibit facility, there are bound to be some built-in problems. Some of these can be minimized or eliminated by designing panels, cases, platforms, or a combination of any of these, which will engulf or hide the construction problems.

Old schools and/or stores may have ceilings 10 feet high or higher. A suspended ceiling over a portion of the room, or a "false front" ceiling over some floor cases will help to change the sense of space within a large area.

Non-load-bearing walls which serve only as partitions to separate rooms in old residences might be torn out, thus creating a much larger area.

An existing wall may be lined with panels of 1/2″ thick Upson board or Homasote which have been covered with a coarse fabric such as colored burlap or monk's cloth. These panels may be interspersed at 2 foot intervals with vertical shelf standards, thus creating a very flexible wall for changing exhibits. The Upson board or Homasote panels permit using pins, tacks, even "L" hooks to hold photographs, drawings, maps, etc. The holes made by the pins, tacks, or L hooks are hidden by the fabric when these fasteners are removed for a new installation. The shelf standards permit locating shelves for some objects, or provide support for shallow wall cases for objects requiring the protection of glass or heavy plastic.

Permanent cases can be built along some existing walls.

Bay windows or dormer windows can be incorporated into built-in cases, creating extra depth and a visual change of pace.

Panels can be interspersed with small cases in hallways or narrow corridors (see pp. 46—51 in *Help!*).

Closets can be provided with hinged exhibit windows by cutting a hole in the closet door and putting in a shadow-box frame with glass. The closets then become

additional exhibit areas where artifacts, dioramas, costumed mannikins, or a variety of other items may be shown. Closets also provide an almost ideal location for rear-screen projection of slides.

Some of these ideas are detailed in the following photographs and sketches. (Figs. 4-1-4-10).

"THIS OLD HOUSE"

Attic: Storage

Second floor: Permanent exhibits
Cleaning closet with second floor cleaning supplies

Ground level: Cleaning closet with first floor clean-
ing supplies
Main office with office supplies in closet
Receptionist's table
Volunteer headquarters
Changing exhibits
Changing panel exhibits on veranda

Basement: Maintenance (furnace, hot water hea-
ter)
Reserve stock for all supplies

CARRIAGE HOUSE

Ground level: Carpenter shop and lumber supplies
Art studio
Photographic studio with darkroom

Second floor: Storage

Fig. 4-1. Suggested uses for space in a house-museum

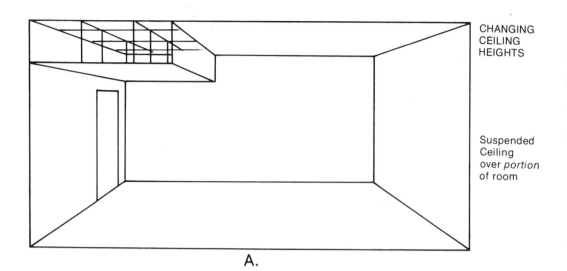

CHANGING
CEILING
HEIGHTS

Suspended
Ceiling
over *portion*
of room

A.

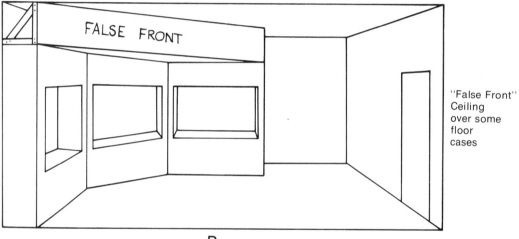

FALSE FRONT

"False Front"
Ceiling
over some
floor
cases

B.

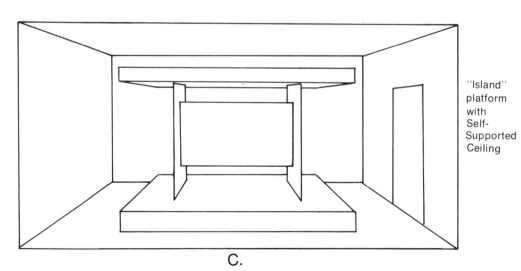

"Island"
platform
with
Self-
Supported
Ceiling

C.

Fig. 4-2. Three ways to change ceiling heights

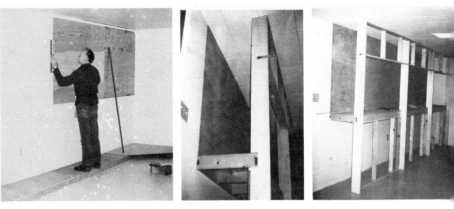

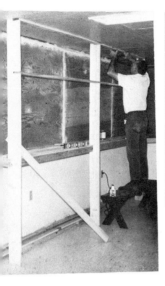

3a Back plyboard panel is bolted or screwed to wall. Exhibit shelf is bolted or screwed to wall, supported temporarily in front until frame is assembled.
Front frame is put together on floor then raised and pushed into place along front of shelf, then bolted or screwed to ceiling and floor.

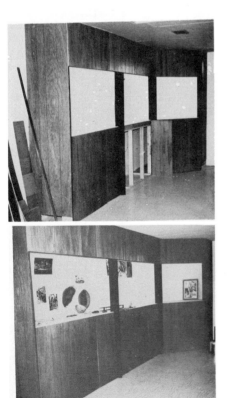

3b Fluorescent lights are mounted in place; front paneling added, end panel added. Glass is installed on slant between vertical frame members.

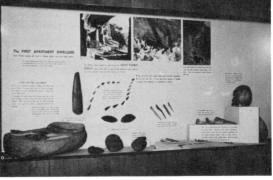

Fig. 4-3. Building against an existing wall
In order to avoid a "chopped-up" appearance and a crowded effect which might be created by a number of small individual cases, a long case with an interior area open from one end to the other can be constructed.

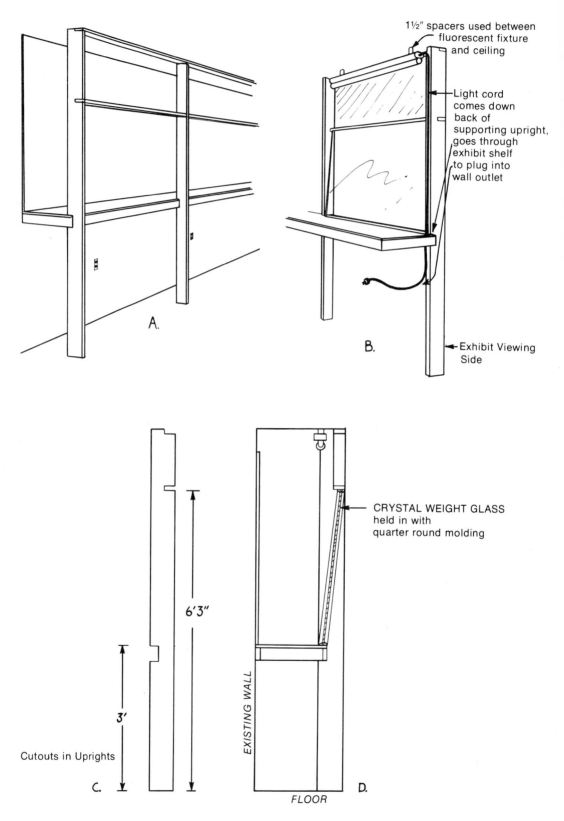

A.

1½" spacers used between
fluorescent fixture
and ceiling

Light cord
comes down
back of
supporting upright,
goes through
exhibit shelf
to plug into
wall outlet

B.

←Exhibit Viewing
Side

6'3"

3'

Cutouts in Uprights

C.

CRYSTAL WEIGHT GLASS
held in with
quarter round molding

EXISTING WALL

FLOOR

D.

Fig. 4-4. Construction specifics for the long case

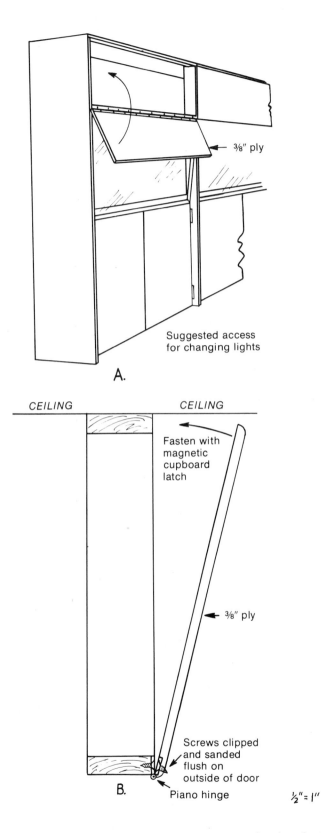

⅜" ply

Suggested access
for changing lights

A.

CEILING CEILING

Fasten with
magnetic
cupboard
latch

⅜" ply

Screws clipped
and sanded
flush on
outside of door

B. Piano hinge

½" = 1"

Fig. 4-5. The hinged upper panel provides access for changing lights

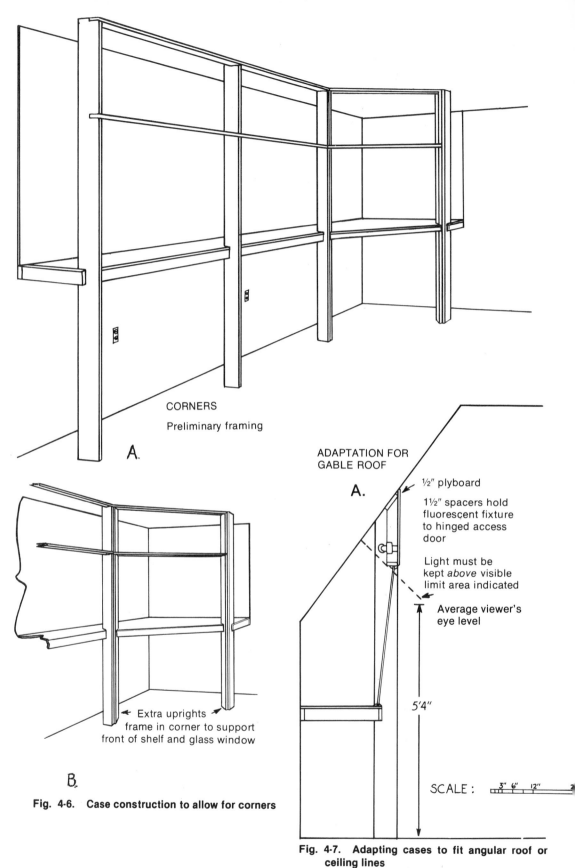

CORNERS

Preliminary framing

A.

ADAPTATION FOR
GABLE ROOF

A.

½" plyboard

1½" spacers hold
fluorescent fixture
to hinged access
door

Light must be
kept *above* visible
limit area indicated

Average viewer's
eye level

5'4"

Extra uprights
frame in corner to support
front of shelf and glass window

B.

Fig. 4-6. Case construction to allow for corners

SCALE: 3" 6" 12"

Fig. 4-7. Adapting cases to fit angular roof or
ceiling lines

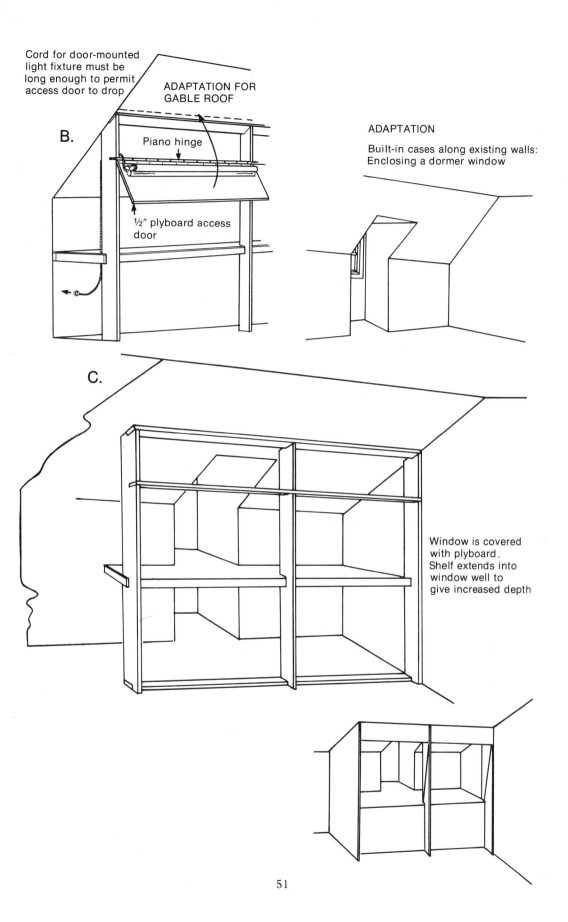

Cord for door-mounted light fixture must be long enough to permit access door to drop

ADAPTATION FOR GABLE ROOF

B.

Piano hinge

½″ plyboard access door

ADAPTATION

Built-in cases along existing walls: Enclosing a dormer window

C.

Window is covered with plyboard. Shelf extends into window well to give increased depth

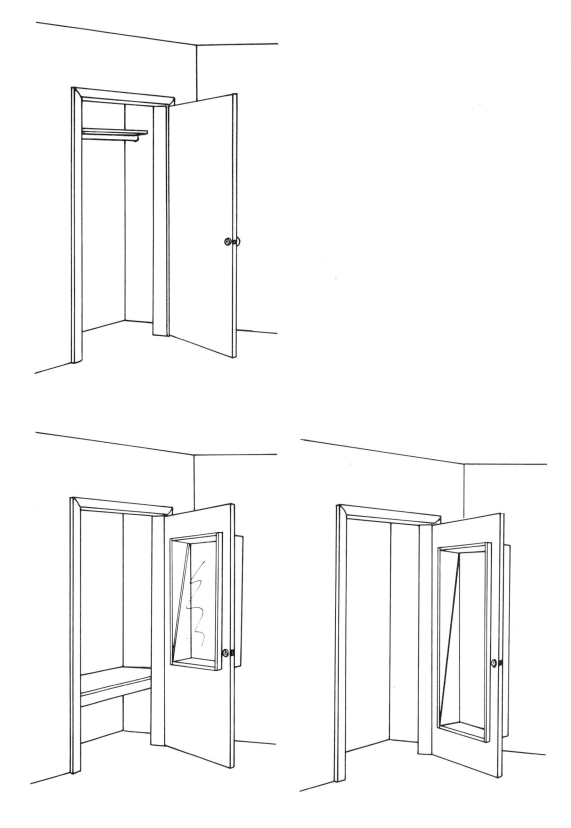

Fig. 4-8. Closets can be converted for exhibit space

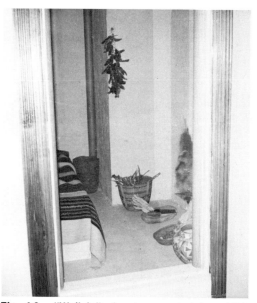

Fig. 4-9. "Walk-in" closet converted to exhibit some crafts of Southwestern Native Americans (Pueblo Metropolitan Museum, Pueblo, Colorado)

Closet with a Slide Projector

A closet with a slide projector, mirrors, and translucent rear-projection screen can be a useful set-up. By "bending" the projector's beam with mirrors, it is possible to get the equivalent of a 6'9" projection distance in a closet that is only 30" deep. (Fig. 4-11).

Using a Kodak Carousel projector equipped with a 5" lens, image sizes will be:

35mm double-frame slide: 14 1/2" x 21 1/2"

126 film (Instamatic): 16 1/2" square

Mirror "A" *must* be a front-surface mirror in order to avoid a double image. (Available from Edmund Salvage Co., N.J.).

The projection screen is made from "Polacoat Flexible Lenscreen, type LS60FM material" and is available from Polacoat Inc. (9750 Conklin Road, Blue Ash, Ohio 45242). It can be stretched easily in the aluminum framing materials sold in hard-

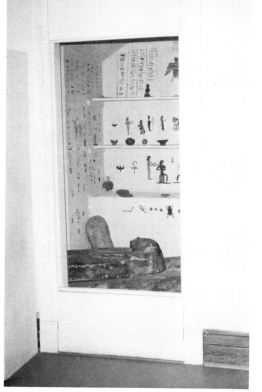

Fig. 4-10. L-shaped storage closet converted to exhibit an Egyptian mummy. (Pueblo Metropolitan Museum, Pueblo, Colorado)

ware stores for "do-it-yourself" storm window and screen construction.

An extra "window" should be cut in the lower portion of the door and a small furnace filter installed. This permits more free air circulation which will be better for the projector and will help to prevent buckling of the flexible projection screen.

The projector should be placed on a low platform (*particularly* if the floor of the closet is carpeted) again to permit free air circulation with the projector's blower.

The entire interior of the closet and the back of the closet door should be painted a flat black to cut down on light reflections, helping to increase brightness in the projected image.

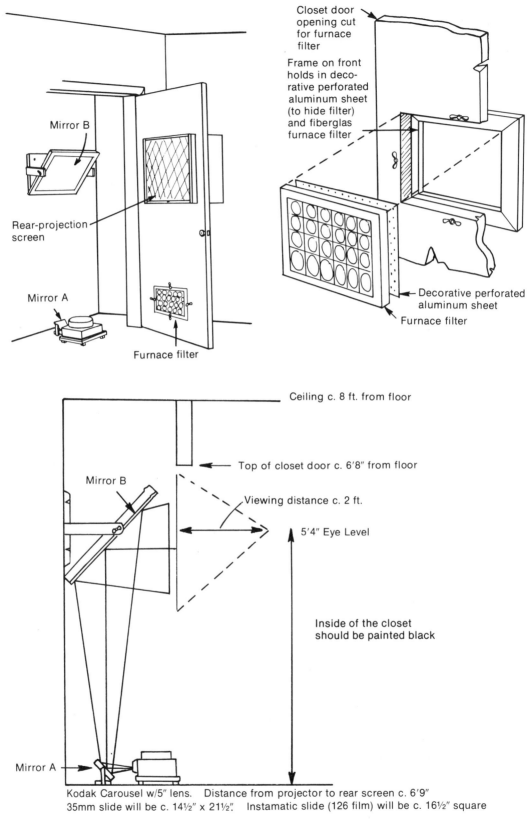

Mirror B

Rear-projection
screen

Mirror A

Furnace filter

Closet door
opening cut
for furnace
filter

Frame on front
holds in deco-
rative perforated
aluminum sheet
(to hide filter)
and fiberglas
furnace filter

Decorative perforated
aluminum sheet

Furnace filter

Ceiling c. 8 ft. from floor

Mirror B

Top of closet door c. 6'8" from floor

Viewing distance c. 2 ft.

5'4" Eye Level

Inside of the closet
should be painted black

Mirror A

Kodak Carousel w/5" lens. Distance from projector to rear screen c. 6'9"
35mm slide will be c. 14½" x 21½". Instamatic slide (126 film) will be c. 16½" square

Fig. 4-11. Setting up a slide show from a closet

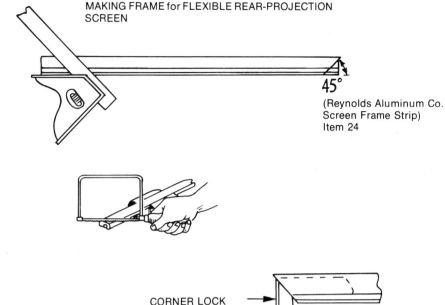

MAKING FRAME for FLEXIBLE REAR-PROJECTION
SCREEN

45°

(Reynolds Aluminum Co.
Screen Frame Strip)
Item 24

CORNER LOCK
(Reynolds Aluminum Co.
Item 25)

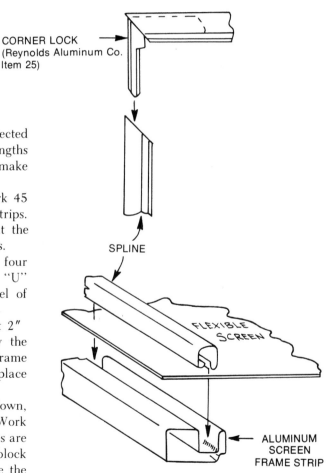

SPLINE

FLEXIBLE
SCREEN

ALUMINUM
SCREEN
FRAME STRIP

Making Frame for Flexible Rear-Projection Screen

After determining actual size of projected image on back of screen door, cut lengths of Aluminum Screen Frame Strip to make rectangular frame. (Fig. 4-12).

Use the combination square to mark 45 degree angles at each end of the four strips.

Hold each strip in a vise, then cut the corners at the marked 45 degree angles.

Use corner locks to assemble the four strips into a frame. Remove the "U" shaped metal spline from the channel of each side.

Cut a piece of flexible screen about 2″ larger than the frame opening. Lay the screen over the channel side of the frame and draw the material tight. Hold in place temporarily with masking tape.

Press the "U" shaped splines down, forcing the screen into the channels. Work from the corners. When all four splines are pressed into the channels, use a small block of wood and a light hammer to force the splines completely into the channels. Trim off excess flexible screen.

Fig. 4-12. Making a frame for a flexible, rear-projection screen.

Lining an Existing Wall

Lining an existing wall with fabric-covered panels and shelf standards can be done with good results. (Fig. 4-13, 4-14).

1. Cut 4 x 8-1/2″ Upson board or Homasote panels to measure 2′ x 6′.

2. Stretch coarse or open-weave fabric over 2 x 6 panels and staple down into *back* of panels. (Fig. 4-13).

3. Rip some 1 1/2″ wide strips from 8 foot lengths of 1/2″ plyboard and attach to wall so that *top* edge of *bottom* strip is 12″ from the floor and the *bottom* edge of the *top* strip is 6′1/2″ above the top edge of the bottom strip. Use 4d coated common nails, *driving into the wall studs.* If the wall is an old one made of lath and plaster construction, use toggle bolts. Be sure to use a *level* to insure the accuracy of these horizontal support strips. (Fig. 4-14a).

4. Install shelf standard at one end of room: Place standard in desired position with trademark at top (consistent placement should help to keep shelf bracket slots level from one shelf standard to the next). Tack temporarily to wall by driving nail through top screw hole partially into wall. Use a level to make sure shelf standard is plumb and mark remaining screw hole positions on wall. Take shelf standard down and drill holes. These holes must be large enough to take a complete toggle bolt with the "wings" folded down. (Fig. 4-14b).

Unscrew bolts from toggles and insert through screw holes in standard. Screw bolts into toggles *just* enough for bolts to catch threads securely. Fold "wings" of toggles down over bolts, push *all* bolts through drilled holes in wall. Tighten bolts. (Fig. 4-14c).

5. Attach a 2 foot wide fabric-covered panel to wall butting up against the shelf standard just installed. (Fig. 4-14d).

Hold panel in place resting on bottom horizontal strip and butting up against shelf standard. Drill 4 holes through panel into wall (2 on each vertical edge). Size of holes should be just big enough for *bolt* of hollow-wall anchor. Take down panel, enlarge holes in wall *just* enough to be able to push a hollow-wall anchor bolt (sometimes called a "Molly" bolt) through the holes. Insert anchor bolts and tighten in each of the four holes in the wall. Then unscrew bolts from secured anchors. Insert bolts through washers then through fabric-covered panel. Be sure to insert all four bolts. Squeeze panel adhesive on the back of the panel (using a cartridge in a caulking gun) and apply to wall. Tighten bolts in previously secured anchors. (Fig. 4-14f).

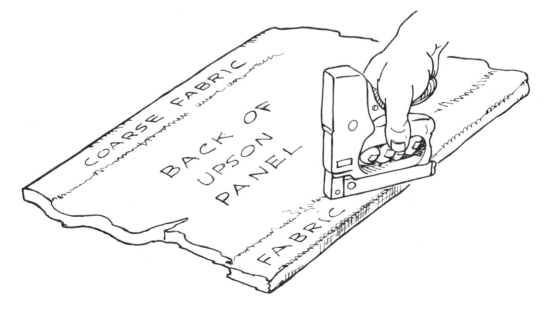

Fig. 4-13. Cutting and covering the panels

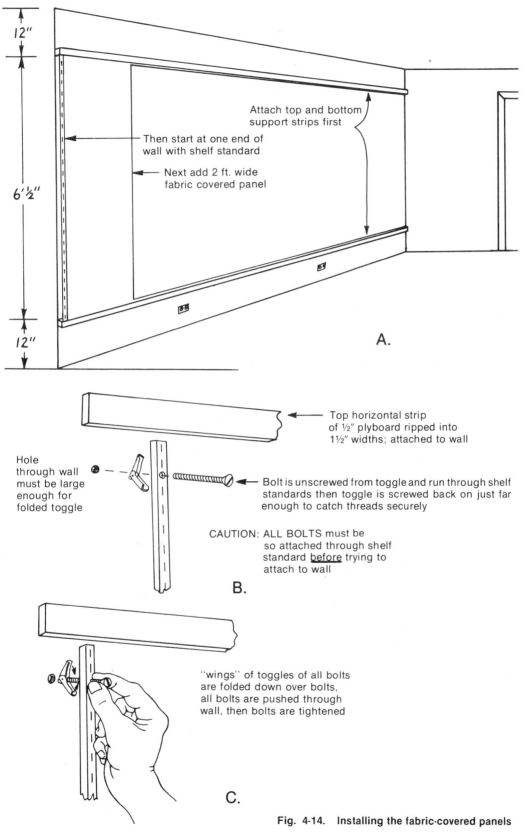

A.

12"

6'½"

12"

Attach top and bottom
support strips first

Then start at one end of
wall with shelf standard

Next add 2 ft. wide
fabric covered panel

B.

Top horizontal strip
of ½" plyboard ripped into
1½" widths; attached to wall

Hole
through wall
must be large
enough for
folded toggle

Bolt is unscrewed from toggle and run through shelf
standards then toggle is screwed back on just far
enough to catch threads securely

CAUTION: ALL BOLTS must be
so attached through shelf
standard <u>before</u> trying to
attach to wall

C.

"wings" of toggles of all bolts
are folded down over bolts,
all bolts are pushed through
wall, then bolts are tightened

Fig. 4-14. Installing the fabric-covered panels

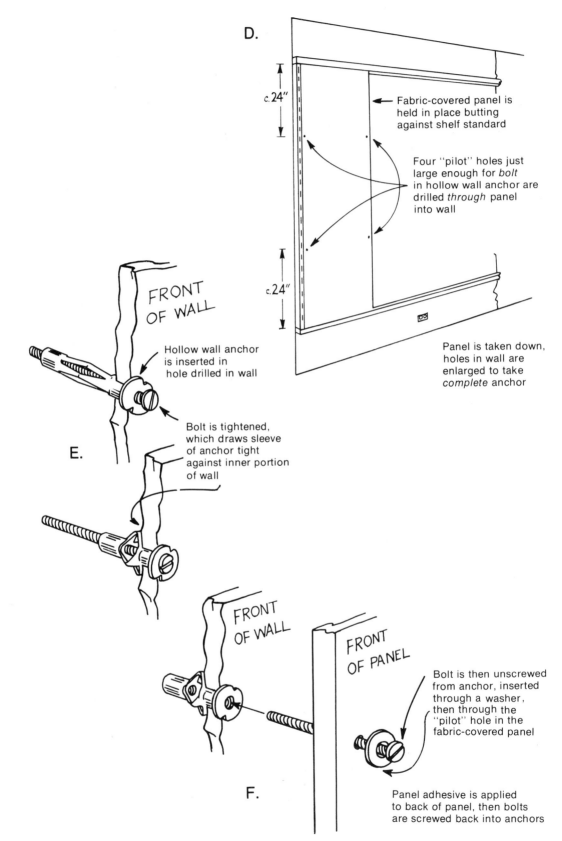

D.

c.24″

Fabric-covered panel is held in place butting against shelf standard

Four "pilot" holes just large enough for *bolt* in hollow wall anchor are drilled *through* panel into wall

c.24″

Panel is taken down, holes in wall are enlarged to take *complete* anchor

FRONT OF WALL

Hollow wall anchor is inserted in hole drilled in wall

Bolt is tightened, which draws sleeve of anchor tight against inner portion of wall

E.

FRONT OF WALL

FRONT OF PANEL

Bolt is then unscrewed from anchor, inserted through a washer, then through the "pilot" hole in the fabric-covered panel

F.

Panel adhesive is applied to back of panel, then bolts are screwed back into anchors

6. Continue alternate installations: shelf-standard, fabric-coated panel; shelf-standard, fabric-coated panel, etc. to end of wall section.

7. Rip some 2″ wide strips from 8 foot lengths of 1/4″ plyboard or use a preshaped 2″ wide molding strip. Use this trim to cover joint between top and bottom strips and panels. (Fig. 4-14g).

Figures 4-15 and 4-16 show some of the variations possible with the shelf-standard/fabric panelled wall. Large maps, photos, pictures, or other graphic materials may be pinned, tacked, or nailed to the wall and the shelf brackets may support shelves for large touchable specimens or a plastic-or glass-enclosed case to show more delicate items.

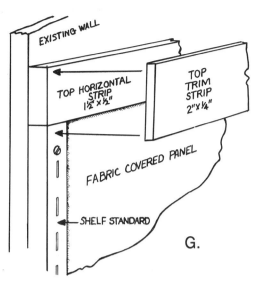

G.

WHEN ALL SHELF STANDARDS AND FABRIC-COVERED PANELS HAVE BEEN APPLIED TO WALL, top and bottom trim strips ripped 2″ wide from ¼″ plyboard are glued and nailed to top and bottom horizontal strips (use white glue and 4d finishing nails) in order to cover joint between panels and strips.

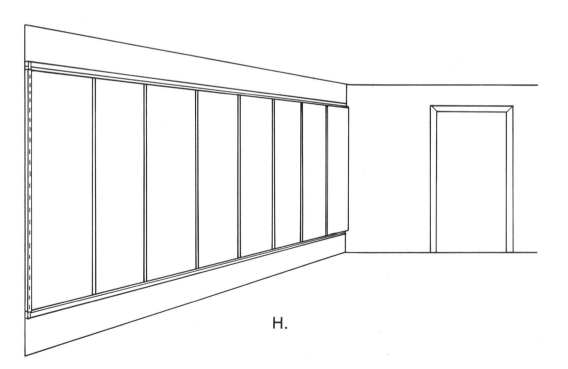

H.

59

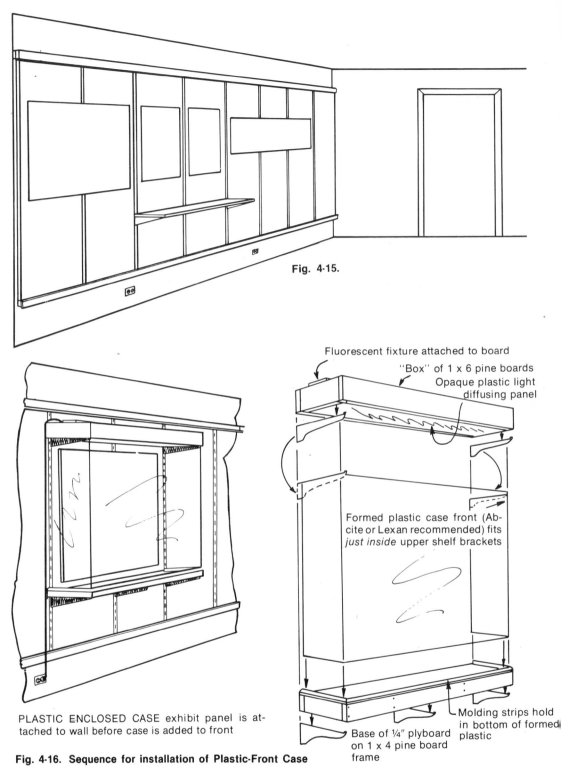

Fig. 4-15.

PLASTIC ENCLOSED CASE exhibit panel is attached to wall before case is added to front

Fluorescent fixture attached to board

"Box" of 1 x 6 pine boards

Opaque plastic light diffusing panel

Formed plastic case front (Abcite or Lexan recommended) fits *just inside* upper shelf brackets

Molding strips hold in bottom of formed plastic

Base of ¼" plyboard on 1 x 4 pine board frame

Fig. 4-16. Sequence for installation of Plastic-Front Case

1. **Base is set on shelf brackets. Exhibit specimens are placed on base.**
2. **Formed Plastic Case Front is set on base with bottom of plastic contained by molding strips on base.**
3. **Top Shelf Brackets are placed even with top of formed plastic case front with plastic on *inside* of brackets.**
4. **Light Box is set on top shelf brackets. Light cord is brought down outside of case to base duplex outlet.**

5 Varieties of Case Designs

Wall Cases

The past several pages have detailed the construction of standard "box" cases. It would be a mistake to limit a total gallery to just one kind of physical installation. The functions of any case are to define an area, set off the objects within it and, most importantly, offer some kind of security for those objects. Sometimes the security is obtained by creating a psychological rather than physical barrier (note the railings on cases shown in Fig. 5-3a) but most often objects requiring protection will be behind glass. In this chapter quite a few variations on the basic box theme are shown and analyzed. The examples are taken from several different sources and the construction drawings are my ideas of how they were or could have been made.

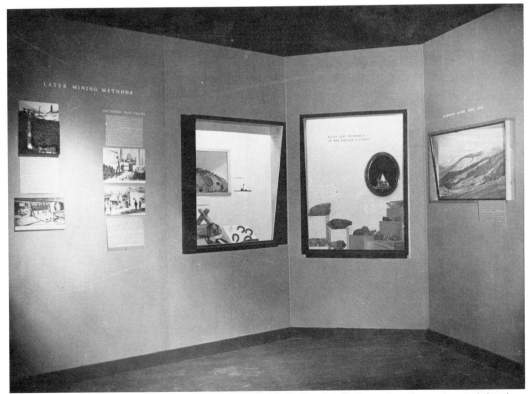

Fig. 5-1. Panel wall with cases brought in from behind. For detailed construction notes and drawings see pp. 132—144 in _Help!_ (Red Men Hall Museum, Empire, Colorado)

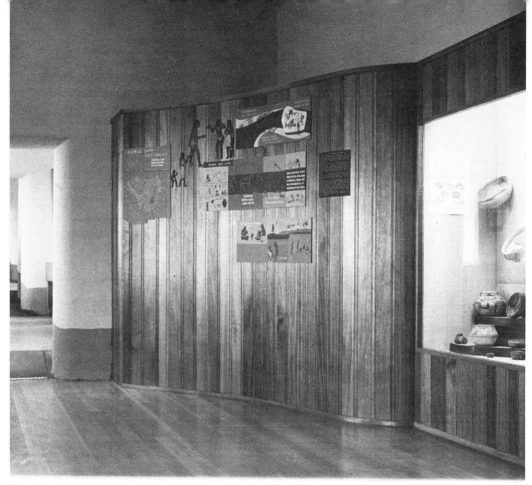

Fig. 5-2. A built-in case with curving panel wall. Here is a nice use of texture and illustrated labels, which attract attention. However, the case would be improved by slanting the glass to avoid light reflections. Labels on the panel are placed too high for comfortable reading. Can you feel that crick in the back of your neck? (Museum of New Mexico, Santa Fe, New Mexico)

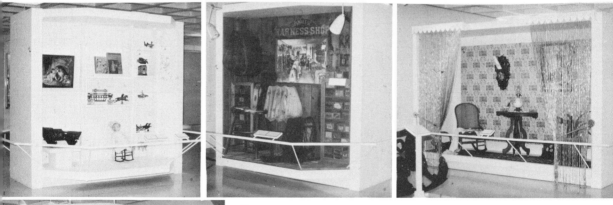

A.

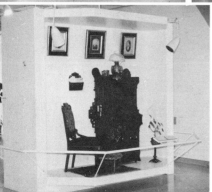

Fig. 5-3a. Display "stages" at the Stuhr Museum of the Prairie Pioneer. Units designed by Margaret Shaeffer.

62

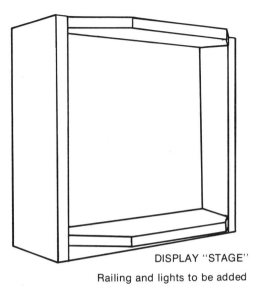

DISPLAY "STAGE"

Railing and lights to be added

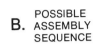

Top can be framed in same manner as platform *but* 1 x 4s may be used for both framing and trim

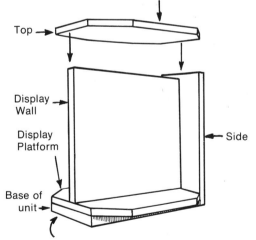

Top

Display Wall

Display Platform

Side

Base of unit

Side pulled away to show relationships of display platform, wall and top to base and sides

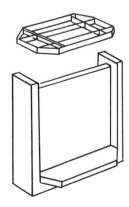

Fig. 5-3b. Possible assembly sequence for a display stage

DISPLAY "STAGE" Suggested Construction Details

All dimensions are approximate

8'

Approx.
6'11½"

Display Wall
(shown on display platform)
Framing all of 2 x 4s

4'

8'

Base

All framing, sides and base of 2 x 4s

8' 4' 4'

Display Platform
Top "skin" from
2 sheets of 4 x 8½" plyboard

Trim of 1 x 4s

4'

8'

Side
(2 required)

Framing of 2 x 4s

Fig. 5-3c. Display stage construction details

Floor Cases

Some small cases may be remodelled and used as floor cases for small objects while others may be hung on walls. One should try to develop some variety in the way materials are presented to visitors and a range of "box," "stage," floor and wall cases interspersed with panel exhibits will help to avoid the monotony that comes with the same kind of exhibit being repeated at length. A precautionary word should also be added, however. Don't put as many different styles together as you can! Develop a sense of balance as you work, choosing the kind of case to use in terms of the sizes and shapes of the objects to be displayed.

Fig. 5-4. Simple glass-top shallow case supported on a sloping-top floor base. The back of the case is about 36″ from the floor, the front is about 24″ from the floor. (Charleston Museum, Charleston, South Carolina)

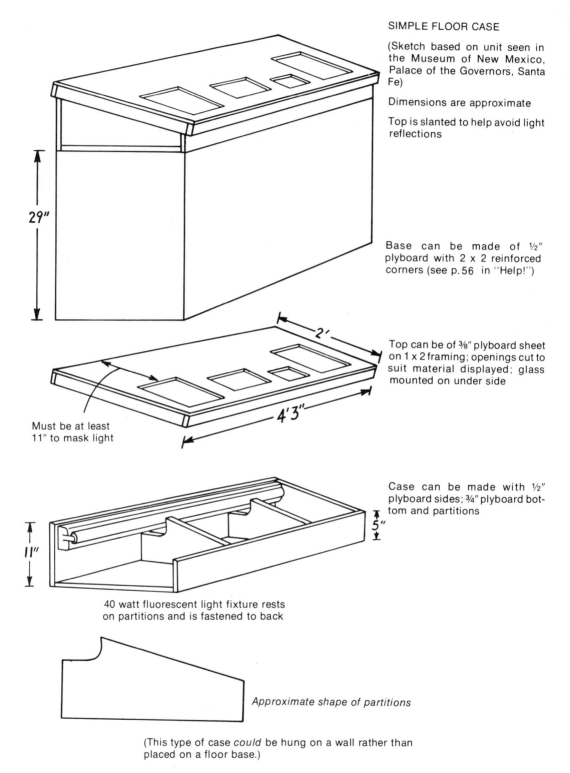

SIMPLE FLOOR CASE

(Sketch based on unit seen in the Museum of New Mexico, Palace of the Governors, Santa Fe)

Dimensions are approximate

Top is slanted to help avoid light reflections

29"

Base can be made of ½" plyboard with 2 x 2 reinforced corners (see p. 56 in "Help!")

2'

Must be at least 11" to mask light

4'3"

Top can be of ⅜" plyboard sheet on 1 x 2 framing; openings cut to suit material displayed; glass mounted on under side

Case can be made with ½" plyboard sides; ¾" plyboard bottom and partitions

5"

11"

40 watt fluorescent light fixture rests on partitions and is fastened to back

Approximate shape of partitions

(This type of case *could* be hung on a wall rather than placed on a floor base.)

Fig. 5-5. Constructing a simple floor case

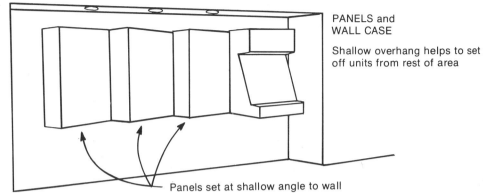

PANELS and
WALL CASE

Shallow overhang helps to set
off units from rest of area

Panels set at shallow angle to wall

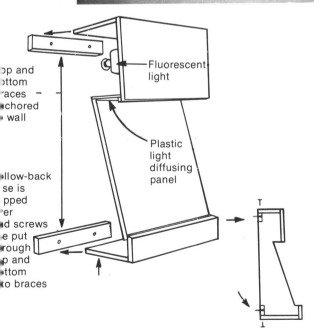

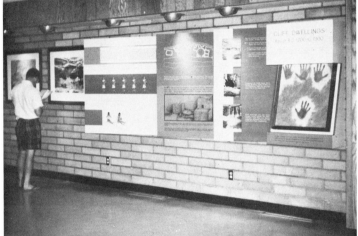

Top and
bottom
braces
anchored
to wall

Fluorescent
light

Plastic
light
diffusing
panel

Hollow-back
case is
tapped
over
and screws
are put
through
top and
bottom
into braces

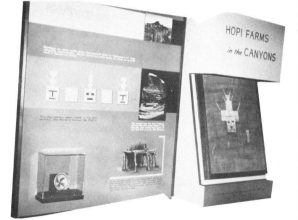

**Fig. 5-6. Combinations of panels
and wall cases make effective
displays**

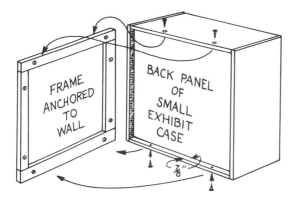

SMALL EXHIBIT CASE
for lightweight items

Method of Attachment
to Wall

FRAME ANCHORED TO WALL

BACK PANEL OF SMALL EXHIBIT CASE

7/8"

Frame of 1 x 2s is anchored to wall

All four sides are routed so that back panel is inset 7/8"

Box is hung on wall mounted frame and screws are put through top and bottom of box into frame

VARIETY OF BOX SHAPES that may be hung in same way

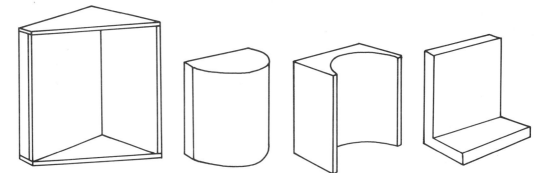

Fig. 5-7. Construction techniques and shapes for a small exhibit used for lightweight items

Fig. 5-8. Small exhibit cases are hung on a slatted divider wall. (Los Angeles County Museum of Natural History)

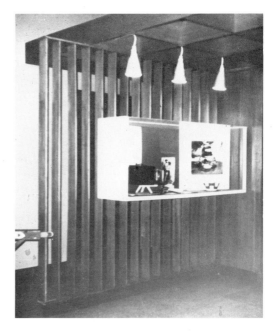

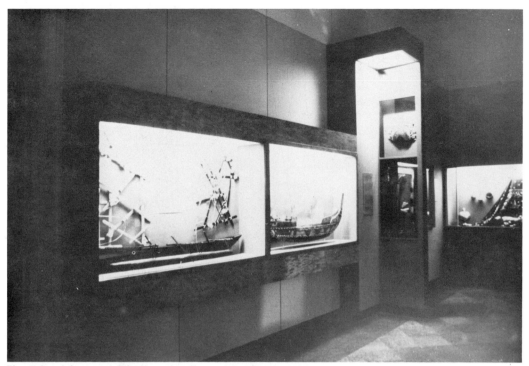

Fig. 5-9. A long, straight line of wall cases is interrupted by the strong vertical line of a partition with "see-through" case. (Los Angeles County Museum of Natural History)

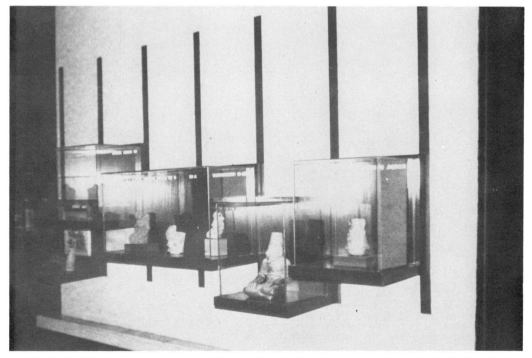

Fig. 5-10. Small cases are supported by shelf brackets. (Museo de Anthropologia, Mexico City)

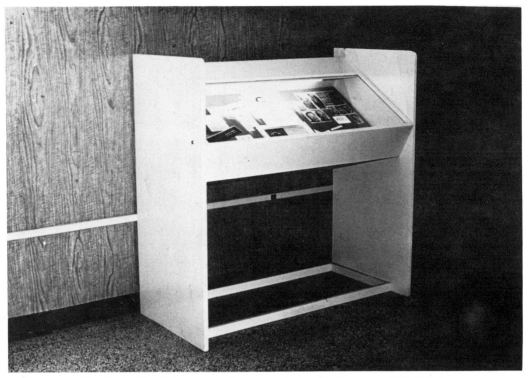

Fig. 5-11. Small floor case. For construction details, see p. 63 in *Help!*

A.

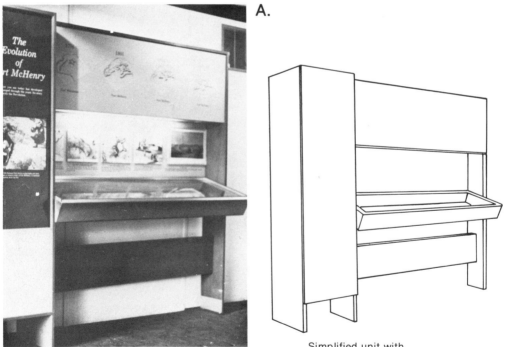

COMBINED PANELS and CASE

Fort McHenry National Monument, National Park Service

Simplified unit with
suggested construction notes

Fig. 5-12a. A wall unit with panels and case, plus construction techniques.

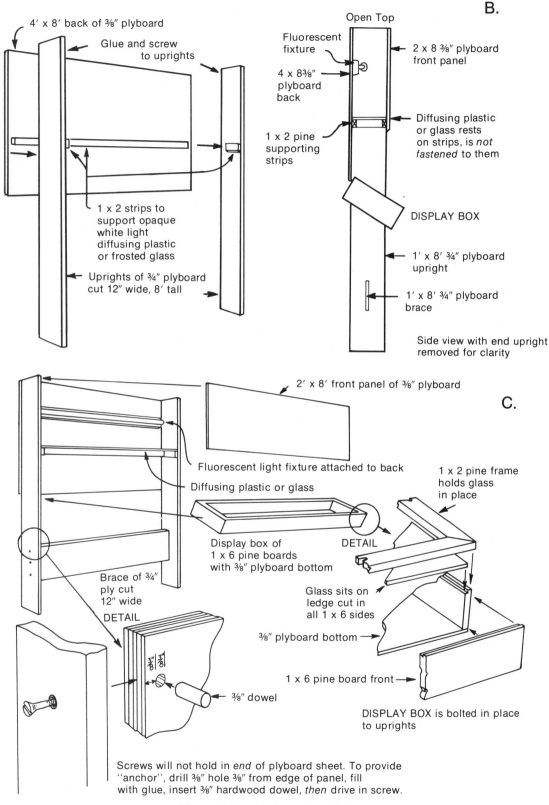

B.

4' x 8' back of ⅜" plyboard

Glue and screw to uprights

Open Top

Fluorescent fixture

4 x 8⅜" plyboard back

2 x 8 ⅜" plyboard front panel

Diffusing plastic or glass rests on strips, is *not fastened* to them

1 x 2 pine supporting strips

1 x 2 strips to support opaque white light diffusing plastic or frosted glass

DISPLAY BOX

Uprights of ¾" plyboard cut 12" wide, 8' tall

1' x 8' ¾" plyboard upright

1' x 8' ¾" plyboard brace

Side view with end upright removed for clarity

C.

2' x 8' front panel of ⅜" plyboard

Fluorescent light fixture attached to back

Diffusing plastic or glass

1 x 2 pine frame holds glass in place

Display box of 1 x 6 pine boards with ⅜" plyboard bottom

DETAIL

Glass sits on ledge cut in all 1 x 6 sides

Brace of ¾" ply cut 12" wide

⅜" plyboard bottom

DETAIL

1 x 6 pine board front

⅜" dowel

DISPLAY BOX is bolted in place to uprights

Screws will not hold in *end* of plyboard sheet. To provide "anchor", drill ⅜" hole ⅜" from edge of panel, fill with glue, insert ⅜" hardwood dowel, *then* drive in screw.

Fig. 5-12b,c. Construction details

71

D.

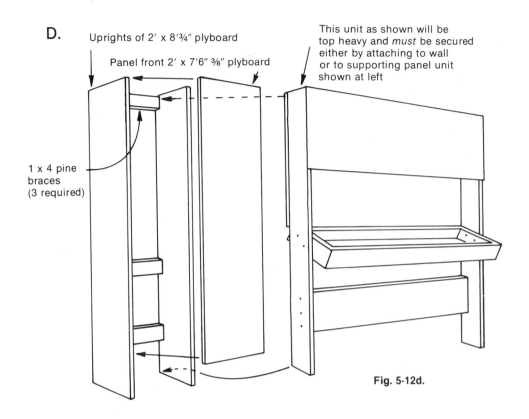

Uprights of 2′ x 8′¾″ plyboard

Panel front 2′ x 7′6″ ⅜″ plyboard

1 x 4 pine
braces
(3 required)

This unit as shown will be
top heavy and *must* be secured
either by attaching to wall
or to supporting panel unit
shown at left

Fig. 5-12d.

REMODELLED CASES

Original Window used two vertical sliding panes
in track

Disadvantages:
light reflections on glass; entry of dust where panes
overlap

Remodelled Window:

Two sliding panes and track removed

"Shadow Box" frame of 1 x 10 boards built, glass
installed on slant

Unit hinged on one side with heavy duty piano
hinge; locked on opposite side with cabinet lock

Fig. 5-13. Remodelling the window of a case

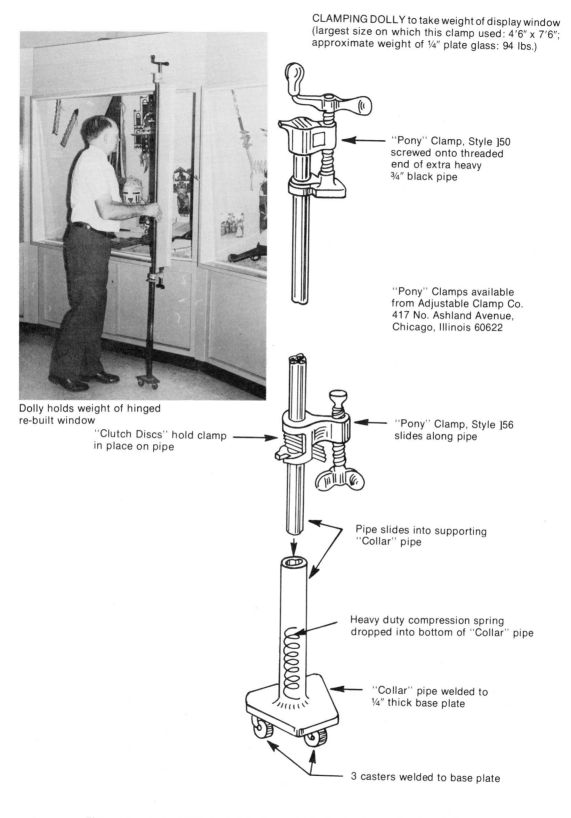

CLAMPING DOLLY to take weight of display window
(largest size on which this clamp used: 4'6" x 7'6";
approximate weight of ¼" plate glass: 94 lbs.)

"Pony" Clamp, Style]50
screwed onto threaded
end of extra heavy
¾" black pipe

"Pony" Clamps available
from Adjustable Clamp Co.
417 No. Ashland Avenue,
Chicago, Illinois 60622

Dolly holds weight of hinged
re-built window

"Clutch Discs" hold clamp
in place on pipe

"Pony" Clamp, Style]56
slides along pipe

Pipe slides into supporting
"Collar" pipe

Heavy duty compression spring
dropped into bottom of "Collar" pipe

"Collar" pipe welded to
¼" thick base plate

3 casters welded to base plate

Fig. 5-14. An assemblage to take the weight off a top-heavy display window

6 Case Interiors

Let's assume that now you have your exhibit story outlined, your empty panels and empty cases built and distributed around the room or gallery according to your predetermined plan. Now is the time to begin an actual case installation.

If it is your first time, your initial reaction may be to sit down and cry, cuss, or stare at the empty "box" that confronts you. Don't worry about it. The problem is not that bad and not that complicated.

A visual flow pattern should be established which will "lead" a visitor's eyes around the case with ease. A symmetrical arrangement will leave him confused. His eyes will focus first on the central object and then

swing pendulum-like from one side to the other because *neither* dominates and invites his attention. Such an arrangement (Figs. 6-1a, b, and c) adds fractionally to visitor fatigue because of the indecision it forces on the viewer's sight patterns.

Logical subdivisions of the main topic of the whole case will offer clues as to how groupings of specific specimens may be "lumped" or segregated from each other (see your breakdown in your story outline for help). The size and placement of headline labels, subheads, and "group" labels also *must* be considered at this time. A detailed explanation of labelling and label production is given in *Help!* on pp. 95 to

A.

B.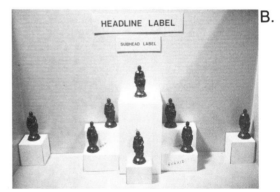

C.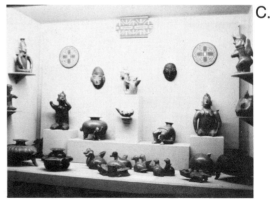

Fig. 6-1. The symmetrical arrangements of artifacts in these displays do not "lead" the visitor's eye around the case—they force the eye to focus first on the central object, then wander.

99 and pp. 153 to 171. (The same information on pp. 153 to 171 is also given in Technical Leaflets 22 and 23.) An extensive discussion on the *design* factors used in developing case interiors and the use of case furniture in achieving a visual flow pattern for the visitors' eyes to follow is given on pp. 67 to 75 in *Help!*. The section which follows in *this* handbook will show how the use of a scale model again, will help to overcome your initial discomfort in experimenting with case interior designs and will show suggested construction details for case interiors and a variety of pieces of case furniture. In addition, photographs of actual installations point out (in some instances) full-size applications of the ideas presented in the scale model set-ups.

The photographs of the scale model show a very simple "case" made from a cardboard carton that once held a piece of luggage. It is approximately 22" wide, 8" deep, and 17 1/2 high. Using a scale of 3 inches equalling 1 foot, this carton represents an actual size case approximately 7'8" wide, 2'10" deep, and 5'8" high. Of this, the top 20" (in the full size case) would probably be used as an area where a light would be located. The scale box front top has been left open for ease of photography.

Case furniture shown scattered in front of the scale case (Fig. 6-2) has been made of light weight poster board from the art section of a paint store or discount drug store. The pieces could just as easily have been made of file folder cardboard. They

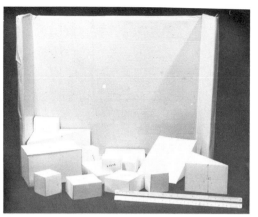

Fig. 6-2. An arrangement in a scale-model case.

are stuck together with matte finish (dull) Scotch tape. Drawings included here (Figs. 6-3 to 6-5) show patterns for scale models of the case furniture to use in working with the scale case. The one inch line in each drawing may be used to measure the patterns so that actual size patterns may be made. For example, the *scale model* of the 8" x 8" x 8" cube will be a 2-inch cube. True full-size dimensions are shown in parenthesis and *are approximate*, since full-size measurements will vary according to the thickness of actual materials used. Make at least three of each size and shape shown and see how many variations which are not symmetrical you can make (Figs. 6-6 to 6-19 show examples). Do not feel it is necessary to use all pieces of case furniture in one exhibit. You may find one or two shapes and sizes more useful than others. As shown in the photographs, all pieces of "furniture" (except the cubes, which of course are the same in any direction) offer the potential of three variations in their use.

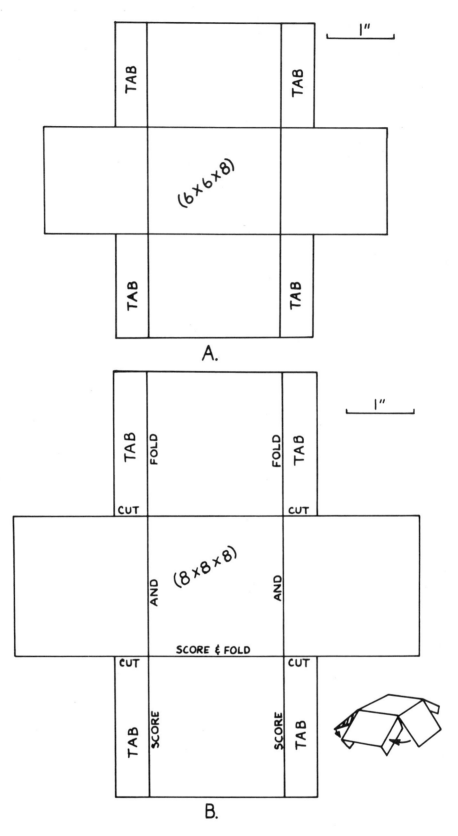

Fig. 6-3. Scale models of case furniture to be used in a scale case.

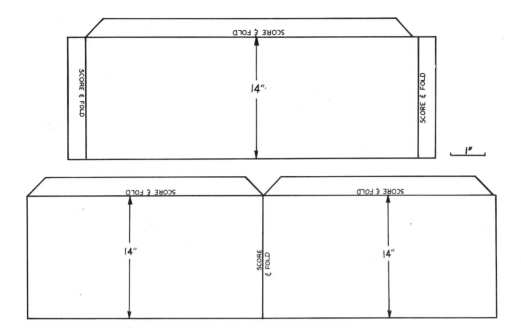

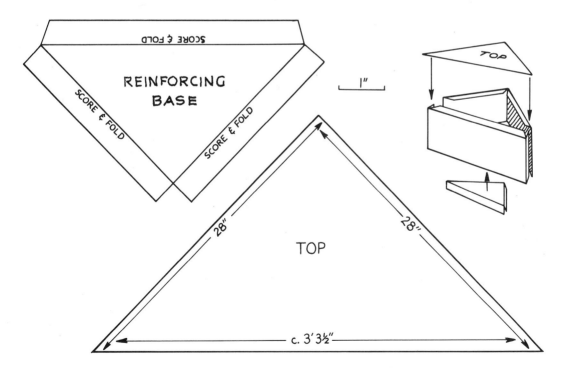

SCORE & FOLD

14".

SCORE & FOLD

SCORE & FOLD

1"

SCORE & FOLD

14"

SCORE & FOLD

14"

SCORE & FOLD

SCORE & FOLD

SCORE & FOLD

SCORE & FOLD

REINFORCING BASE

1"

TOP

28"

28"

TOP

c. 3' 3½"

Fig. 6-4.

77

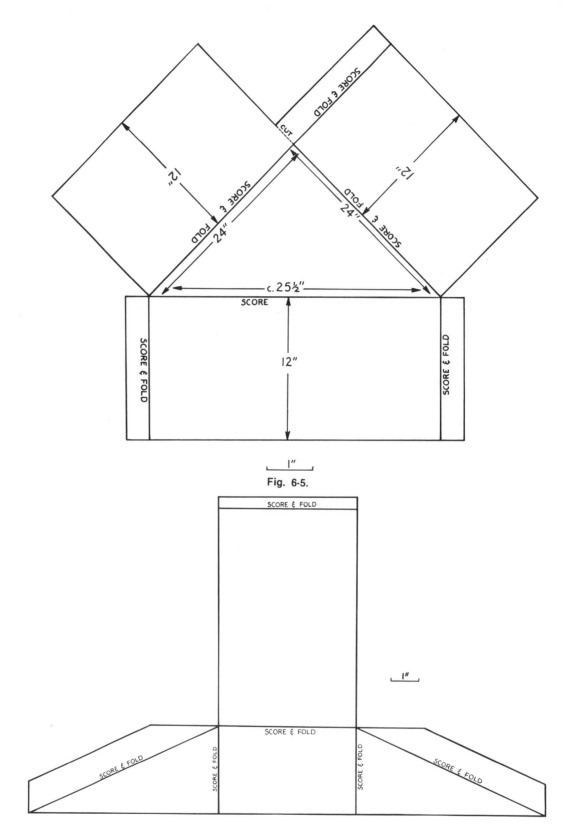

SCORE & FOLD

SCORE & FOLD

CUT

SCORE & FOLD

SCORE & FOLD

12"

12"

24"

24"

c. 25½"

SCORE

SCORE & FOLD

SCORE & FOLD

12"

1"

Fig. 6-5.

SCORE & FOLD

1"

SCORE & FOLD

SCORE & FOLD

SCORE & FOLD

SCORE & FOLD

SCORE & FOLD

Fig. 6-6.

A.

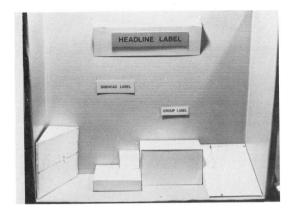

Fig. 6-7a. Asymmetrical scale model furniture arrangements

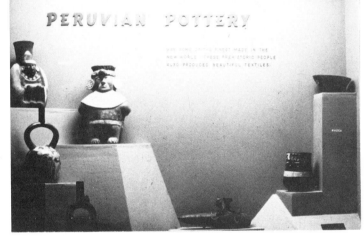

B.

Fig. 6-7b. Similar arrangements as used in the Denver Museum of Natual History.

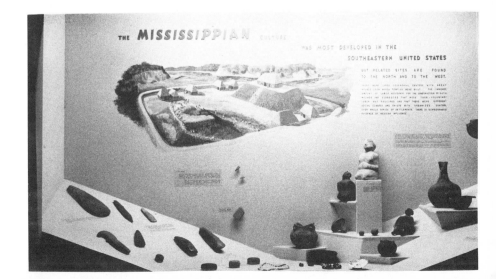

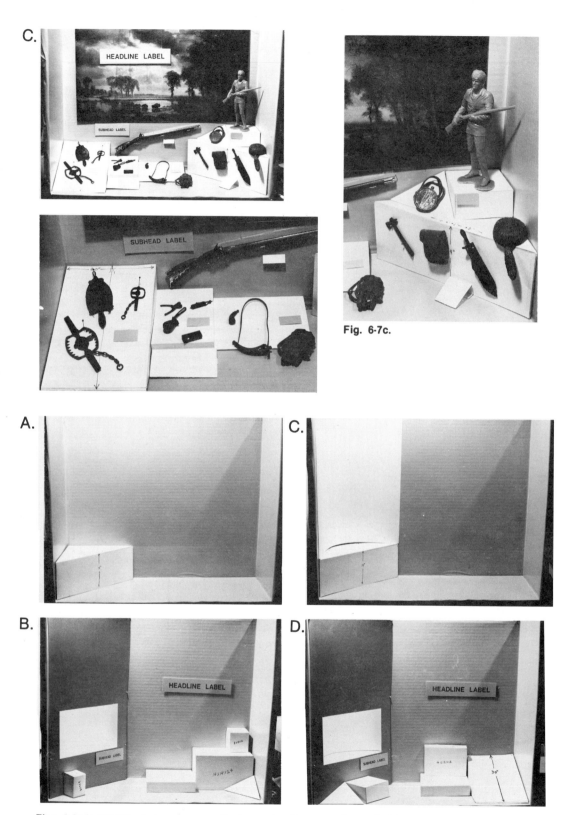

Fig. 6-7c.

Figs. 6-8a,b and 6-8c,d show how a unit of case furniture may be set behind a panel which has a window cut through it. This gives emphasis to the object behind the window.

a. Full case showing use of panel across left side, case furniture, and window cut through back of case.

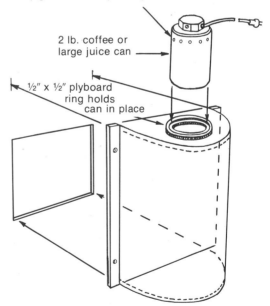

Holes for venting heat from light (light will also spill out)

2 lb. coffee or large juice can

½″ x ½″ plyboard ring holds can in place

b. Window in case back emphasizes importance of figurine. Lighting is from "home-made" spot. For construction details see Fig. 6-10.

c. Background for window is curved 1/8″ Easy Curve (Upson Board) with plyboard top and bottom.

Fig. 6-9. A complete case at the Denver Museum of Natural History.

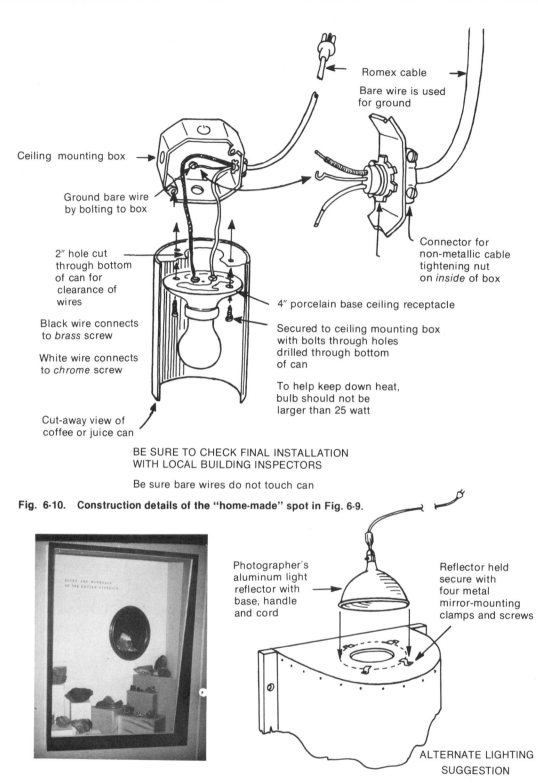

Romex cable

Bare wire is used for ground

Ceiling mounting box

Ground bare wire by bolting to box

2" hole cut through bottom of can for clearance of wires

Black wire connects to *brass* screw

White wire connects to *chrome* screw

Cut-away view of coffee or juice can

Connector for non-metallic cable tightening nut on *inside* of box

4" porcelain base ceiling receptacle

Secured to ceiling mounting box with bolts through holes drilled through bottom of can

To help keep down heat, bulb should not be larger than 25 watt

BE SURE TO CHECK FINAL INSTALLATION WITH LOCAL BUILDING INSPECTORS

Be sure bare wires do not touch can

Fig. 6-10. Construction details of the "home-made" spot in Fig. 6-9.

Photographer's aluminum light reflector with base, handle and cord

Reflector held secure with four metal mirror-mounting clamps and screws

ALTERNATE LIGHTING SUGGESTION

Fig. 6-11. An alternative lighting suggestion for a case (Red Men Hall Museum, Empire, Colorado). This case has an added dimension for eye-attraction—the mineral displayed in the opening is on a continuously running turntable. The incandescent spotlight brings out the variety of color and sparkle of the specimen.
 a. Hole cut through the back of the case is framed with an old picture frame from second-hand store. Background is made in the same way as that for Fig. 6-9
 b. Alternate lighting suggestion is shown.

A.

a. Case as seen from the front wall. Hole in the back of the case houses a miniature diorama.

b. Case from behind the wall, pulled back from the wall (window opening, not shown, is to the right).

c. Diorama shell similar in construction to curved backgrounds shown in Figs. 6-9 and 6-11. Lighting, however, is from an 8 watt fluorescent mounted on the back of the case, just over the diorama opening.

B.

C.

Fig. 6-12. Another variation of the "hole in the wall." (Red Men Hall Museum, Empire, Colorado)

A.

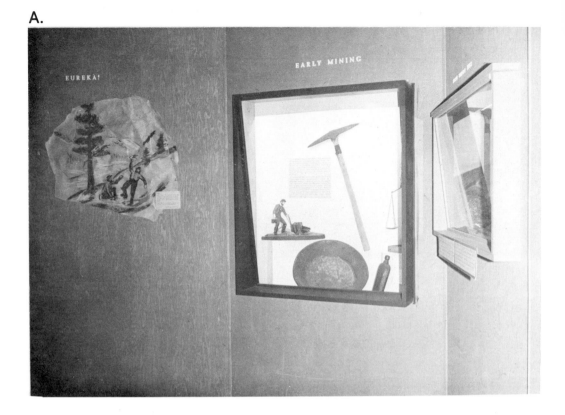

B.

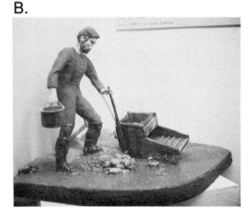

a. Panel at left has quick sketch (until a diorama might be made) of the discovery of gold and a short label.

b. Center panel has case opening with case removable from the back (similar to the case shown in Fig. 6-12). A single miniature figure about 9″ high shows how a "rocker" was used to recover gold.

c. Whenever possible, artifacts should be shown in the position of use. The hand is cut from a 1/2″ thick piece of Cellotex, nailed and glued to a small wooden brace which is attached to the case wall (see sketch). The miner's balance is held to the hand with a simple loop of wire.

C. Hand as seen from back

1 x 2 screwed to case

Wire loop

Miner's balance

Fig. 6-13. Three sections of a panel-case wall displaying the early mining history of Empire, Colorado.

A.

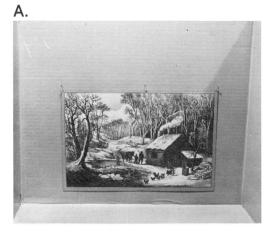

B.

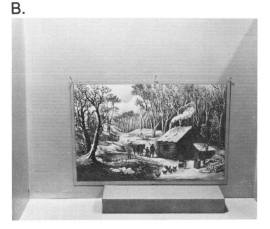

C.

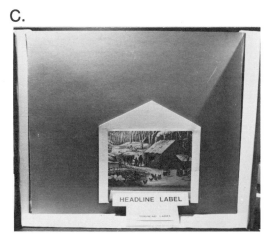

Scale Model Arrangement

a. Enlargement of an old print on the back of the case.

b. Spacer block helps determine the distance of the false back from the actual case back and may also serve as a platform on which to display artifacts, if desired.

c. False back (shown here with stylized architectural detail) installed with opening showing the print.

d. e. and f. Examples of actual "hole in the wall" installations (Nebraska State Historical Society Museum, Lincoln, Nebraska).

D. **E.** **F.**

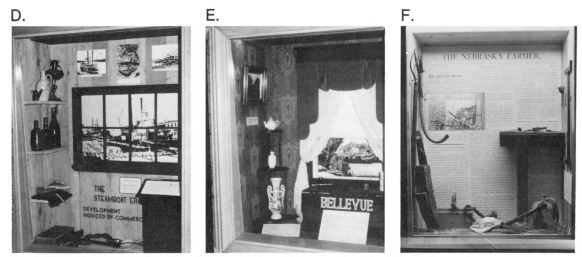

Fig. 6-14. **False case back with a "window."** A painting or enlarged photograph may be mounted directly on the back of a case and a false back with a "window" or similar appropriate opening cut through it installed about 6″ in front of the back of the case.

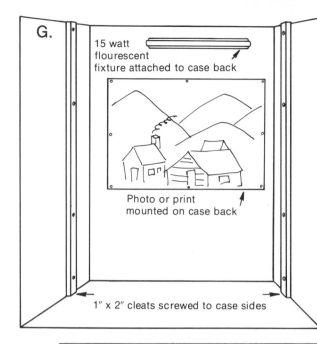

G.

15 watt flourescent fixture attached to case back

Photo or print mounted on case back

1" x 2" cleats screwed to case sides

H.

False back attached to cleats

g. and h. Sketches show suggested construction methods. Lighting for the front part of the case is over the actual case window.

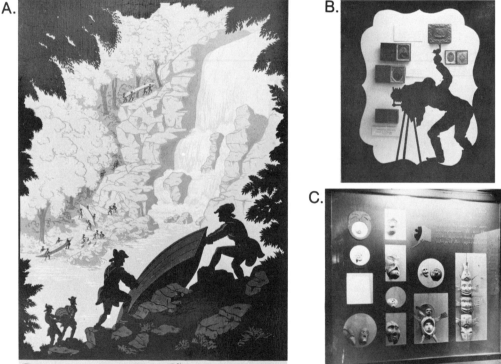

A.

The portage around Skowhegan falls.

B.

C.

Fig. 6-15. An extremely effective attention-getting technique is to cut an opening in a sheet of material which is placed directly inside the front glass of a case, through which the viewer looks to see the displayed items. While photo a is actually a trail marker on the Arnold Trail in Maine, the darkest portions, shown as black and gray in the photo, could be cut from 1/8″ or 1/4″ Upson board and be used to "frame" an exhibit of small items carried on the Trail. The same technique has been used in photo b to highlight daguerreotypes (Nebraska State Historical Museum); while a very large but shallow case, shown in photo c, uses a false wall on which a basic label has been glued and through which various sizes and shapes of openings help emphasize and separate a series of Eskimo masks (Old Milwaukee Public Museum). The particular effect shown in c—without the glued-on label—could be achieved very simply by just painting the inside of the glass.

Fig. 6-16. This time the "hole in the wall" is contained *within* the case and provides emphasis for the pieces in it.

A.

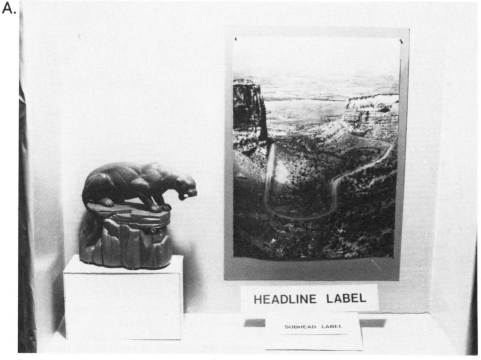

Fig. 6-17. The use of large photographic blow-up
 a. The use of large photo blow-ups (as in this scale model) helps create a sense of environment no matter what the material that may be exhibited. . .

87

B.

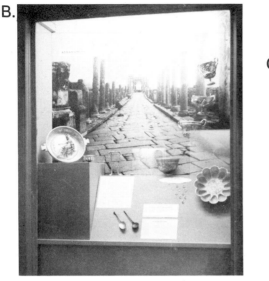

C.

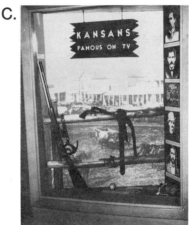

Fig. 6-17. These photos help "set the scene"
 b. Whether it be the formal aspects of ancient Rome (Old Milwaukee Public Museum)...
 c. Or the "wild west" of early Kansas (Kansas State Historical Museum).

B.

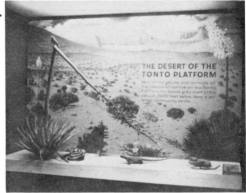

A.

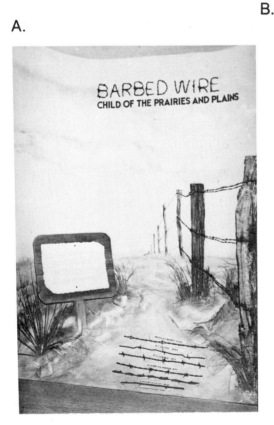

a. A piece of 1/8″ Upson Board ("Easy Curve") with a simple background painting has been installed in a curve from one side of the case to the other. An actual wooden post (in the extreme foreground, right), combined with painted posts on the background, serve to hold three strands of barbed wire. The "sign" describes the development and differences in early "bobbed" wire, while the simple sloping foreground panel displays actual examples. (Museum of the Great Plains, Lawton, Oklahoma).

b. A large, fairly detailed painted background places the few mounted specimens of animals and the one plant in proper ecological setting. (Grand Canyon National Park Visitors' Center).

Fig. 6-18. Large paintings and/or the design of particular pieces of case furniture also help create a sense of environment.

C.

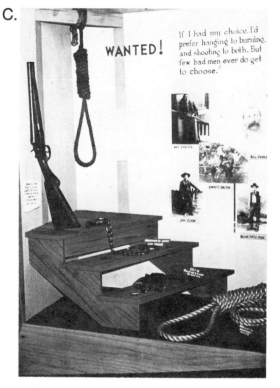

c. The specific design of this case furniture makes an immediate impression on the viewer. (Museum of the Great Plains, Lawton, Oklahoma).

A. **B.**

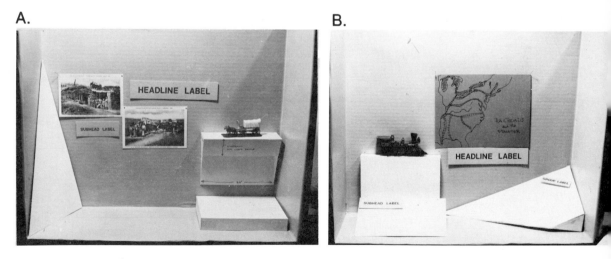

Fig. 6-19. Scale model kits can sometimes be found, assembled and painted. If a small museum has a volunteer association which includes a model enthusiast, scale models can be built from "scratch." Used with photographs, maps or other documents, they add interest and attract attention to what might otherwise seem dull.

a. and b. Scale model case showing two suggested layouts.

C.

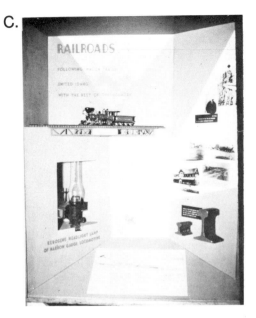

D.

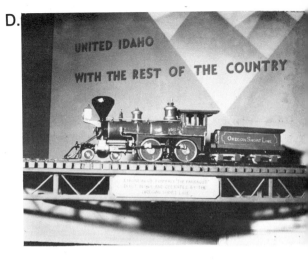

Fig. 6-19.
 c. Scale model of a railroad engine and coal car is combined with very few actual artifacts, photos and maps. Angle of the panels across the case corners and the sloping panel across the base all focus attention to the main subject: "RAILROADS . . . UNITED IDAHO . . ."

 d. Detail of c

7 Getting It All Together

Creating a Changing Relationship: Changing Case "Liners"

It is a good idea to line permanent cases with Upson board, Cellotex, Homasote, Armstrong Insulation Board—with any of a number of comparatively *soft* building sheets (which are much like very heavy cardboard) and which are *not* sheet rock or gypsum (plaster) boards normally used in dry-wall construction. Liners make it possible to change the interior of a case quickly and easily simply by taking out one set and replacing them with a newly created set. This lining of the back and both sides of a case permits the easy use of pins in attaching photographs, maps, labels, drawings, etc., to the case. With this cardboard-like material (which ranges in thickness from 1/8" Upson board's "Easy Curve" to 1/2" thick Upson, Cellotex, Homasote, etc.) added *over* the basic permanent case walls (which may have been made of plyboard, particle board, or hardboard), the exhibit designer has the option of mounting lightweight materials with pins, "cigar-box" nails, brads, Velcro, or similar materials used in the "soft" lining. Heavier objects may be attached by using 1" wire nails, larger nails, standard round-head or flat-head wood screws, self-tapping metal pan-head screws, "L" hooks, screw-eyes, or other pieces of hardware which go through the soft lining and anchor into the permanent case construction walls.

Because the softer materials may tend to sag or "bow" they should be reinforced on the sides by the use of metal or wooden

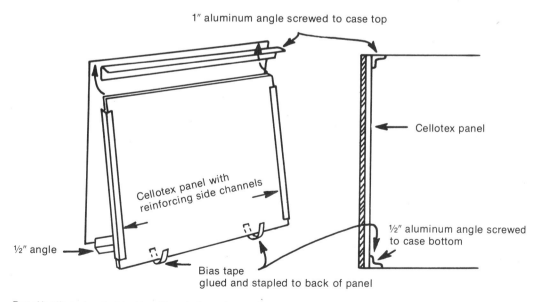

1" aluminum angle screwed to case top

Cellotex panel

Cellotex panel with reinforcing side channels

½" aluminum angle screwed to case bottom

½" angle

Bias tape glued and stapled to back of panel

Panel is slipped up behind top 1" angle then dropped into place behind bottom ½" angle

Bias tapes on bottom help to lift panel up and out when case is changed

Fig. 7-1. Changing a panel with channels on the case

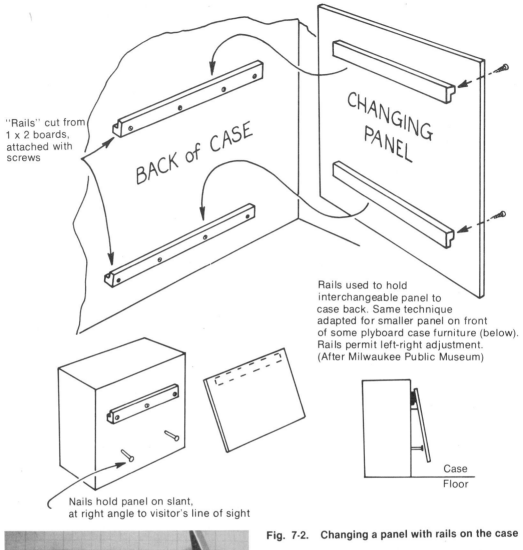

"Rails" cut from 1 x 2 boards, attached with screws

BACK of CASE

CHANGING PANEL

Rails used to hold interchangeable panel to case back. Same technique adapted for smaller panel on front of some plyboard case furniture (below). Rails permit left-right adjustment. (After Milwaukee Public Museum)

Nails hold panel on slant, at right angle to visitor's line of sight

Case
Floor

Fig. 7-2. Changing a panel with rails on the case

Fig. 7-3. Fastening methods
1. **Large-size toggle bolt (one use shown in Fig. 4-14).**
2. **Screw with tap-in plastic sleeve (broken off from a row of sleeves to right).**
3. **Screw with tap-in lead anchor.**
4. **Two sizes of hollow wall anchors (use shown in Fig. 4-14 e., f.)**

channels or moldings. Plastic moldings are not rigid enough to provide proper support.

Changing the panels becomes easy if they are installed either in channels built into the top and bottom of the back of the case or hung on "rails" attached both to the permanent case and changeable back, as shown in Fig. 7-1 and 2.

Forming a Lasting Attachment

A number of fastening methods and materials have been detailed in the preceding pages. Some are shown again in Fig. 7-3.

The following photographs and sketches show miscellaneous fastening and supporting techniques which may be used in a wide variety of exhibit situations. Most of the illustrations are self-explanatory.

Fig. 7-4: "Gamblers and Fancy Women" (Museum of the Great Plains, Lawton, Oklahoma). Pins holding playing cards in place are *not* pushed through cards but are just outside the edge of the cards and placed at an angle across cards. The two crystal liqueur glasses (barely visible just below the left end of the row of poker chips) may be tied in place with nylon

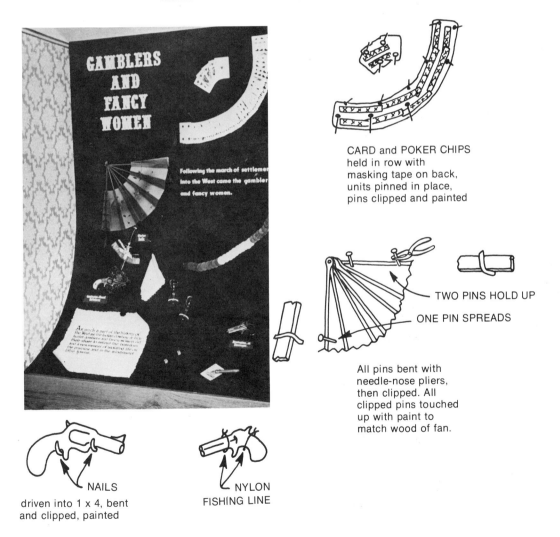

CARD and POKER CHIPS held in row with masking tape on back, units pinned in place, pins clipped and painted

TWO PINS HOLD UP

ONE PIN SPREADS

All pins bent with needle-nose pliers, then clipped. All clipped pins touched up with paint to match wood of fan.

NAILS driven into 1 x 4, bent and clipped, painted

NYLON FISHING LINE

Fig. 7-4. "Gamblers and Fancy Women" display

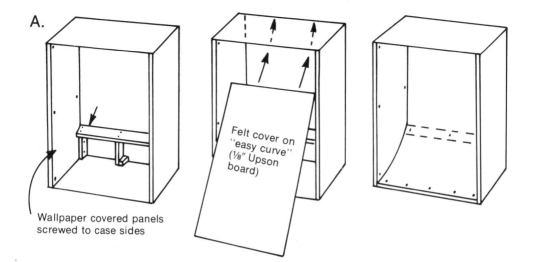

A.

Wallpaper covered panels
screwed to case sides

Felt cover on
"easy curve"
(⅛" Upson
board)

Fig. 7-4a. Background box construction

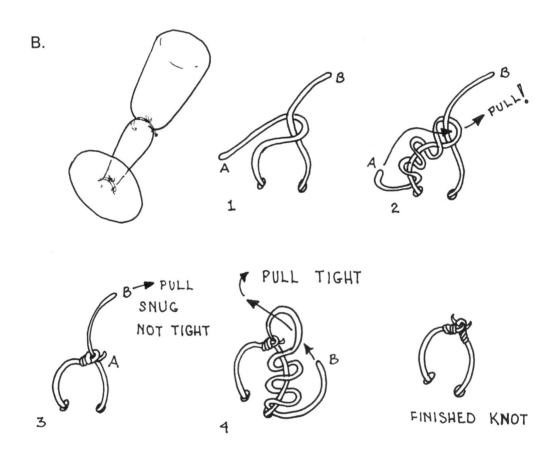

B.

B

A

1

B

PULL!

A

2

B → PULL
SNUG
NOT TIGHT

A

3

PULL TIGHT

B

4

FINISHED KNOT

Fig. 7-4b. Tying nylon line for attaching objects to Upson Board panel

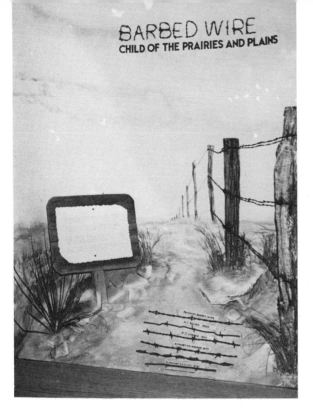

Actual post
attached to
side of case

Remaining posts
painted

3 strands of
barbed wire
run from real
post to front
pointed post

A.

Label "sign"
board nailed
into 1" x 2"
board

Barbed wire specimens
held in place by pins
pushed into cellotex
base

Board put
through hole
in cellotex base

Base covered with Elmer's glue; sand, dirt
and rocks glued in place

**Fig. 7-5a. The curved background and sloping
panel help to overcome the "boxiness" of a
standard case. An environmental feeling is
created with the painted background and
"sign" label.
b. Construction details**

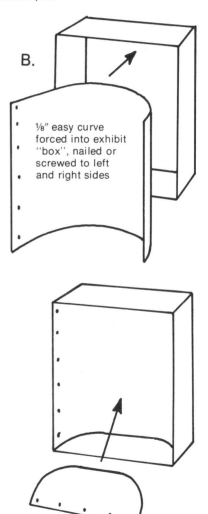

B.

⅛" easy curve
forced into exhibit
"box", nailed or
screwed to left
and right sides

½" cellotex base
placed against curved
background nailed or
screwed to base of case
along front edge

fishing line threaded *through* the curved
Upson board back panel with a curved
needle. See Fig. 7-4b for probable way of
tying nylon line for this purpose.

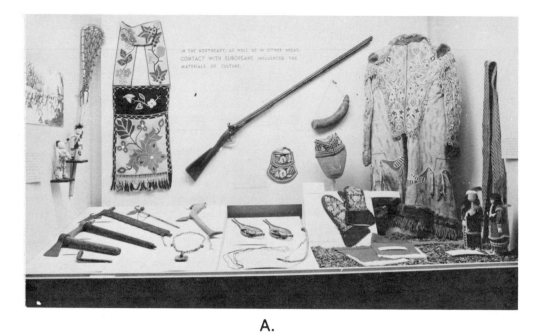

A.

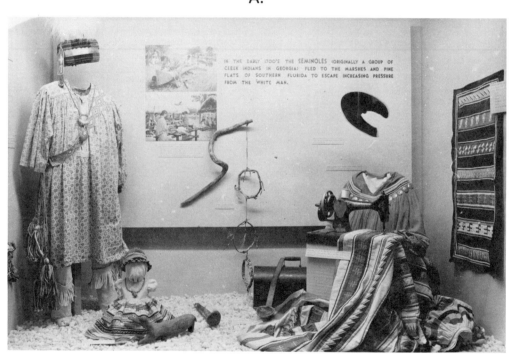

Fig. 7-6.　Displays of clothing on forms
　　　　a. Cases
　　　　b. Construction details

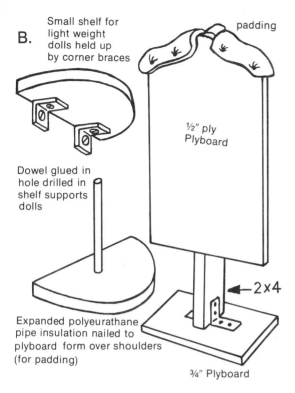

B. Small shelf for light weight dolls held up by corner braces

padding

½" ply Plyboard

Dowel glued in hole drilled in shelf supports dolls

Expanded polyeurathane pipe insulation nailed to plyboard form over shoulders (for padding)

2×4

¾" Plyboard

Turban (left) and cloth-covered cardboard support for hairstyle (right) suspended in case with nylon fishing line j)see Fig. 7-11 for knots.)

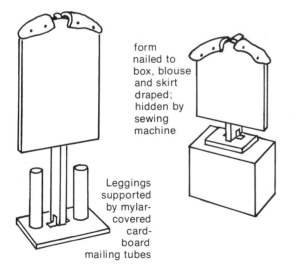

form nailed to box, blouse and skirt draped; hidden by sewing machine

Leggings supported by mylar-covered card-board mailing tubes

Fig. 7-6a: Dolls (left and right) are tied to vertical dowels. Back of both cases (top and bottom) lined with 1/2″ Homasote. Gun (top) and "S" shaped stick of wood (bottom) supported by nails driven into Homasote, bent around gun or stick, and nipped off, as in Fig. 7-8. 7-6b: Forms for clothing have padding over shoulder areas to prevent "ridge" from forming in clothing from narrow plyboard edge. Cardboard mailing tubes inside leggings (bottom) are covered with mylar plastic (an inert material) so that acid in cardboard will not ultimately stain leggings.

Fig. 7-7a,b: It is sometimes necessary to place graphic materials or labels on the sides of a case or at the top visual limit of the case interior. Both locations are awkward and if installed flat against the sides or back, are quite difficult for a visitor to read. The surface "slides away" from the viewer's line of sight and his eyes must refocus constantly. Since the majority of American adults wear eye glasses, the difficulty of seeing the panel contents is increased considerably. These panels should be placed so that the front plane is close to a right angle with the visistor's line of sight.

Fig. 7-7a shows a panel attached to the side of a case. The front edge is nailed directly to the case wall while the back of the panel is held away by a nail driven into the case wall separately from those which hold the panel in place.

Fig. 7-7b shows a method for attaching a panel toward the top of a case. Here the top is tilted forward by the L-hooks and screweyes and the bottom is nailed directly to the case back.

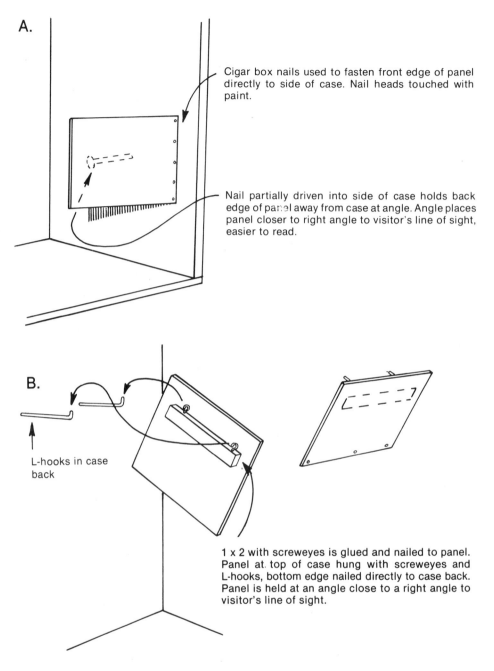

A. Cigar box nails used to fasten front edge of panel directly to side of case. Nail heads touched with paint.

Nail partially driven into side of case holds back edge of panel away from case at angle. Angle places panel closer to right angle to visitor's line of sight, easier to read.

B. L-hooks in case back

1 x 2 with screweyes is glued and nailed to panel. Panel at top of case hung with screweyes and L-hooks, bottom edge nailed directly to case back. Panel is held at an angle close to a right angle to visitor's line of sight.

Fig. 7-7. Installing the angled panels

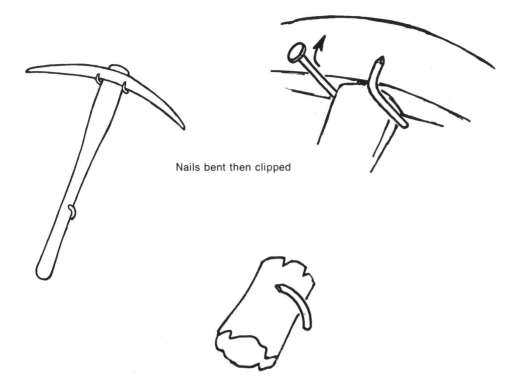

Nails bent then clipped

Fig. 7-8. Attaching a pick

Fig. 7-9: "Hook n' Loop," "Velcro," and "Scotchmate" are three brand names for the same thing—paired tapes, one with tiny nylon hooks, the other of a soft pile material. The tape may be found in almost all fabric shops. Used in small pieces, the tape will support up to about 3 pounds weight. The "hook" tape may be fastened to a supporting surface with pins for a temporary arrangement (as first described by Lili Kaelas of the Gothenburg (Sweden) Archaeological Museum) or may be glued with a contact cement for a more permanent display.

Adhesive wax which is translucent, odorless, stainless, and inert is a "must" for displaying coins. Corrosion is a constant worry in working with rare metal coins. One recommended wax is "Bulletin Board Styx" which may be obtained from Lea A-V Service, 182 Audley Drive, Sun Prairie, Wisconsin 53590.

Fig. 7-10: Lightweight objects may be held in place by using a square knot to tie one loop of shoemaker's thread around the object, then tying another loop around a pin or nail which is then pushed or driven into the supporting surface.

Fig. 7-11: If light-weight objects are to be suspended by a *single* line of nylon, the nylon *must* be anchored by means of a brass snap swivel of the kind used in fishing. No matter how strong the monofilament may be, it will twist itself in two if the suspended object turns within the case. Use of the swivel permits the line to rotate *with* the swivel, not around itself.

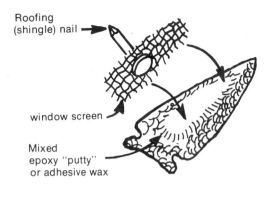

Roofing (shingle) nail →

window screen →

Mixed epoxy "putty" or adhesive wax

artifact held suspended away from supporting panel of cellotex homasote or upson board

"hook" tape

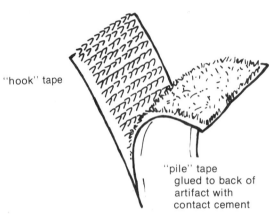

"pile" tape glued to back of artifact with contact cement

pins pushed into cellotex case back hold "hook" tape

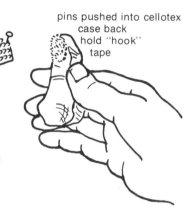

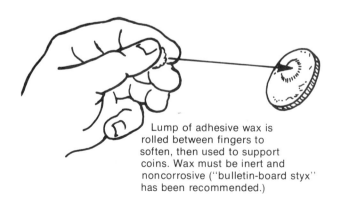

Lump of adhesive wax is rolled between fingers to soften, then used to support coins. Wax must be inert and noncorrosive ("bulletin-board styx" has been recommended.)

Fig. 7-9. Mounting devices—putty, paired tapes and wax

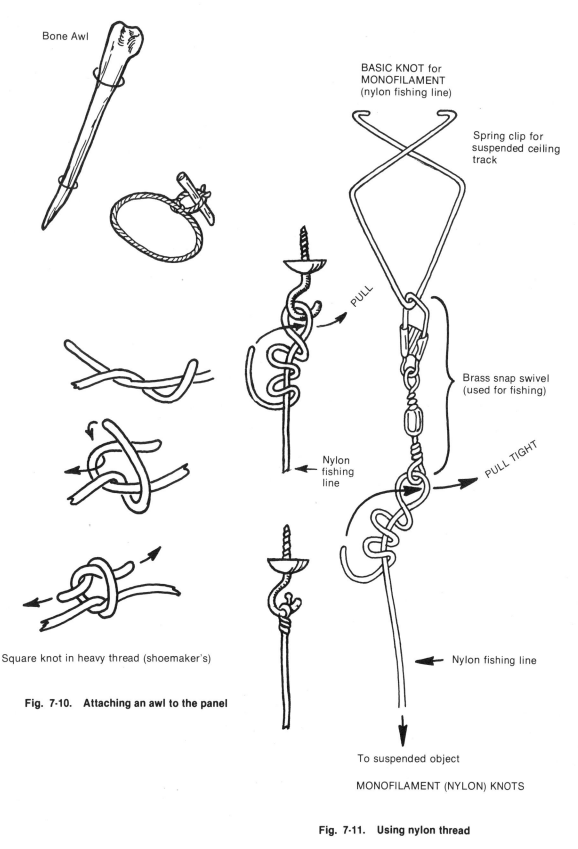

Bone Awl

BASIC KNOT for
MONOFILAMENT
(nylon fishing line)

Spring clip for
suspended ceiling
track

PULL

Brass snap swivel
(used for fishing)

Nylon
fishing
line

PULL TIGHT

Square knot in heavy thread (shoemaker's)

Fig. 7-10. Attaching an awl to the panel

Nylon fishing line

To suspended object

MONOFILAMENT (NYLON) KNOTS

Fig. 7-11. Using nylon thread

101

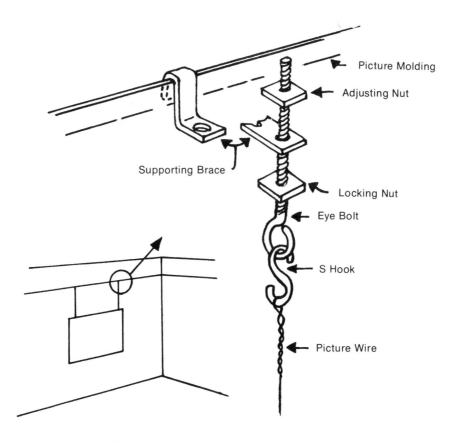

Fig. 7-12. Hanging and leveling panels or paintings

Fig. 7-12: Method of hanging and leveling large panel or painting. A supporting brace is made by bending one end of a corner brace to hang in the picture molding on a wall. One nut is run to the "eye" of an eye-bolt and the bolt is put through the hole of the supporting brace hanging from the picture molding. A second nut is run about 1″ on to the eye bolt. A second set of supporting brace and eye bolt is placed along the picture molding (about the distance of the width of panel or painting being hung). Picture wire with an S hook is brought up from each side of the panel or painting; the S hooks are slipped through the eye bolts.

The panel or painting is levelled by moving the adjusting nut up or down and is secured in place by moving the locking nut against the supporting brace and tightening both nuts.

8 Lighting

Both in *Help! for the Small Museum* and this handbook I have discussed the importance of creating a pattern for flow: "traffic" flow in a gallery, hall or corridor; "visual" flow for the eye within a case exhibit or on a panel display. Lighting design can assist and enhance these flow patterns. The key words in any lighting design are *flexibility* and *maintenance.* The most exciting lighting effect is only as good as the design for ease of maintenance that accompanies it. If lights are extremely difficult to change, the effect may last only as long as the first set of lamps, for a maintenance crew may conveniently forget to replace burned-out bulbs if it will be an all-day project. Once the final design is set, fixtures should be so installed that they return to their original positions whenever lamps are changed. Otherwise the original effect may well be lost over a period of time.

Maintenance lighting for clean-up and for exhibit installation in a room will need to be of a high light level. This can be provided by fluorescent fixtures mounted flush in the ceiling or held in the recesses of poured concrete ceiling or floors. They should be provided with diffusion covers. They *must* be on a switch or switches which are separate from any exhibit lights or outlets.

Entrance lobbies, corridors, gift shops and other areas where there is a high concentration of visitor traffic moving from one area to another should have generalized lighting which again may be obtained from ceiling-mounted lights. Fluorescent fixtures, either flush mounted in the ceiling or attached to the ceiling should always be used with plastic diffusing covers to avoid creating a glare in the visitors' eyes. Fluorescent lights are much more economical than incandescent and create less heat.

Incandescents bring out the brilliance in gems and polished metals, and create strong shadows. These lights also should be wired on a switch or switches which are separate from the maintenance lights and exhibit lights.

In an exhibit gallery a number of lighting techniques may be used. As a general rule for exhibit rooms there should be little or no generallized, overhead, over-all lighting, *particularly* if the room contains cases with glass fronts, covers, or boxes. Such illumination creates problems with reflections in case display windows by indiscriminately lighting polished floor areas and objects within the room so that they are reflected in case glass. Usually the light within case exhibits and the spots or floods used for large floor displays and panels will provide plenty of light for the room in general.

If you have the good fortune to be able to design the lighting capability for a room from "scratch," install duplex outlets on the walls around the room about 12" to 16" above the floor and about 6 feet apart. In any room 20 feet or more wide, plan a row of floor outlets 6 feet apart down the center of the 20-foot width. These outlets should be equipped with screw-in caps to keep out dirt when they are not being used. In this same room, plan a border of ceiling outlets approximately 6 to 8 feet in from the walls of the room and about 6 feet apart. The wall outlets should be on one switch; floor outlets on a second; and the ceiling outlets on a third. *All switches should be in an area not available to the public.* There is something irresistible about a switch in a public area.

If you must use an already existing room, try to finance rewiring as described above. If your "old" room has dropped ceiling lights ask an electrician if some of them could be put on one switch for maintenance and the others replaced with duplex outlets

or light bulb sockets. You might try to have every other light switched for clean-up with the alternates used for exhibit purposes.

Track lighting on ceilings is extremely flexible but is also, unfortunately, expensive.

With the flexibility you will have as described with the above wiring, it should be possible to create interesting, sometimes exciting lighting effects. It is a good idea to balance between exciting lighting design and ordinary, so that there is a visual change of pace. As with all display, *always remember the reason for the exhibit is communication.* If, to create an effect, the total lighting level is so low it is difficult for the visitor to find his way, your "effect" outweighs communication and your display has failed. If, to create a different effect, the total lighting level is so bright and brilliant that exhibits fade by comparison, your display has failed.

Use lights for:
> *general* case, panel, or wall illumination;
> *accents* within a case, on a wall or panel, or on specific objects displayed in the floor area.

Vary the pace between general and accent lighting. Accent lights, well placed, will help to move traffic along.

Plan the lighting design at the same time as you plan your entire exhibit. On your written exhibit outline (described in Chapter 2) it would be a good idea to include the kind of lighting desired in the "Exhibit Method" column. Then as you work out your actual floor plan, consider the availability of wall and floor outlets, the location of available sockets or plug-ins for ceiling lights, and place cases, walls, panels, floor platforms, pedestals, etc. both in relation to your previously developed "story" and the availability of your electrical power.

Perhaps the greatest problem in designing the layout of a series of glass-protected exhibits (whether case "windows," protective sheets on vertical or horizontal surfaces, four-sided cases, etc.) is that of

avoiding reflections and glare. Shiny surfaces (highly polished floors and high-gloss painted walls) compound the problem. You will make a good start toward the solution if you can use carpet, poured-plastic, or dull, textured tile for floor areas and satin-finish paint or textured wall covering such as vinyl wallpaper, wood, woven mats, etc, for vertical surfaces such as walls, panels, outsides of cases, and pedestals. The best solution is to plan the placement of lights in relation to the angle and direction of glass surfaces. Remember that light will reflect off an object at the same angle at which it strikes that object. Often just changing the angle of a light (and thus the position of the object it is to illuminate) will "kill" a reflection in the windows of a nearby case. Whenever possible, slant the glass protecting an exhibit, and slant it at as extreme an angle as is possible. Slanted glass will pick up most of its reflections from the floor. If the floor is not polished, reflections will be minimized. **Illustrations 8-1 through 8-7 show some of the most common lights used for exhibits (together with their dimensions) and suggest various lighting techniques.**

Lights have been combined and synchronized with sound in at least two exhibits this writer has seen: one in Denmark and one in the United States. The technique may have been used in additional areas as well. In Denmark, an exhibit uses a stylized metal sculpture of a tree on the branches of which are large diameter rings in which taxidermy preparations of birds are mounted. The "tree" is in an alcove where seven different recorded bird songs are played. As one song begins, a pin-point spotlight illuminates the bird whose song is being played. When the song is finished, the light goes out and a different one turns on to identify the bird associated with the next recorded song. This continues until all seven birds and their songs have **been presented. Back-lighting can be used for both black-and-white and color print photographs, though color prints may fade within six months.**

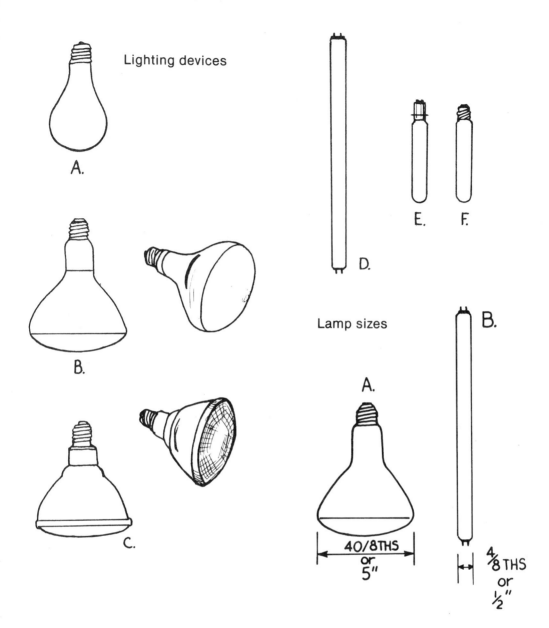

Lighting devices

A.

B.

C.

D.

E. F.

Lamp sizes

A.

40/8THS
or
5"

B.

4/8 THS
or
1/2"

Fig. 8-1. Commonly used lighting devices
 a. "A" type, ordinary incandescent lamp
 b. "R" type, incandescent lamp with built-in silvered reflector. Both spots and floods are available. The front glass is a spot is almost clear; in a flood it has a milky appearance. These lamps are made of soft glass and should not be used out-of-doors.
 c. "PAR" type, incandescent lamp with built-in parabolic reflector. Made of hard glass, the two-piece bulbs are available in both spots and floods. Spots have an almost clear "face"; floods have a "pebbled" or "checkered" face (as shown at right). Being made of hard glass, these lights usually are suitable for outdoor use.
 d. Fluorescent lamp tube. Ordinarily available from 8 to 40 watts.
 e. "T" type, tubular incandescent lamp with bayonet base
 f. "T" type, tubular incandescent lamp with screw-in socket base

Fig. 8-2. Lamp sizes: all bulbs are measured across their greatest width in *eights of an inch*
 a. R-40: An incandescent reflector bulb 5 inches (40/8ths) wide.
 b. T-4: A fluorescent lamp 1/2 inch (4/8ths) wide.

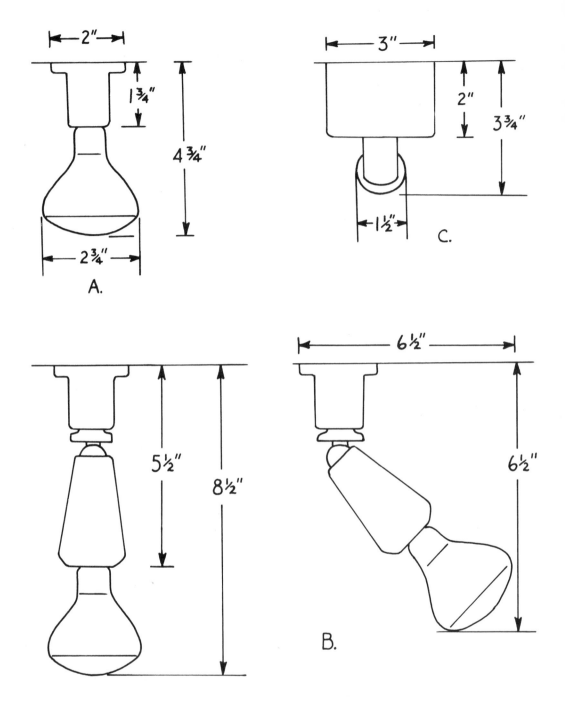

Fig. 8-3. Space used by lighting devices
 a. Space taken up by standard porcelain cleat receptacle with 30 watt reflector spot.
 b. Space taken up by standard porcelain cleat receptacle with swivel adapter socket and 30 watt reflector spot.
 c. Space taken up by standard single-tube fluorescent fixture and lamp. Some city codes require a 1 1/2" spacer between the back of the fixture and the surface to which it is attached. This is for protection against fire if the ballast in the fixture is shorted and burns up. Wiring and typical installation of a fluorescent fixture using 1 1/2" spacers is shown on pp. 145—148 in *Help! for the Small Museum.*

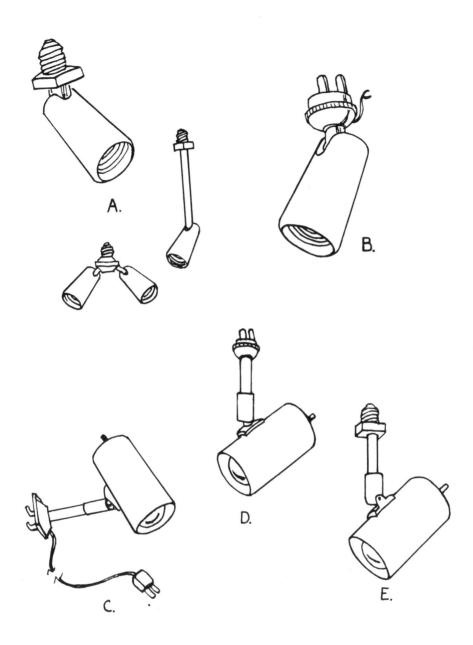

Fig. 8-4. Swivel lighting
 a. A variety of screw-in swivel sockets is available. The "long stem" type comes with 6″ and 12″ extensions. These sockets are used with reflector type lamps.
 b. Plug-in swivel socket, with grounding wire. Used with a reflector type lamp.
 c. Lamp housing with hooks for peg board. Uses ordinary "A" type incandescent lamp.
 d. Plug-in swivel lamp housing with grounding wire. Uses "A" type incandescent lamp.
 e. Screw-in socket type swivel lamp housing. Uses ordinary incandescent lamp.

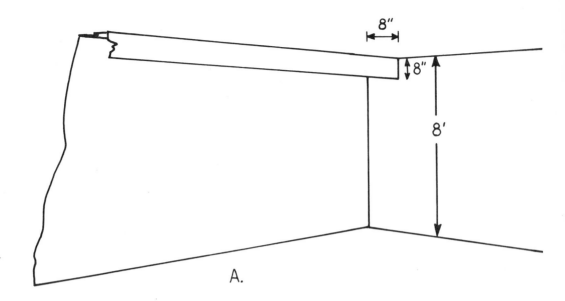

A.

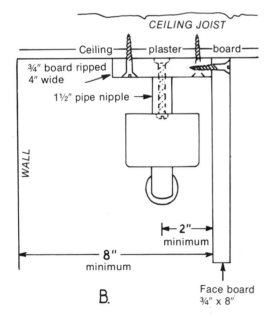

B.

Face board
¾″ x 8″

Fig. 8-5. Installing lights
 a. Cornice Light: fixture and face board in-
 stalled against ceiling. Used for a general
 wall wash for standard height (8′) ceiling.
 b. Construction detail: light fixture is bolted
 to a length of board 3/4″ x 4″ wide the
 length of the fixture. Nuts are counter-
 sunk into board. Board is then screwed
 through ceiling *into* ceiling joists with
 leading edge at least 8″ away from wall.
 If ceiling joists are parallel with board,
 board is attached with toggle bolts or
 heavy-duty hollow wall anchors (see Fig.
 7-3). Face board is screwed to light fix-
 ture board. Back side of face board and
 ceiling behind board should be painted a
 matte white to help reflect light from the
 fixture.

Fig. 8-6. Wall bracket light
 a. Wall bracket light is used when ceiling is
 higher than standard 8′. Used for a gen-
 eral wall wash for a specific piece or
 series of pieces.
 b. Method of mounting to wall: 4″ corner
 braces are anchored against the wall for
 the bottom edge of the end of the wall
 bracket; the bracket with top braces al-
 ready attached, is lifted on to the braces
 on the wall; screws are then put into wall
 bracket and through top set of braces
 into wall. All wall braces should be an-
 chored with heavy-duty hollow wall
 anchors unless heavy screws can be
 driven into studs.
 c. Detail of wall bracket

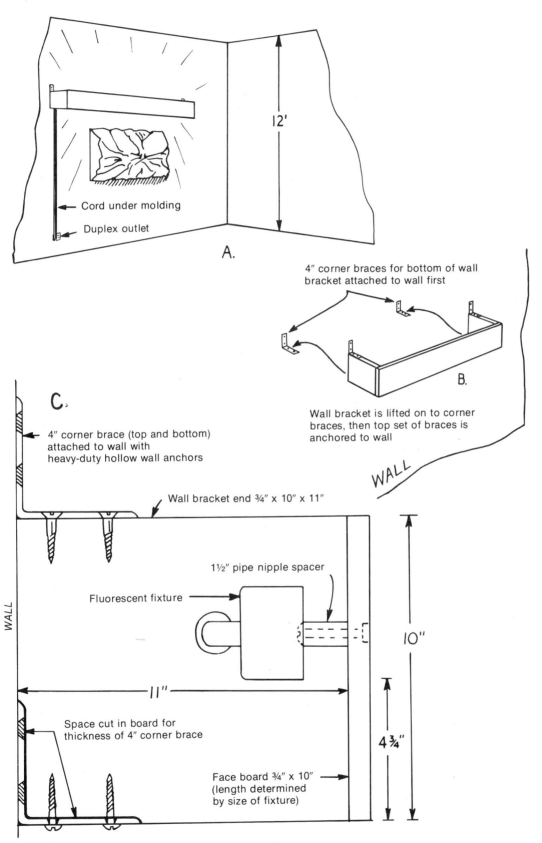

Cord under molding

Duplex outlet

A.

4″ corner braces for bottom of wall
bracket attached to wall first

12′

B.

Wall bracket is lifted on to corner
braces, then top set of braces is
anchored to wall

WALL

C.

4″ corner brace (top and bottom)
attached to wall with
heavy-duty hollow wall anchors

Wall bracket end ¾″ x 10″ x 11″

1½″ pipe nipple spacer

Fluorescent fixture

WALL

10″

11″

4¾″

Space cut in board for
thickness of 4″ corner brace

Face board ¾″ x 10″
(length determined
by size of fixture)

109

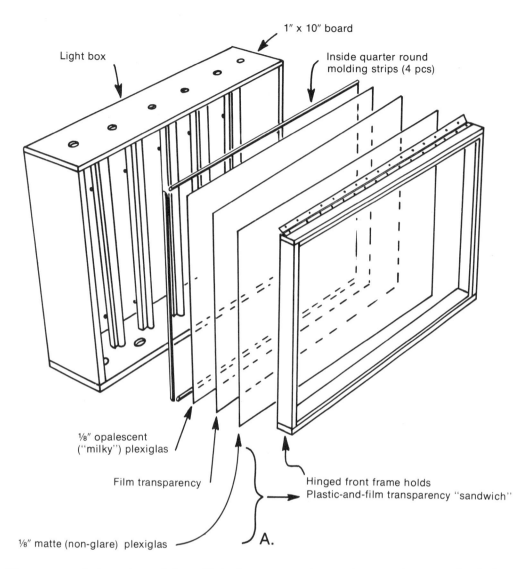

1" x 10" board

Light box

Inside quarter round
molding strips (4 pcs)

⅛" opalescent
("milky") plexiglas

Film transparency

Hinged front frame holds
Plastic-and-film transparency "sandwich"

⅛" matte (non-glare) plexiglas

A.

The same technique is used in a United States museum exhibit of musical instruments from Africa. The taped recording includes a short narrative about an instrument, where it is made, how, and how it is used. This is followed by the sound of the instrument as it is played. Again, a pinpoint spotlight picks out the instrument being played. In both exhibits—Denmark and the United States—seats or a bench make it possible for the visitor to relax as he enjoys listening to the sounds.

While the author has never installed such an exhibit, it would seem that the same type of synchronizer which is used with a stereo tape recorder and a remote-control slide projector might provide the proper device for coordinating the lights with the recorded sound. Back-lighting also will enhance portions of textiles, emphasizing the texture of the weave. A light box with fluorescent fixtures and a hinged front which holds sheets of opaque (milky) and clear Plexiglas is easy to build. It can be hung against a wall or panel, or supported by two uprights. The fluorescent light tubes should always be covered with plastic ultra-violet filters to protect the materials being displayed. Construction of such a light box is shown in Fig. 8-7a-c. A similar box is described in the "Practically Speaking" column of *History News*, Vol. 29, No. 1 (January, 1974) and shown in Fig. 8-8.

The "island" exhibit shown in Fig. 8-9 is installed in the center of quite a large room. Power has been dropped to it from the ceiling and track lights used to show the displayed items.

General room lighting gives generalized illumination in Fig. 8-10 and swivel spotlights highlight specific items on the platform against the wall.

Whenever possible, visitors should not be required to look at an unshielded light. Figure 8-11 shows an example of glare from light which could be controlled easily by the addition of a simple baffle in front of the fluorescent light.

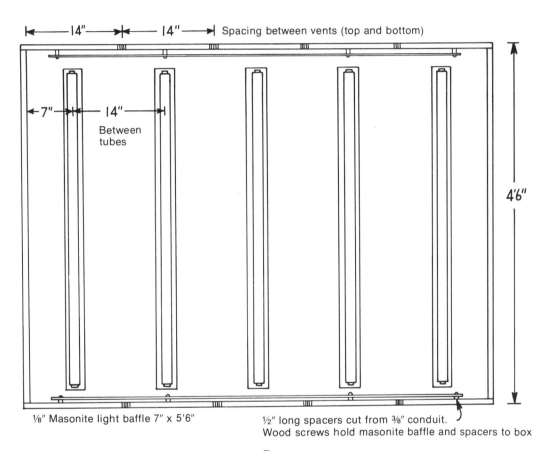

B.

Fig. 8-7. Light box
a. A light box is used for backlighting photographs, textiles, prints, etc. Note: a layer of mylar film should be added between the opalescent Plexiglas and the material being exhibited. This increases the filtering of UV rays.
 The box shown is 4′6″ high and 6′ wide. It is made of 1″ x 10″ boards with a back of 3/8″ plyboard. The hinged front frame is made of 1″ x 4″ boards with the plastic held in place by strips of quarter round.
b. Front view of the box showing spacing between 40 watt single-tube fluorescent fixtures; spacing of 3/4″ holes drilled in top and bottom as vents; placement of 1/8″ masonite light baffles top and bottom. The vent holes permit circulation of air and provide an escape for heat. The baffles, held away from the box by 1/2″ spacers, permit air flow at the same time they block light from showing.

111

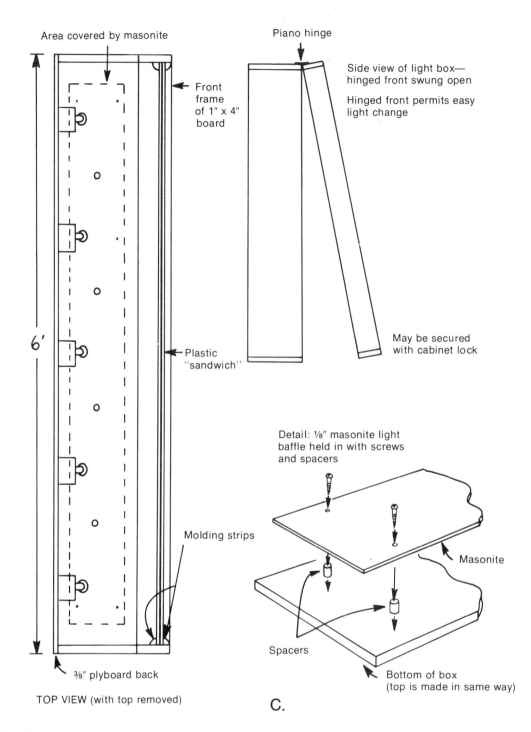

Area covered by masonite

Piano hinge

Front frame of 1" x 4" board

Side view of light box— hinged front swung open

Hinged front permits easy light change

6'

Plastic "sandwich"

May be secured with cabinet lock

Detail: ⅛" masonite light baffle held in with screws and spacers

Molding strips

Masonite

⅜" plyboard back

Spacers

Bottom of box (top is made in same way)

TOP VIEW (with top removed)

C.

Fig. 8-7.

 c. top and side views, and a detail of the method of fastening the masonite baffles and spacers to the box.

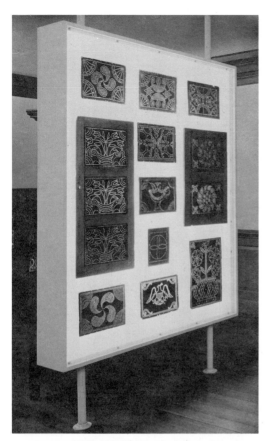

Fig. 8-8. Light box as used at Colonial Williamsburg to display punched tin panels. The tin panels were wired to the opalescent Plexiglas and, since the objects were not fragile, the clear Plexiglas panel was not used.

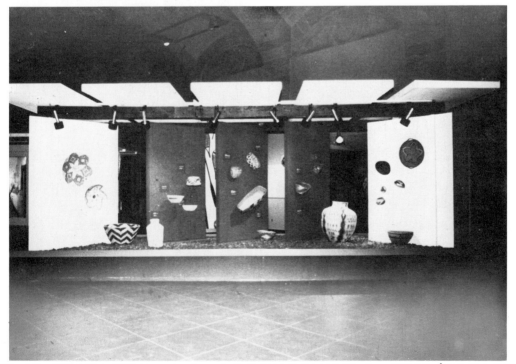

Fig. 8-9. "Island" exhibit in a very large hall; lighted independently by spotlights used in a track system. (New York State Museum)

113

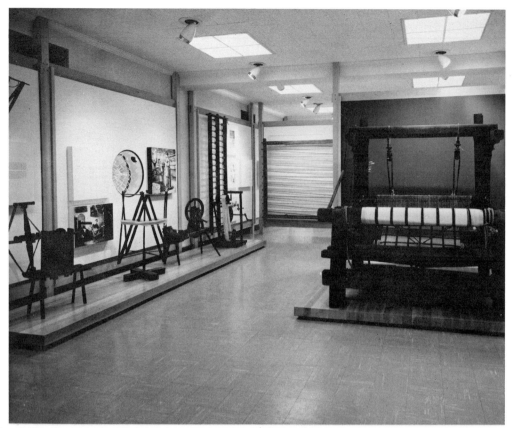

Fig. 8-10. General room lighting for a large area displaying big, bulky objects in the main floor area; swivel spotlights are used to highlight materials on platform along the wall. (Merrimack Valley Textile Museum)

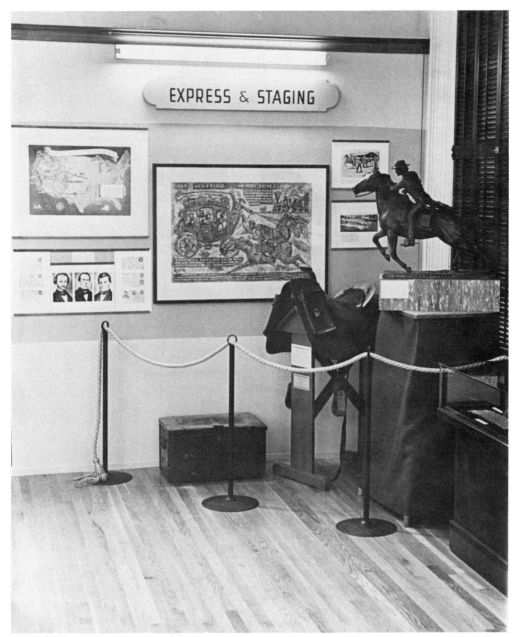

EXPRESS & STAGING

Fig. 8-11. Addition of a wall bracket in front of this fixture would eliminate the glare in a visitor's eyes.

9 Mannikins

Museums large and small often wish to make use of mannikins as a way of displaying a particular style of clothing. The advent of "wax" museums across the country, with their highly realistic figures, sometimes discourages museum staff members from attempting to create figures, for they feel they must compete with these sculptures.

A great variety of mannikins actually are in use in exhibits across the country. Some are the "wax" museum realistic figure, many are increasingly simplified versions of the human figure (Figs. 9-1 and 9-2). The ultimate costume display is that which uses no figure at all. Figure 9-3 shows uniforms which simply have been pinned to the case background in appropriate positions together with accessory items such as the rifles and sabre. Figure 9-4 was a department store window and shows again what a delightful imagination can accomplish with no mannikins at all. Clothing

was stuffed to proper shapes and the extreme action accomplished by the use of wires or light weight nylon line attached to the clothing and suspended from the ceiling. The entire scene is great fun.

A similar action-packed form is shown in Fig. 9-5a and b. Here, a very simple form has been made of //4″ hardware cloth. The costumed figure is held in its action pose by nylon fish line attached to the top of the case.

Between the "no figure" mannikin and the highly realistic "wax" museum figure is a simple, easily made type of wooden figure photographed in the late 1940s in the Museum of International Folk Art in Santa Fe, New Mexico (Fig. 9-6). As seen, the figures are adjustable, making a variety of poses possible. They are stylized, making no attempt to recreate realistic heads or hands, and serve admirably for the main function of any form: to show clothing as it appears in motion on a living form. An

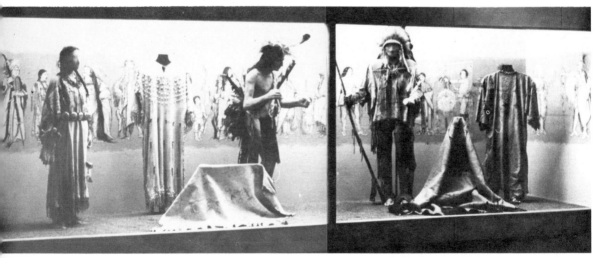

Fig. 9-1. Semi-stylized mannikins: generalized faces, more realistic hands and arms, combined in a case with simple cutouts which support the clothing. (Los Angeles County Museum of Natural History)

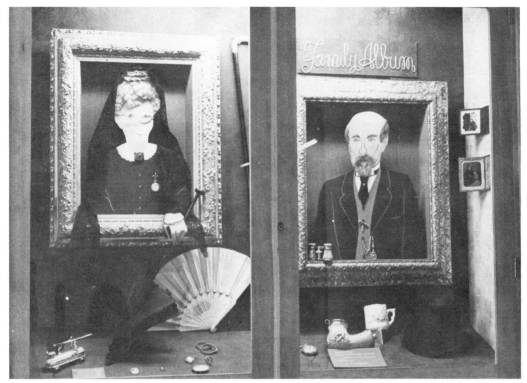

Fig. 9-2. Simple caricature cutouts with painted costumes serve as mannikins to display accessories: brooch, eyeglasses, watch-chain and fob, etc. (Museum of New Mexico, Santa Fe, New Mexico)

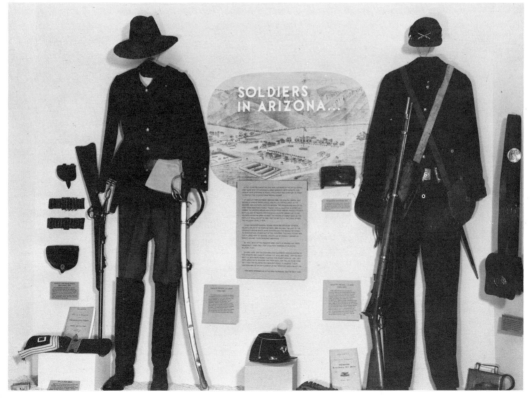

Fig. 9-3. A costume arrangement with no figure

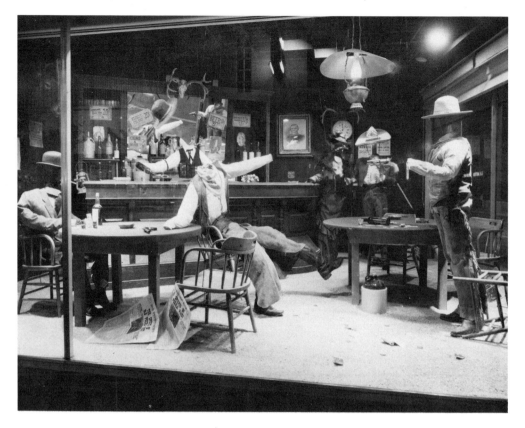

Fig. 9-4. A window display by Budd Sherril, display manager for Steinfeld Stores, Inc., Tucson, Arizona

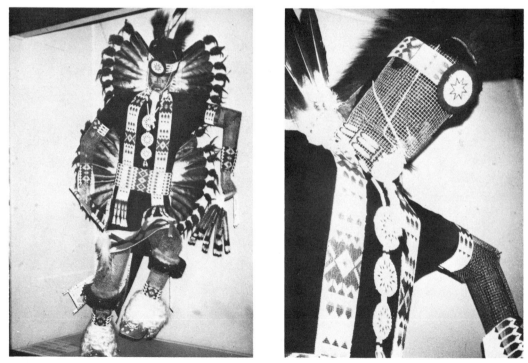

Fig. 9-5. A very active figure made of simple materials

118

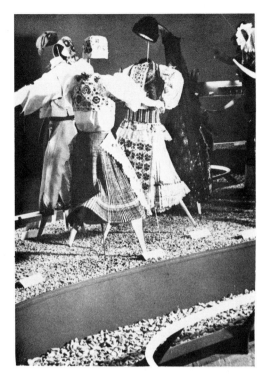 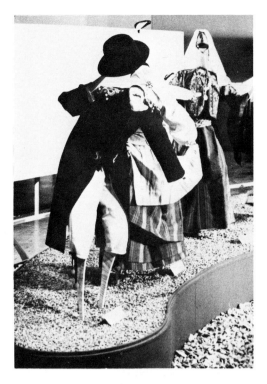

Fig. 9-6. Costumes displayed solely with wooden forms

unclothed figure (Fig. 9-7) shows some of the details. Figures 9-8 through 9-10 show patterns against a 1″ square scale, making it possible to transfer the patterns to full size. These photographs were taken with an ordinary sewing cutting board providing the background for the wooden pieces. To transfer the patterns, tape a large piece of tracing paper over a similar cutting board and trace the lines square by square. The drawings show dimensions of wood used, size of bolts, and some details of joining the finished pieces.

Other methods for creating mannikins are described in the AASLH Technical Leaflet No. 64; in Vol. 77, No. 3 (July, 1971) of *El Palacio* (published by the Museum of New Mexico in Santa Fe, N.M.); and in a mimeographed booklet *Making a Mannequin*, by O. Ray King, available from the Ohio Historical Society, Columbus, Ohio 43211.

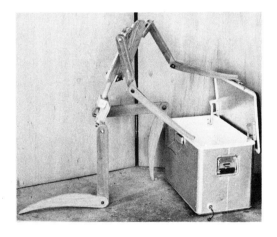

Fig. 9-7. An unclothed wooden figure

A.

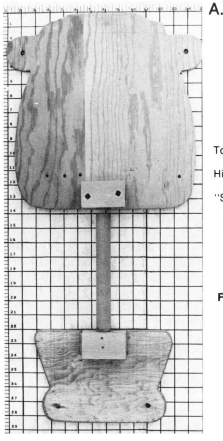

Torso: ⅜" plyboard

Hips: ⅜" plyboard

"Spine": 1" dowel glued and nailed into hole drilled into hardboard block 1½" x 1¾" x 3". Block glued and screwed to plyboard hips.

Fig. 9-8. Patterns for making a wooden figure torso and construction details
 a. Torso has a hardwood block. It is important that the 1" hole for the dowel be drilled *before* the block is cut in half. The width of the saw cut diminishes the hole just enough that, when the carriage bolts holding half of the block to the torso are tightened, a clamp is made on the dowel. This permits adjusting both the height of the figure and the twist of the upper portion of the form.
 b. Detail of the torso

B.

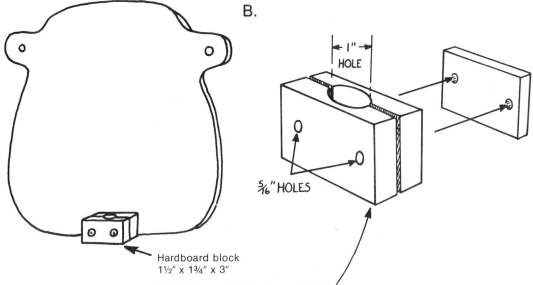

Hardboard block
1½" x 1¾" x 3"

Drill 1" diameter hole through block

Drill 2 holes ⁵⁄₁₆" diameter through block from back
Saw block in half
Glue and screw one half to torso
Glue and nail ⅜" plyboard reinforcement on opposite side of torso.

Use existing holes in hardboard block for guides and drill through torso and ⅜" plyboard reinforcement
Use ¼" x 3" carriage bolts, washers and wing nuts

120

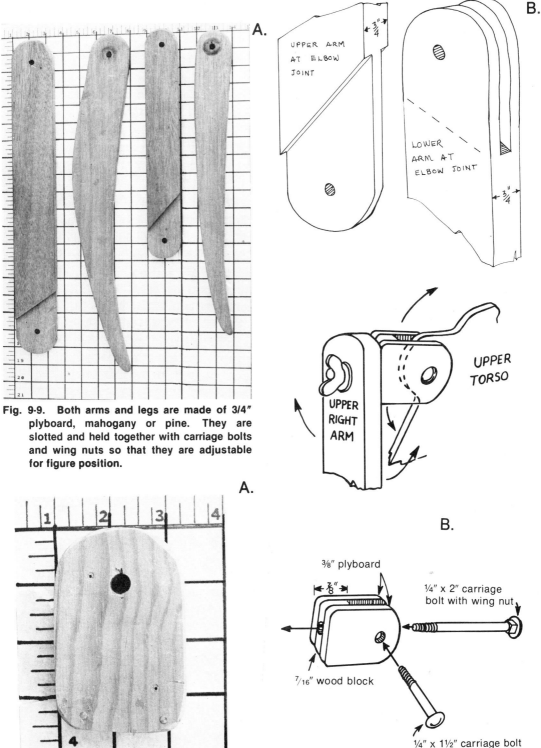

A.

UPPER ARM AT ELBOW JOINT

$\frac{3}{4}''$

B.

LOWER ARM AT ELBOW JOINT

$\frac{3}{4}''$

UPPER RIGHT ARM

UPPER TORSO

Fig. 9-9. Both arms and legs are made of 3/4″ plyboard, mahogany or pine. They are slotted and held together with carriage bolts and wing nuts so that they are adjustable for figure position.

A.

B.

⅜″ plyboard

$\frac{7}{8}''$

¼″ x 2″ carriage bolt with wing nut

7/16″ wood block

¼″ x 1½″ carriage bolt with wing nut

Fig. 9-10. Assembling the wooden figure. Shoulder and thigh joints are identical. They are made of 3/8″ plyboard with 7/16″ thick wood block spacer. A hole in the spacer permits the use of a 1/4″ x 2″ carriage bolt which holds the upper arm or upper leg; the holes in the plyboard permit using a 1/4″ x 1 1/2″ carriage bolt to fasten the "joint" to the "shoulder" or "thigh." Experimenting with these adjustable joints will reveal an amazing number of position variations which may be made.

121

10 Labels

Labels in any exhibit have but one function—communication. A label communicates best when the information is written in commonly understood language, is concise, presents the most important ideas at the beginning, and is designed to be read with the greatest possible visual ease.

Labels are a necessary part of any exhibit. *Panels* which introduce display sequences need a "headline" and perhaps a "subhead" to inform visitors as to the broad subject areas to be seen in that sequence (Fig. 10-1). *Case exhibits* should have a headline and subhead which permit the visitor to know the basic idea illustrated by the items in the case (Fig. 10-2). *Specimens which are grouped* together because of some common function should have a "group" label which identifies that function. *Individual specimens* should be named, dated (if appropriate), and a description given as to how they worked and how they were used.

Labels are limited—or at least they should be. In these days scarcely any designer, script writer/editor, or scientific advisor produces the equivalent of a textbook for a series of labels, though long and hard battles often are fought. No one will hand a departing visitor a college degree in a subject area encompassed by some of the museum's displays even if that visitor somehow has managed to read every label in the museum. Chances the visitor *will* have read all labels are slim, for museum fatigue will have set in before the visitor departs.

For those who must write labels, several profitable hours might be spent over the course of a typical museum year just listening to visitors' comments about the displays and labels. A term, name, or phrase which might be perfectly understandable to the label writer may be completely misinter-preted by the visitor. Did you know that, to one museum visitor, a "planetarium" is a "place where they show plants," and one youngster wondered aloud what a plug of tobacco might be, seeing only the label "Plug Tobacco Cutter."

Some "vital statistics" of concern to label writers:

Most adults read at the rate of about 250 to 300 words per minute.

Readers prefer short sentences—on an 18 to 20 word average.

The average viewing time for most exhibits is no more than *forty-five seconds.*

Thus, a visitor reading at a rate of 300 words per minute will average about 5 words per second, or 225 words for the full 45-second attention span. If he reads the full 225 words which might be in a label, probably he will not see the objects. The lesson should be clear. Labels must be concise.

The above statistics represent averages discovered by visitor research. The attention span per exhibit *may* be increased to more than 45 seconds if:

case design presents materials *and* labels in easily comprehended units;

labels give immediate, then secondary, and finally detailed information; visitors are given the opportunity for a "mini" rest (leaning on a railing or a wall) or a "maxi" rest (sitting down) while viewing the display.

To check labels for comprehension, try them in reference to the following formula, reprinted from *Gobbledygook Has Gotta Go* by John O'Hayre.[3]

3. Reprinted by permission of the Bureau of Land Management, U.S.D.I.

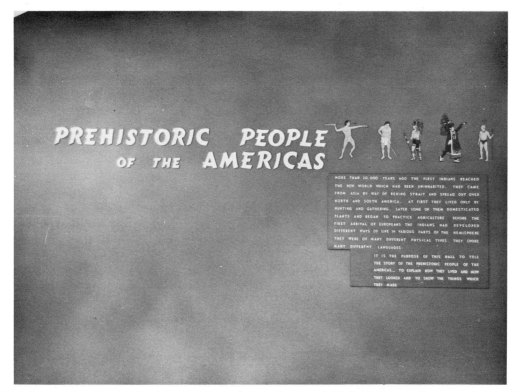

Fig. 10-1. A headline and subhead at an entrance to an exhibit hall (Denver Museum of Natural History)

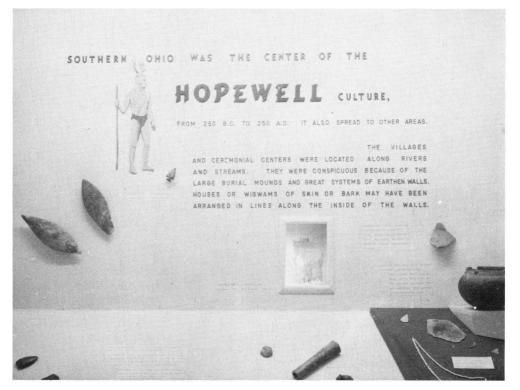

Fig. 10-2. Headline and subhead in an exhibit case (Denver Museum of Natural History)

Rather than counting every syllable or only words of three syllables or more, we concentrate on words which make up nearly three-fourths of plain English, the words most natural to the language, especially its native nouns and verbs, its one-syllable words. When the writer deals with the words most natural to English, he learns how to handle the language.

Next to Chinese, English is the most monosyllabic major language. The formula stresses one-syllable words, not just because of their occurrence in plain English, but because (1) many of the strongest verbs are of one syllable, and strong verbs are the guts of good writing; (2) there is a vigorous tendency to form strong, active verbs with verb-adverb combinations such as 'put up with,' 'fall away from,' 'stand up to,' 'go for,' 'hold up,' 'put a stop to,' etc.; forms you can use to describe even the most complex or abstract actions.

"The Write Formula has a feature that goes a long way toward protecting the writer from falling into the passive voice, a weakness of much Government writing. In counting one-syllable words we do not count these one-syllable verbs: 'is','are', 'was', and 'were'. Since these verbs are so often used to form the weak passive voice, our formula 'emphasizes them out,' and the writer is forced into using stronger verbs. Another word we do not count is 'the.' It simply isn't needed in a good many cases.

"One thing the Write Formula has in common with some others is that it measures sentence length. . . . By giving points for shortness, the writer is encouraged to create a short sentence average.

"Here's how to use the Write Formula:
(1) Count a 100-word sample.
(2) Count all one-syllable words except 'the', 'is', 'are', 'was,' and 'were'. Count one point for each one-syllable word.
(3) Count the number of sentences in the 100-word sample to the nearest period or semicolon and give three points for each sentence.
(4) Add together the one-syllable word count and the three points for each sentence to get your grade.

"For example, if you have 55 one-syllable words in your 100-word sample, with each worth 1 point, and if you have 5 sentences (semicolons count as periods), your total score will be 70.

"If your piece has less than 100 words, multiply your tally to get the equivalent of 100:

Multiply a 25-word sample by 4; a 33-word sample by 3; a 61-word sample by 1.65, etc.

"If you tally between 70 and 80 points, you are in the right bracket for the average adult reader. A score of 80 is close to ideal, but if you score over 85 you may be getting too simple; if you drop much below 70, you're too complicated unless you are writing as a technician to another technician in the same specialized field.

"A score of 75 or 80 means you can get through to an average American reader. This kind of uncomplicated writing is preferred by most college graduates, but can also reach high school graduates. The 'think' magazines like *Harpers* and *Atlantic* come out between 65 and 70. *Time* and the *Wall Street Journal* run between 70 and 75. *Reader's Digest* floats between 75 and 85. *Children's Digest* ranges upward from 85 to over 100.

"This formula may seem easy; it's gnashingly tough. It will not let you rest on the one-syllable connectives and prepositions, but will force you to use the strong verbs and colorful nouns so lacking in gobbledygook. It will force you to write as good writers do: with the strong, clear, active words nongovernment English is blessed with.

"Use the formula until you feel you understand its purpose, then forget it except for periodic checkups to see if you're still writing within readable limits."

Designing Easy to Read Labels

How large should labels be?

Headlines and Subheads—The distance from which the label is to be seen is a major factor in the readability of that label. Because the headline and subhead labels in an exhibit serve not only to inform the visitor, but to attract him *to* the exhibit, these labels should be made large enough to be seen from at least a 10-foot distance. They may be made easily from plastic, cardboard, or plaster three-dimensional letters or by using flat letters from dry-transfer sheets, precut self-sticking vinyl letters, or by hand lettering. Some large letters are prepared by making the label first with dry-transfer letters which are then photographed. The negative is used to enlarge the label to the desired size and the

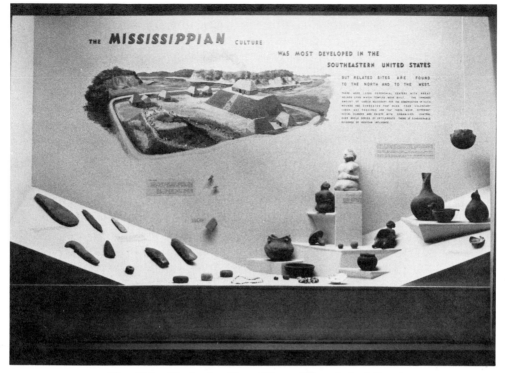

Fig. 10-3. Display headline of three different size letters

DEVELOPED IN THE

SOUTHEASTERN UNITED STATES

BUT RELATED SITES ARE FOUND
TO THE NORTH AND TO THE WEST.

THERE WERE LARGE CEREMONIAL CENTERS WITH GREAT
MOUNDS UPON WHICH TEMPLES WERE BUILT. THE IMMENSE
AMOUNT OF LABOR NECESSARY FOR THE CONSTRUCTION OF SUCH
MOUNDS HAS SUGGESTED THAT MORE THAN VOLUNTARY
LABOR WAS REQUIRED AND THAT THERE WERE DIFFERENT
SOCIAL CLASSES AND CHIEFS WITH ORGANIZED CONTROL
OVER WHOLE SERIES OF SETTLEMENTS. THERE IS CONSIDERABLE
EVIDENCE OF MEXICAN INFLUENCE.

Fig. 10-4. Detail of Fig. 10-3.

label is then silk-screened onto a label-panel or onto the exhibit panel itself.

In Fig. 10-3 the headline is made up of three different sizes. Use of these sizes helps to emphasize the main points being stated. The word "MISSISSIPPIAN" is made from 2″ plaster letters produced in the museum workshop (see AASLH Technical Leaflet No. 23 for step-by-step instructions). The words "The Mississippian culture was most developed in the southeastern United States . . ." are formed by 3/4″ cardboard letters which have been painted. The remainder of the headline sentence (Fig. 10-4) ". . . but related sites are found to the north and to the west" is composed of 1/2″ plastic letters. The subhead, which begins "There were large ceremonial centers . . ." is made from 1/4″ plastic letters.

Figure 10-5 shows one technique to use in installing three-dimensional letters in a case exhibit. A thin strip of wood (a yardstick may be used) is taped to the vertical surface. Be sure the edge is straight so that the line of letters will be straight. The painted letters (see pp. 159, 160 in *Help!*) are transferred from the masking tape which holds them to the background, using the wooden straight-edge as a guide. A tiny thread of white glue placed on the back of the letters with a toothpick anchors the letters in place. *Spacing is extremely important* and is covered in the next section.

Figures 10-6 through 10-9 show introductory exhibit section panels produced in a variety of ways.

Group text and Specimen labels—Most "nitty-gritty" labels such as those which discuss common functions, sequences, chronologies, and the like, and individual specimen labels usually are notably smaller than the headlines and subheads previously described. They may be produced by hand-

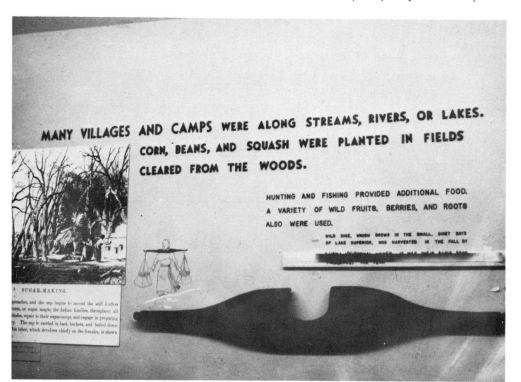

Fig. 10-5. One installation technique
Main phrase MANY VILLAGES AND CAMPS in the headline label is made of 1 1/4″ cardboard letters; the remainder of the headline is made of 3/4″ cardboard letters. Subhead label ("Hunting and fishing etc.") is made of 1/2″ plastic letters. Third statement ("Wild rice, which grows, etc.") in the process of installation, is made of 1/4″ plastic letters.

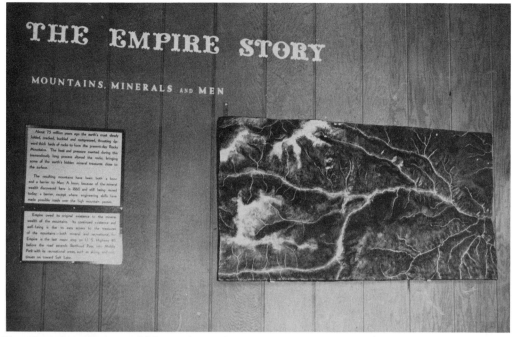

Fig. 10-6. Introductory exhibit panel
This panel is at the entrance to a small museum. The main label "The Empire Story" is made of plaster letters designed by the museum staff; "Mountains, Minerals, and Men" is made of commercially available plastic letters. The text has been set in type. (Red Men Hall Museum, Empire, Colorado)

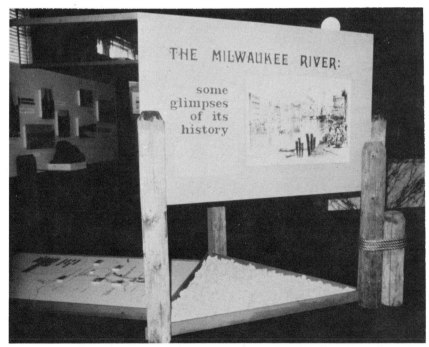

Fig. 10-7. Panel at the entrance to a temporary exhibit. The letters may have been prepared with dry-transfer lettering. (Milwaukee County Historical Society, Milwaukee, Wis.)

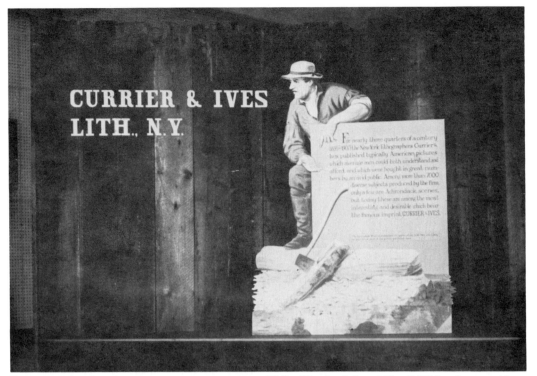

Fig. 10-8. Panel at the entrance to a temporary exhibit. "Currier & Ives Lith., N.Y." has been cut from hardboard. The figure was photographed from one of the lithographs in the exhibit, enlarged photographically, mounted on hardboard and cut out, and the introductory label then hand-lettered. (Adirondack Museum, Blue Mountain Lake, N.Y.)

Fig. 10-9. This entrance panel to an exhibit sequence could have been made by preparing a much smaller layout with dry-transfer lettering and copies of illustrations from harness catalogues which was then photographed and enlarged for silkscreen printing. Lacking expertise in silkscreening techniques, one could prepare this panel by using large dry-transfer or vinyl self-sticking letters, photographing the illustrations and projecting them on the panel surface to be traced onto the panel. (Adirondack Museum, Blue Mountain Lake, New York)

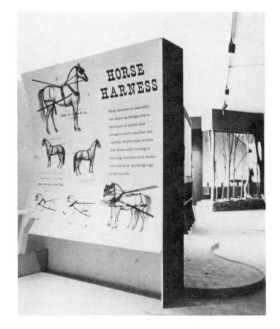

lettering, dry-transfer letters, or set in type. Some typewriters may be obtained which are equipped with large-size type and are designed as label typewriters.

Those producing labels should remember always that the reading process is a combination of physical and mental exertions: the eyes scan the lines of type, recognizing and identifying word and phrase patterns in a series of small rapid jerks and relaying these to the brain for comprehension. When the eyes reach the end of one line they make a long sweep to the left to the beginning of the next line. If a label is produced in such a manner that extreme eye and/or head movement is required for the eyes to read, museum fatigue will set in at a rapid pace.

Above all, *never* use "cute" or "tricky" arrangements of letters within a label. They are never justified, serving only to diminish legibility. The one function of any label is communication; this cannot be emphasized enough. In the design of the label, speed of reading and comprehension are of overriding importance.

How big should the letters be?

Bigger is not always better. Many museum people will use a typewriter for labels and hope that, by using all capital letters, the label will be easy to read. Research in reading patterns and legibility have shown that the use of nothing but capital letters may reduce the speed of reading by almost 14 percent over the same label printed in the standard combination of caps and lower case. In addition, text written entirely in capitals occupies about 40 to 50 percent more space than text in both caps and lower case.

The characters on standard typewriters (not label typewriters) are about the same size as ten-point printing type. This size is designed to be read at a distance of about 15 inches. To use this size type for labels which will be 2 feet or more distance from the reader is not practical.
Recommended sizes:

Nothing smaller than 24-point for specimen labels;

Generally, 30-point or 36-point for group labels, with emphasis sometimes being gained by the use of a combination.

A combination of sizes, never more than two, as mentioned above, is used to emphasize a heading or main subject which has been incorporated in the label (Fig. 10-10).

How close together may the letters of a word be?

The thickness plus half of the letter "I" may be used for a *general* rule in hand-lettering (see AASLH Technical Leaflet No. 22) or in spacing between applied letters such as dry-transfer, vinyl stick-on, or three-dimensional letters. This general rule should be tempered by the actual *visual impact* a word may have. Depending upon the size and style of type used, the rule may be varied to a slightly thinner space between letters or a slightly wider space. See Fig. 10-11.

Dry transfer letters may be used for many labels.

Fig. 10-10.

How close together may the words of a line be?

It is absolutely essential that the visitor be able to scan words as readily recognizable patterns. This means that enough space must be allowed between words for the eyes to distinguish the word pattern. If *too* much space is created between words it will be difficult for the eyes to identify the "flow" of the sentence.

Width of the letters "M" or "W" of the particular label type style may be used as a general rule for measuring between words. Some "scrunching" or expanding may be permitted but the words should never be placed so closely together that the viewer's eyes cannot separate them.

How long should the lines of a label be?

A line of type, whether applied 3-D letters, type-set, typewritten, hand-lettered, or applied dry-transfer should not range over approximately 50 to 65 letters. This letter-count should include spaces between words and between sentences as part of the total. Lines may, of course, be shorter, but not longer. A line of type which is too long makes it difficult, sometimes impossible, for the viewer's eyes to journey from the end of one line safely back to the beginning of the next line.

Should the lines be justified?

"Justified" lines are those seen in conventionally printed books and newspapers where the right-hand margin is "squared-up," or straight, as is the left-hand margin. This is accomplished by varying the spaces between letters and between words. In typewritten labels it is produced by adding spaces between words. In a text with "unjustified" lines, words are evenly spaced (as described above with the width of an "M" or "W") and the right-hand margin is uneven. Experiments have shown that, so far as legibility is concerned, there is no significant difference between justified and unjustified type.

SPACING IS CRITICAL IN THE PREPA-RATION of LABELS.

Fig. 10-11.

LETTERS and LINES are hard

to read if placed TOO CLOSE TOGETHER

or TOO FAR APART.

If LETTERS are properly spaced but the LINES are too close, THE MEDIUM HAS OBSCURED THE MESSAGE.

Fig. 10-12.

How much space should there be between lines?

See Fig. 10-13 for an illustration of legible spaces between lines. This general pattern should be followed either with 3-D or flat applied letters: *at least* the height of the capitals (e.g. "A", not "a") should be allowed between the bottom of a top line and the top of the next line. The label will be easier to read if even a little more space is permitted. See pages 163 to 171 in *Help! for the Small Museum* for a more detailed explanation.

How much space will a label require?

To be able to plan ahead what space will be required for some applied (cardboard or plastic) 3-D labels, the following chart may be useful. The letter counts are based upon standard "Gothic" type designs normally available from most letter suppliers.

1/4" Plastic CAPS
 42 letters per 12" length of line.
 Space *between bottoms* of lines of type: 5/8".

1/2" Plastic CAPS
 25 letters per 12" length of line.
 Space between bottoms of lines of type: 1 1/8".

3/4" KABEL Cardboard
 17 letters per 12" length of line.
 Space between bottoms of lines of type: 1 5/8".

1" KABEL Cardboard
 14 letters per 12" length of line.
 Space between bottoms of lines of type: 2 1/8".

1 1/2" KABEL Cardboard
 12 letters per 12" length of line.
 Space between bottoms of lines of type: 3 1/8".

2 1/2" MODERN BLOCK Cardboard
 8 letters per 12" length of line.
 Space between bottoms of lines of type: 5 1/4".

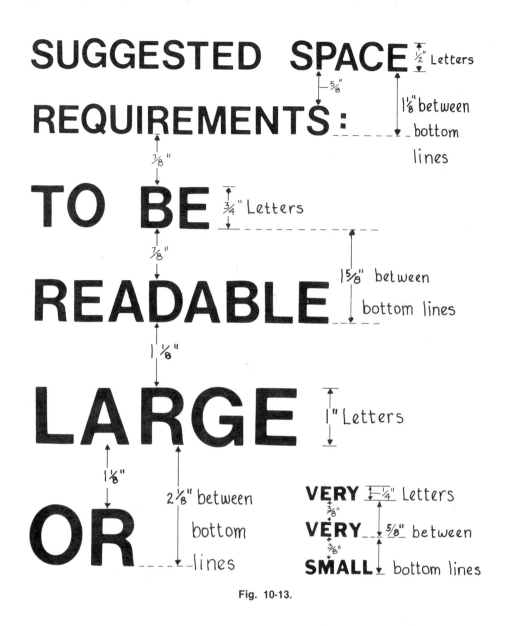

SUGGESTED SPACE ½" Letters

⅝"

REQUIREMENTS: 1⅛" between bottom lines

⅞"

TO BE ¾" Letters

⅞"

1⅝" between bottom lines

READABLE

1⅛"

LARGE 1" Letters

1⅛"

2⅛" between bottom lines

OR

VERY ¼" Letters

⅜"

VERY ⅝" between

⅜"

SMALL bottom lines

Fig. 10-13.

ROYAL TYPEWRITER for labels
72 characters per 12" length
of line. Double spacing
gives ½" space between lines.

Fig. 10-14.

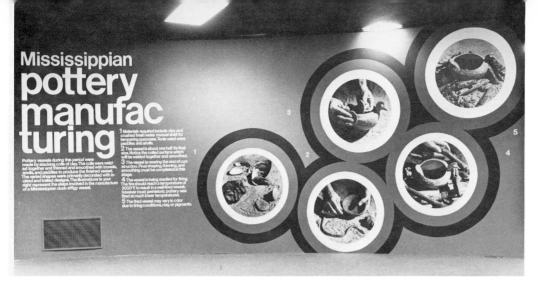

Fig. 10-15. This label is very hard to read

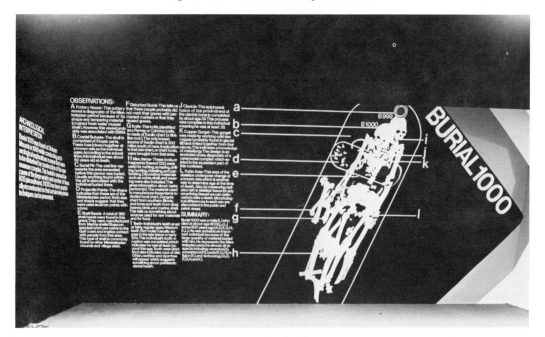

Fig. 10-16. Another hard to read label

The ROYAL TYPEWRITER for labels produces letters approximately 1/4″ high: 72 letters per 12″ length of line.

Double-spacing gives 1/2″ space between lines. (Fig. 10-14)

Figures 10-15 and 10-16 show the almost total impossibility of reading lines of labels which are placed much too close together. These are both wall displays. The walls are about 10 feet high. No matter how far back a visitor may stand, he will find it difficult to read the type in such a layout. The letters and words obviously have been used as design blocks, not as a means of communication.

Labels (signs) which are to be legible to the driving public must be designed for reading at 55 m.p.h. (Fig. 10-17).

Even a four-sentence label (sign) must be designed with a pull-out so the driver may park his car while he reads (Fig. 10-18).

Fig. 10-17. Highway sign

Label Production

Some techniques for making, painting, and installing three-dimensional labels are described in *Help!* (pp. 153 to 160) and in AASLH Technical Leaflet No. 23.

"Flat" labels—typed, p r i n t e d , dry-transfer or vinyl stick-on should, most often, be made with label paper that matches the color of the case. Labels which are typed on white index cards create bright, white areas that pull eyes away from the objects they describe. Matching color paper is easy to produce. When the exhibit case is painted, paint a number of sheets of brown wrapping paper (no shiny glazing, please!) which have been stretched (Fig. 10-19a-c). Cut the paper from the supporting cardboard; trim the edges with a paper-cutter. *Do not trim to final size* until lettering is complete and paper is, perhaps, mounted on a supporting lightweight cardboard.

Save a small jar of the paint. Use it for touch-up when lettering is done and for nail heads which may be used to attach the completed label in the exhibit.

Vinyl Stick-On Letters

Plastic (vinyl) letters in a variety of colors and ranging from 1/4″ to 6″ in height in-

Fig. 10-18. Roadside historical marker with large lettering

creasingly are available from stationery stores, school supply sections of drug stores, and art materials stores. The letters may be used outdoors or indoors and are relatively easy to work with.

Tape your painted label paper to a drawing board and use a T-square to draw two very light lines with a soft pencil (Fig. 10-20). These lines should be as far apart as the letters are high. For a series of lines of letters follow the spacing suggestions shown in Fig. 10-13.

A.

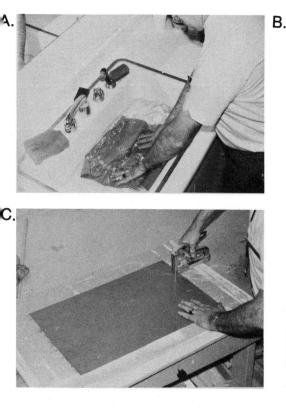

B.

C.

Fig. 10-19. Making background label paper to match the case color
 a. Soak ordinary wrapping paper for about 5 minutes in lukewarm water
 b. Drain the paper, holding the sheet successively by the four corners
 c. Smooth the damp paper on a sheet of Cellotex, Upson board or similar thick cardboard and staple down with about 3/4″ margin. Note the back of the staple gun is away from the wet paper. This helps to prevent marking or denting the paper. The paper will be rumpled but will pull tight as it dries. Paint it. It will rumple again but again will stretch tight as it dries.

Peel the surrounding plastic away from the backing sheet (Fig. 10-21) before starting to use the letters. Remove only the plastic around the letters. There will be some places where the plastic may not have been cut cleanly and it will be necessary to use an Xacto knife to clear the letter.

Use an Xacto knife to lift a portion of the desired letter (Fig. 10-22).

Use model-maker's tweezers to set the letter in the desired position (Fig. 10-23).

If spacing is tricky, the letters may be arranged first on a sheet of stiff waxed

Fig. 10-20.

Fig. 10-21.

Fig. 10-22.

Fig. 10-23.

paper (tape waxed paper to a light cardboard) with the bottom 1/16″ of the letters extending beyond the line of waxed paper. When the letters are properly spaced, the bottom edges are pressed down on the guide line drawn on the label paper and the waxed paper is slid up and away.

When all letters have been placed, put a piece of paper over the entire label and rub down with the bowl of a spoon or some other smooth tool. Use double-stick adhesive paper to attach the untrimmed label to a supporting cardboard; trim on paper cutter. Do not try to erase the pencilled guide lines. Erasing will change the color and texture of the painted paper. Instead, use a dab of the paint used to color the paper and a very fine, pointed artist's paintbrush (about a No. 1 red sable) and paint out the lines.

Spray completed label with a light coat of a matte-finish clear plastic (such as Krylon).

The letters will not stick properly to a dusty, waxy, or oily surface.

Do not try to dry-mount the lettered label. Heat will affect the plastic.

Dry-Transfer Letters

Hundreds of different type styles in many colors including white, now are available on printed plastic sheets. "Dry-transfer" means literally that—the plastic sheet is placed over paper, the desired letter rubbed hard with a smooth tool, and the letter is transferred from the plastic sheet to the paper. The letters are used most easily on labels that do not have an even right-hand margin. Depending upon the manufacturer, the lines of letters on the plastic sheet may have a row of guide dots or dashes just under the line of letters.

Tape colored label paper to a drawing board and draw a series of light pencil lines. Place the backing sheet that comes with the plastic sheet over the label paper just below the first guide line. This protects the label paper from wax on the back of the plastic sheet. Line up the printed guide lines under the desired letter along the light pencil line then transfer the letter by rubbing it with a smooth, blunt tool (Fig. 10-24). The protective tip of a ball-point pen works well. You will see the color of the letter change from a crisp, dark color to a grey. Carefully peel the plastic sheet away from the transferred letter (Fig. 10-25). Continue transferring letters until the label is complete. Place the protective backing sheet over the entire label and use the bowl of a spoon or similar tool to burnish down all of the letters.

Follow the same steps as described for vinyl stick-on letters to finish the label.

Label Placement

After the trauma of writing, designing and producing a good label or series of labels, communication may still be blocked if the labels are not placed properly. Generally, the following should be considered:

136

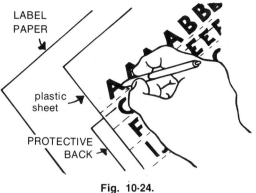

LABEL
PAPER

plastic
sheet

PROTECTIVE
BACK

Fig. 10-24.

Fig. 10-25.

MAIN (headline) LABELS should be no more than a foot above eye level;

SECONDARY (subhead) LABELS should be at or a foot below eye level;

GROUP AND INDIVIDUAL SPECIMEN LABELS should be located as close to the objects described as is possible.

No labels (and *no objects* smaller than a standard-size typewriter should be any lower than 24" from the floor.

As near as is practical, all labels should be as close as possible to a right angle with the visitor's line of sight.

Labels on the bottom of a case should be propped up on a slant;

Labels on the sides of a case should be angled out at the back (See Fig. 7-7a);

Labels on panels above eye level should be tipped forward at the top edge (See Fig. 7-7b).

These generalizations concerning the angle of view also should be used with photographs, maps, and pictures.

Remember that according to one source, 54 percent of the population of the United States over the age of 6 years wears glasses. Of that 54 percent, many people wear bifocals. For them, any label placed higher than the average eye level will be most difficult to read (Fig. 10-26).

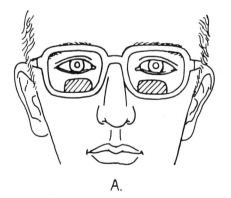

A.

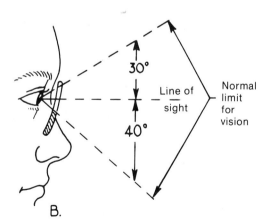

30°

Line of sight

40°

Normal limit for vision

B.

Fig. 10-26a,b. Viewing limits

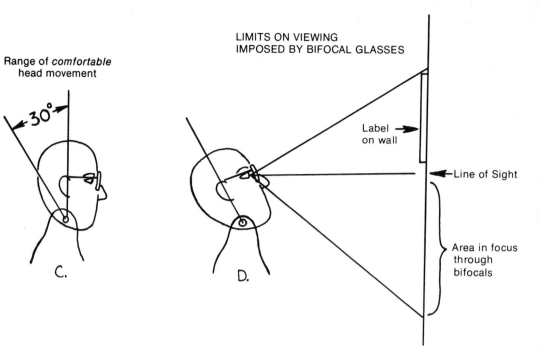

Range of *comfortable* head movement

30°

C.

LIMITS ON VIEWING
IMPOSED BY BIFOCAL GLASSES

Label on wall

Line of Sight

Area in focus through bifocals

D.

Fig. 10-26c,d.

11 Museum Fatigue and Human Anatomy

"Museum Fatigue" is an almost unavoidable ailment for visitors. How severe the case may become depends greatly upon the exhibit designer. As has been mentioned in the chapter on labels, those who must design and build displays could spend several profitable hours observing visitors who come to their institutions. Body positions reveal much about how tired a person may be. Most people will agree that standing in one place is much more tiring than walking from one place to another. By the very fact that museums show objects which people want to see a fatigue problem inevitably is created, for these objects are best seen from a standing, not a walking position.

What do *you* do as you stand watching, looking at, or reading something? If your hands are free of objects you are a step ahead of others. Women, carrying purses, are apt to develop fatigue sooner than men who are carrying nothing. If your clothing has comfortable pockets in which your hands can be hooked, or shoved against, you have a built-in "mini-rest" factor. Figure 11-1 shows two ways people relieve fatigue by changing weight pressure-points: arms folded across the chest, and hands on hips.

Why do these position changes help? Airplane passengers are advised to get up and move about the cabin once the seat-belt sign is turned off. Lacking the opportunity to do this, passengers are told to stretch their leg muscles by bending the feet back and forth and to tighten and release their calf and thigh muscles. The

Fig. 11-1. A variety of museum stances

reason for these exercises is that prolonged sitting inhibits blood circulation causing lower legs and feet to cramp, swell, and/or "go to sleep." Prolonged standing with short spurts of walking also tends to affect circulation. Hands, hung down at the sides, begin to swell. Feet and legs, not normally accustomed to holding up the poundage of the full body for an appreciable time, tire rapidly. The body compensations are shown in the following photographs. (Figs. 11-2-7). A jointed cardboard figure (Fig. 11-10) may be made from file folder cardboard following the pattern in Fig. 11-11 and putting together with eyelets or snaps at the indicated pivot points.

As Figs. 11-12 through 11-18 show, the figure helps to determine reachable distances from panels, bench and chair measurements, and useful railing heights.

Figure 11-15 shows how material mounted on a panel may be protected by the use of a floor case or exhibit surface. This holds the visitor away from the wall. Assume the visitor will brace himself against anything available, leaning on the sloping exhibit surface that extends from the wall. Any flat display pieces placed on this surface (labels, maps, drawings, photos,

Fig. 11-2. Fatigue begins to show as a visitor leans against a conveniently blank wall.

Fig. 11-3. "Mini-rests" are taken leaning on or hanging from the frame surrounding exhibit glass.

Fig. 11-4. Weight shifts and hands in pockets help to brace the lower back.

etc.) will need some extra protection against wear. This could be extra coats of matte finish spray plastic, a covering of clear Contac plastic, or a piece of Abcite or Lexan (an abrasive-resistant acrylic sheet similar to Plexiglas). A four to six inch toe-space should be provided at the base of the unit for visitor comfort.

Fig. 11-5. With knees braced against a railing and the upper body sagging against locked arms, some relief is sought.

A. B. C.

Fig. 11-6. Listening to over-long recorded tours increases fatigue. The usual weight shifts can be observed (a); a convenient sill provides a variation in body support (b); a railing gives support for a bent knee which in turn supports the elbow of the hand holding the earphone—all braced by the right arm (c).

Fig. 11-7. This poor man not only is tired to the sagging point—he must plug one ear so that he may hear the recorded tour with the other. As shown below, this same railing could be used with bracing, to support a narrow padded bench.
The bench not only would provide a place for a short rest; those sitting on it to listen to the earphone would be out of the line of sight for standing visitors.

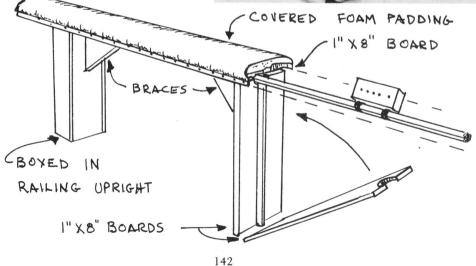

COVERED FOAM PADDING

1" X 8" BOARD

BRACES →

BOXED IN
RAILING UPRIGHT

1" X 8" BOARDS

Fig. 11-8. These are nicely designed panels—but who will see those so far above the eye level?

Fig. 11-9. With the explanation of Hopi kachinas almost 8 feet from the floor, with text print so small, who will know anything about these fascinating spirit representations? How many of your visitors have knees young enough to see a pottery exhibit in such a case?

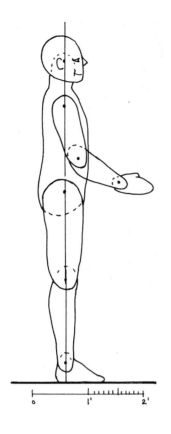

Fig. 11-10.

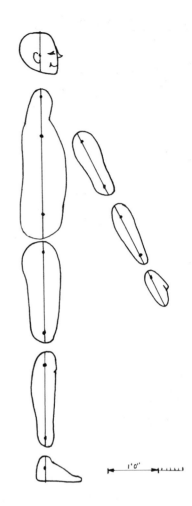

Fig. 11-11.

Fig. 11-10: Jointed cardboard figure, may be made from file cardboard joined by eyelets or snaps.

Fig. 11-11: Pattern for cardboard figure.

Fig. 11-12: Use of the jointed figure with scale drawings of benches, cases, railings, panels, etc., will help designers visualize physical handicaps and limits.

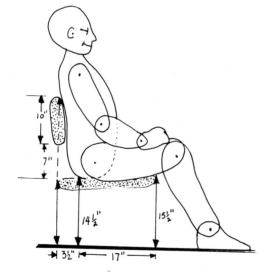

Fig. 11-12.

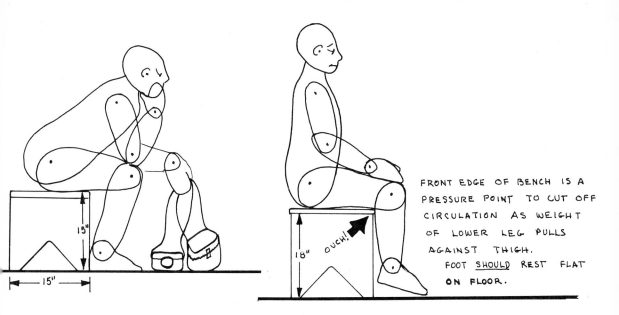

FRONT EDGE OF BENCH IS A PRESSURE POINT TO CUT OFF CIRCULATION AS WEIGHT OF LOWER LEG PULLS AGAINST THIGH.

FOOT SHOULD REST FLAT ON FLOOR.

Fig. 11-13. Good and uncomfortable bench heights

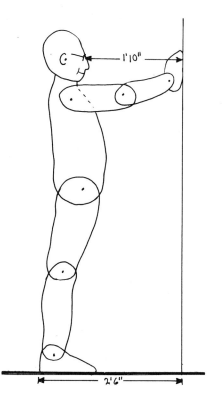

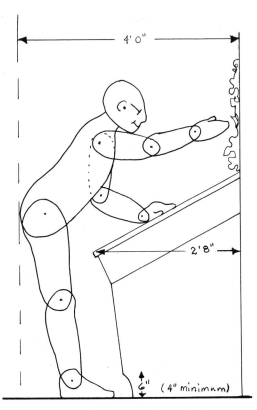

Fig. 11-14. No protection—panel will be touched

Fig. 11-15. Case in front of panel helps protect the vertical surface

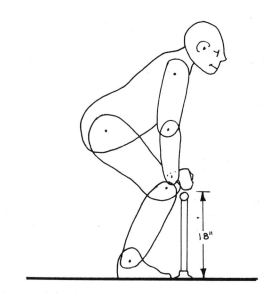

Fig. 11-16.

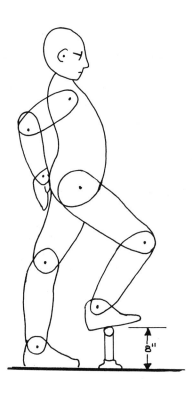

Fig. 11-17.

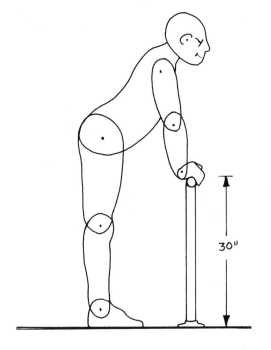

Fig. 11-18. Railing heights provides "mini-rest"
opportunity

146

Appendix **A**—Ten Commandments

In the June, 1949 issue of the *Clearing House for Southwestern Museums* the late Eric Douglas published a "first draft" of a "simple set of rules to guide in the installation of museum exhibits." The first draft was never revised and, from time to time, has been reprinted. The author feels the points made are still valid and worth presenting once more.

Ten Commandments for Museum Exhibitors

I You shall always remember that you are arranging exhibits for human beings, creatures with a definite range of physical and mental powers well-known to museum staffs, but frequently forgotten; and that children, equally capable of learning and enjoyment, are smaller than full-grown adults.

II You shall have a plan for your exhibit and make it immediately clear to the visitor.

III You shall remember that the human eye is lazy and usually looks only ahead and down, with little upward motion; and that many persons wear bifocal glasses, thus increasing the tendency to look down.

IV You shall not allow 'eye-catchers' in your exhibits, or around them, to distract attention from the specimens.

V You shall always show objects in their functional position, or suggest it to some degree.

VI You shall always keep your display equipment and mechanics as inconspicuous as possible.

VII You shall not arrange monotonous rows of things on shelves; nor crowd your cases.

VIII You shall compose your displays in three dimensions, using asymmetrical balance as much as possible; and avoid tacking objects flat on the backs or sides of cases.

IX You shall use labels which approximate the color of the case background; are written in contemporary American; are printed in big type; and are placed below eye level.

X You shall not hesitate to break any of these commandments if the greatest efficiency of any display is obtained by so doing. Always let imagination and good sense temper rules!

In the August, 1949 issue of the *Clearinghouse* two comments on the "commandments" are worth reprinting. Concerning commandment VIII: "This might be better worded to advise a general practice of hanging objects slightly away from the background—with aid of a block or the like —but at the same time recognize that a flat hanging sometimes is either unavoidable or outright desirable. The basic thought is that an object attains a greater dignity and prominence if it is free in the air than if it is flat against something."

"The term 'eye-catchers': This expression, used in commandment IV, has been questioned for meaning. If you are looking in a case and find your eye constantly pulled away by a shiny thumbtack head you are trying to cope with an 'eye-catcher.' Even the head of a common pin will distract, so always clip off the heads of pins. Thumbtacks are always bad, but if you have to use them paint or otherwise cover the heads. Other types of eye-catchers are: fancy work around the frame of a case; flakes of paint, bits of lint or the like which chip off or accumulate in a case; labels on

glaring paper; identification tags tied on specimens; installation equipment (string, small blocks, etc.) which are coarse, brightly colored; devices used to hold labels in place (pins, wire holders, blocks); cracks between blocks on which objects are set. . . .

"The basic good practice is, on closing a case, to check ruthlessly for any sort of distraction, for eye-catchers will absolutely ruin a display, even if only the tiniest of shiny or dark points."

Appendix B—Criteria

"Some Criteria for Evaluating Displays in Museums of Science and History" by Gilbert Wright, Office of Exhibits Central, Smithsonian Institution (First published in the *Midwest Museum Quarterly*, Vol. 18, No. 3, 1958)

These remarks are offered as a starting point for the evaluation of museum exhibits. They are not meant to be exhaustive, nor are the criteria always applicable. The outline was submitted as a basis for further discussion by those attending the Exhibits Workshop Section of SEMC, meeting October 11, 1957, at the Florida State Museum.

1. *Uniqueness of Museum Exhibits.*

Exhibits are universally recognized as a prime activity of museums. Other museum activities that may be of equal or greater importance are: (a) acquisition and preservation of collections; (b) research and publication of technical reports and popular bulletins based on study of collections; (c) teaching and recreational activities, such as docentry, museum classes, hobby clubs, etc.

Distinctive features that characterize museum displays are: (1) They result from an effort on the part of scientists, scholars, teachers and/or exhibits specialists to extend the horizons of knowledge to a wider audience. (2) They usually combine objects from the collections with some kind of verbal communication (the spoken, printed, or recorded word). (3) They have no propaganda or salesmanship bias, but represent the disinterested approach of the scientist or scholar.

2. *Influence of Other Media of Mass Communication on Museum Exhibition.*

Museum exhibition is but one type of display among many. Everywhere, the public is conditioned by visual modes of communication. A plethora of visual images is a sign of the times we live in. The principal media for visual communication are: the movies, television, picture magazines, advertising literature, billboards, newspapers, traveling shows, fairs, festivals, expositions. Today museum exhibits are planned and built in such a matrix or atmosphere. Museum exhibits are in a sense competitive with other forms of visual communication. High professional standards for visual presentation and communication have been created in advertising and commercial art, show-window display, motion picture and TV studios, etc. Museum exhibition has been, and will continue to be, influenced by these other channels of communication.

3. *Environment of Museum Exhibits.*

Most, but not all, museum exhibits are found in museums. The loan exhibit, traveling exhibit, or mobile exhibit, may be designed in isolation to its surroundings, but not the exhibit-in-the-museum. Principles of architecture and contemporary interior design have a significant bearing on creating an effective environment for museum displays, and relating them to that environment.

4. *Art Exhibits vs. Science and History Exhibits.*

History and science museum exhibits are synthetic and integral, and in this respect they are comparable to art objects. Nevertheless there are important differences. In art exhibits the aim is generally to allow first-hand experience of the art object by the spectator. The art object, like beauty "is its own excuse for being." Its theme or story may be of minor importance, or may be absent altogether, as in the case of abstract paintings. Science and history

exhibits are not ends in themselves, but aim to be educational. Theme or story is of major importance in these exhibits, and specimens are often displayed only for illustrating or illuminating the story. Although these displays are integral and more or less complex, for study purposes they must be analyzed into their component parts. Criteria for evaluation are based on such an analysis.

5. *Time, Space, and the X-Factor.*

This phrase, taken from a book on photojournalism by Wilson Hicks, *Words and Pictures*, describes the fusion that takes place when a spectator views a museum exhibit. Captions, labels, and statements in a display are made up of words which must be followed in logical order through a period of actual time. The visual aspect of an exhibit may be seen all at once and is not discursive. Here the elements are not presented successively, but simultaneously. The aim of an exhibit is to bring about one communicative result through combined use of visual and verbal means. Normally, the two are not fused in the exhibit itself, but are fused in the mind of the spectator. The ideal is reached when the two values are equal and in balance; then the exhibit has maximum impact. A third "over-value" or X-Factor occurs when the exhibit viewer supplies material from memory and imagination to round out and enrich what is being conveyed to him by the display.

I. Criteria for evaluating the verbal, thematic, or literary components of an exhibit.
 A. Main Caption, or Title
 1. Is one present?
 2. Is it concise? Are there any unnecessary words?
 3. Is it attractive? Does it compel further attention to the display?
 4. Is it accurate? Does it accurately describe the subject matter of the display?
 5. Is it to the point?
 6. Is its size and importance in proper proportion to the exhibit? (Is it too large or too small)?
 B. Secondary Statements
 1. See 1, 2, 3, 4, 5, 6 above.

2. Do these follow through with the thought expressed in the main caption?
 3. Are they related to the visual components of the display?
 4. Are they in logical sequence, and will they be read in proper order?
 C. Is the amount of verbal material in balance with the visual components of the exhibit?
 D. Grammatical Construction
 1. Are the verbs colorful or drab?
 2. Are beginnings of statements weak (i.e.: "A. . . ;" "The . . .;" "There are"
 3. Is the structure of various statements repetitious or monotonous?
 4. Have the verbal statements been well edited?
 5. Are statements significant?
 E. Are objects adequately identified?
II. Criteria for evaluating the visual components of an exhibit.
 A. Is there a high degree of over-all unity to the display?
 1. Is there unity in arrangement of visual elements?
 2. Is there congruity of visual elements?
 3. Are visual elements pertinent to the theme, as expressed in main caption?
 4. Is there harmony in the use of color?
 B. Is there variety in the visual components?
 C. Is there seriality in the visual components?
 1. Is there good transition from one part of the exhibit to another so far as visual components are concerned?
 2. Has rhythm or repetition been used to promote transition?
 3. Is opposition and contrast apparent in the visual components of the display?
 D. Is the principle of dominance evident in the visual components?
 E. Is there a focal point or center of interest?
 F. Has there been a pleasing use of textures?
 G. Are the relationships of spaces, objects, and labels in pleasing or harmonious proportion?
III. Criteria for evaluating the technique in execution.
 A. Quality
 1. Has skill been used in the selection and use of materials, tools, and methods of construction?

2. Is lettering neat and highly legible?
3. Is lighting adequate, or could it be improved?
4. Is style of construction consistent with modern techniques in leading museums?

B. Performance (Applies to permanent rather than temporary displays.)
 1. Is the exhibit characterized by stability and permanence?

C. Are construction details functional or are they in any degree anachronistic?

D. Special Problems
 1. Habitat Groups
 a. Are representation of nature in foreground accessories and in painted background naturalistic to a convincing degree?
 b. Are animal forms mounted in realistic and likely poses?
 c. Is the break between foreground and painted background almost imperceptible?
 2. Miniature Dioramas
 a. See a, b, c, above.
 b. Are all elements in proper scale?
 c. Is diorama placed in best viewing position for both adults and children?
 3. Period Rooms
 a. Are objects contemporaneous for period?
 b. Are human figures convincingly posed and appropriately costumed?

IV. Criteria for evaluating the exhibit in its environment.
 A. Room in which exhibit is placed:
 1. Is there a focal point that invites the visitor into the room?
 2. Are all exhibits in room harmonious as to subject material?
 3. Are exhibit cases in the room related to each other in size, shape, and color?
 4. Are case and background colors subdued so that color and lighting of exhibits gives them emphasis?
 B. Are all the exhibit rooms unified together to any extent?
 C. Is visitor circulation controlled and adequate?

V. Summarizing Criteria
 A. Is the display authentic? Does it represent the thinking of authorities in its field?
 B. Has the display told a complete story? Are important questions left unanswered?
 C. Is the display relevant to the objectives of the sponsoring museum?
 D. Has there been any over-playing of the obvious in the presentation?

Appendix C Portfolio of Exhibit Photographs

A. **HISTORICAL BACKGROUND:** Some museums today still use display techniques that were seen in early exhibitions.

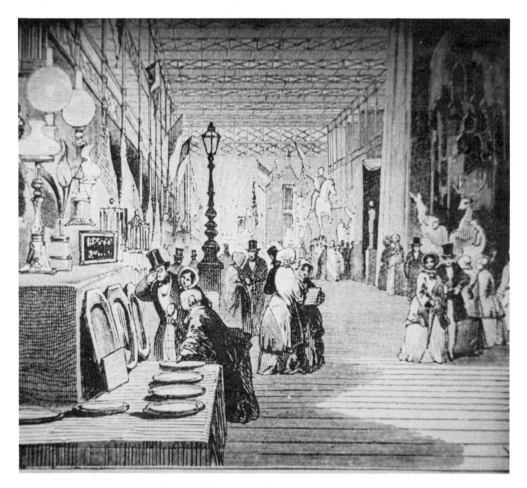

1. "The Main Avenue—East," from The Crystal Palace Exhibition Catalogue, London 1851. Dover Publishers, Inc., 1970.

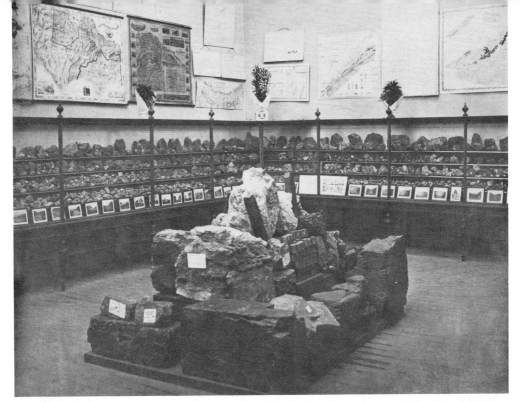

2. Colorado ores shown at the Exposition Universelle, Paris 1867. (Denver Public Library Western Collection)

B. ENVIRONMENTAL SETTINGS: Photographs, alcove settings, models and dioramas help to present a sense of environment.

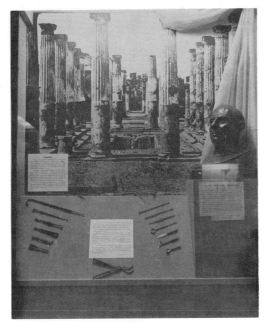

1. Materials from Pompeii. (Milwaukee Public Museum, old building)

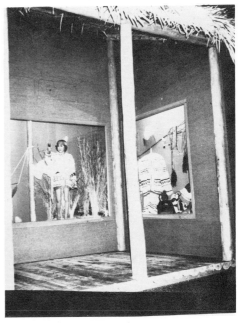

2. Alcove for Seminole Native American materials. (Milwaukee Public Museum, new building).

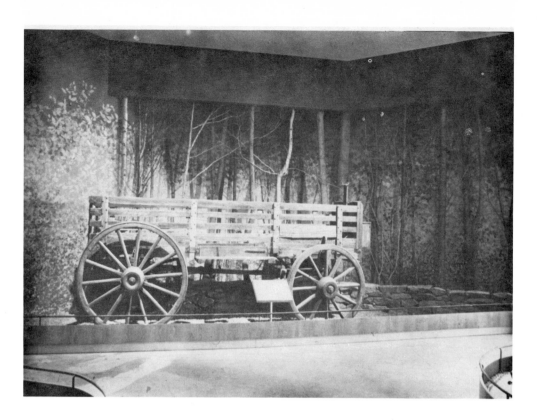

3a. Woods setting for farm wagon. Actual tree trunks, stylized background painting. (Adirondack Museum)
 b. Detail, rear of wagon, showing close-up of painting.

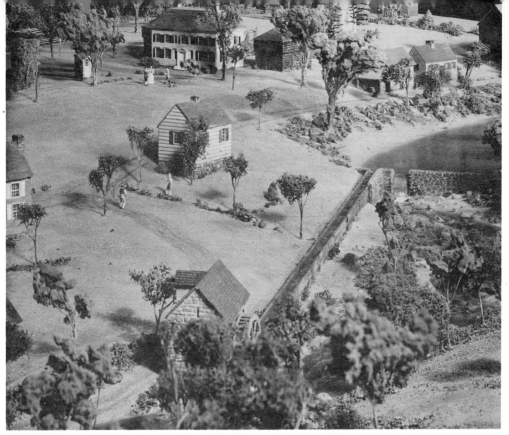

4. **Models may be used to show establishment of towns in relation to environment. (New York State Museum)**

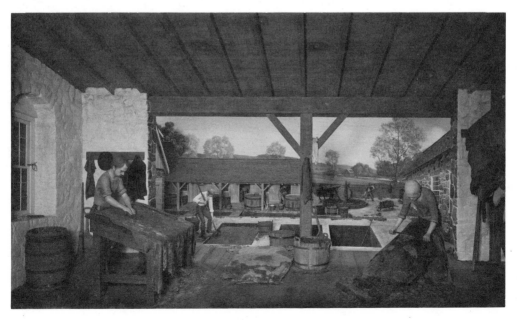

5. Dioramas also help create a setting. (Hagley Museum)

C. OUTDOOR EXHIBITS AND DEMONSTRATIONS

2. Historical archaeology is explained in progress at Harper's Ferry.

1. Painting showing appearance of Yeoman's Home interprets archaeological excavation for visitors to Jamestown National Park.

3. Native arts are demonstrated by skilled craftsmen at Ocunaluftee Village, owned and operated by the Cherokee Indians. (Qualla Reservation, Cherokee, North Carolina.)

4. The Provincial Museum in Victoria, British Columbia, sponsors demonstrations of traditional totem pole carving by Northwest Coast native people.

5. Changing exhibits in local airport terminals invite travellers to visit a local museum. A stronger light on the case interior would help overcome some of the problems of reflections.

D. MODELS AND DIORAMAS

1. Diorama included in room of artifacts helps to show prehistoric pueblo—its relationship to environment, town layout, location of garden plots, etc. (Museum of New Mexico)

2. Diorama shows both a reconstruction of prehistoric life and techniques of the archaeological "dig" which yield the information for interpretation. (Cleveland Museum of Natural History)

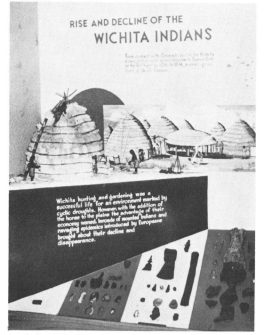

3. A model village and painting enhance an exhibit of a sequence of artifacts. (Museum of the Great Plains)

4. Dolls may be used to show fashion changes as well as being included in toy displays. (Helen Hays Memorabilia Exhibition, Cayuga Museum of History and Art)

E. NATIVE AMERICANS AND EARLY SETTLERS

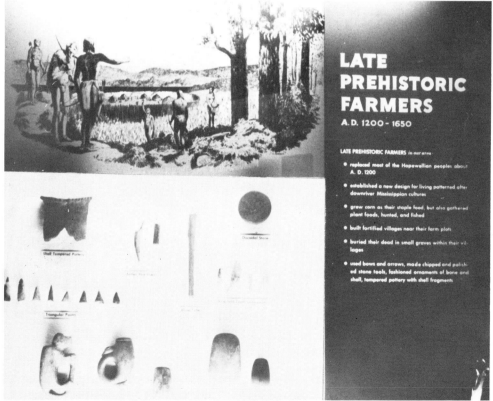

1. A painting and simple, direct labels provide excellent communication for this shallow-case exhibit of artifacts. (Carnegie Museum)

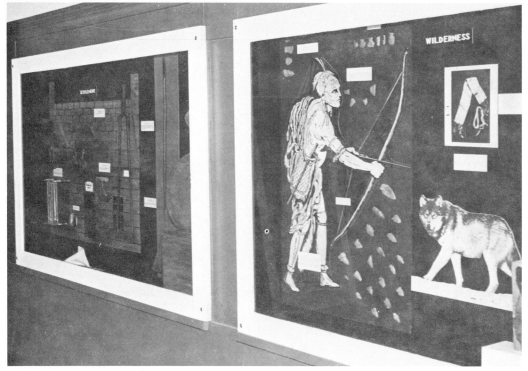

2. Enlargements from an early steel engraving and a photo of a wolf create interest in this case depicting early development of the village of Cattaraugus. (Cattaraugus Area Historical Society Museum)

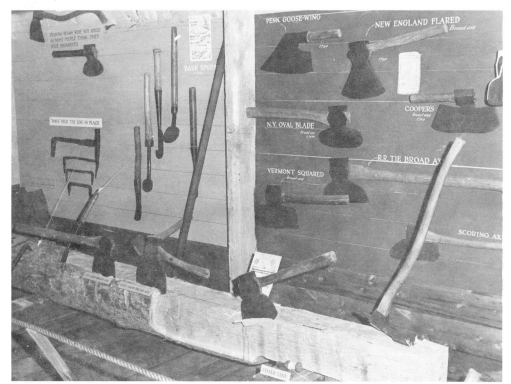

3. Early tools for building are shown in positions of use and in a "framing" reminiscent of heavy beam construction. (Sloane-Stanley Museum)

1. A commercial trade fair exhibit demonstrates good ideas which can be borrowed by museums: sequence labels of technical development about six inches above average eye-level; sloping panels at right angles to viewer's line of sight; cove lighting; railing at a height for comfortable leaning.

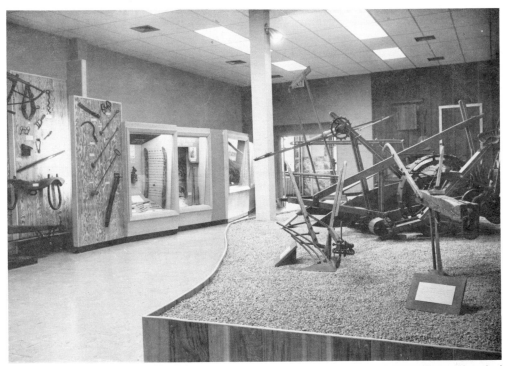

2. Platform, panel and case exhibits provide good visual change of pace. (Kansas State Historical Society Museum)

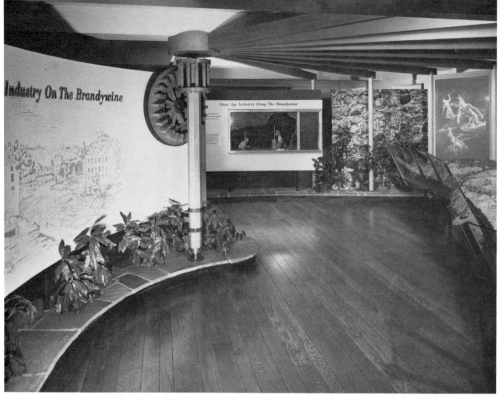

3. Stylized gear, cog, ceiling "spokes," long relief model (left), curving introductory panel all combine to form a handsome, interest-compelling entrance to this exhibit. (Hagley Museum)

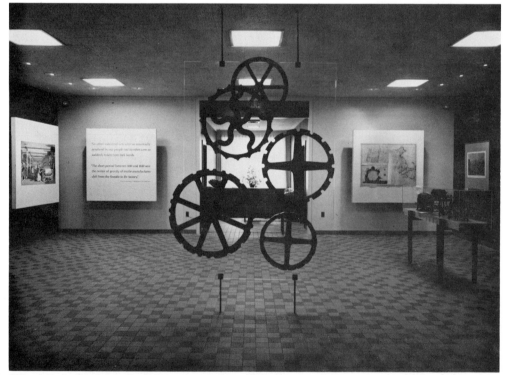

4. Silhouetted wheels anchored to transparent sheet; large graphics and *readable* labels enhance the exhibit of the transition of textile production from "fireside to factory." (Merrimack Valley Textile Museum)

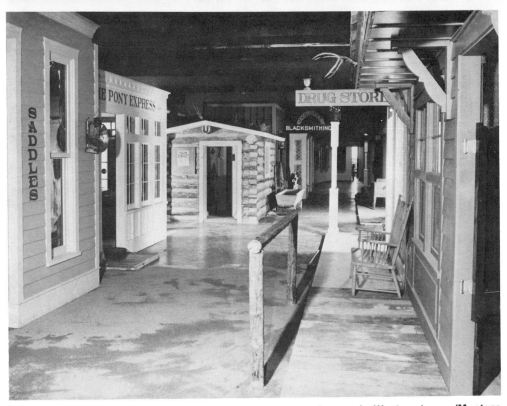

5. **Stylized interior construction help to recreate the feeling of an early Western town. (Montana Historical Society)**

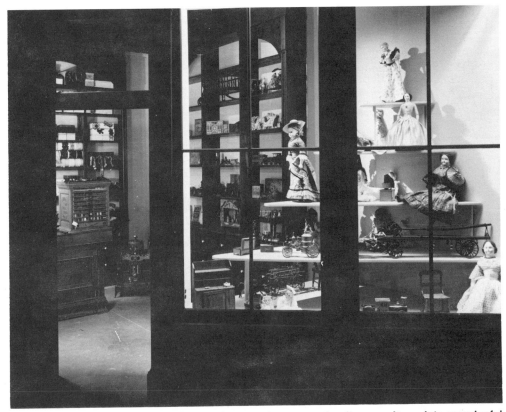

6. **Recreated dry-goods store front and interior organize many miscellaneous items into meaningful context. (Buffalo and Erie County Historical Society)**

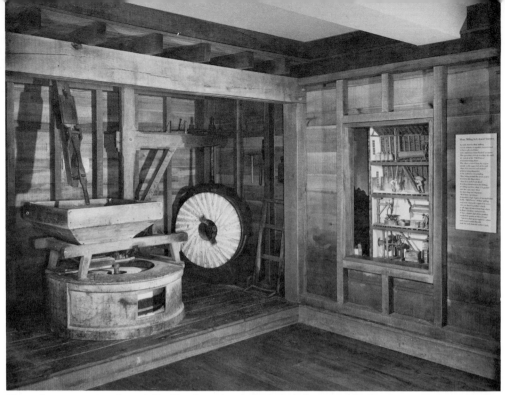

7. Heavy beam construction of display alcove and platform help create feeling for setting of massive machinery. "Window" at right houses model showing flour milling sequence in Colonial times. (Hagley Museum)

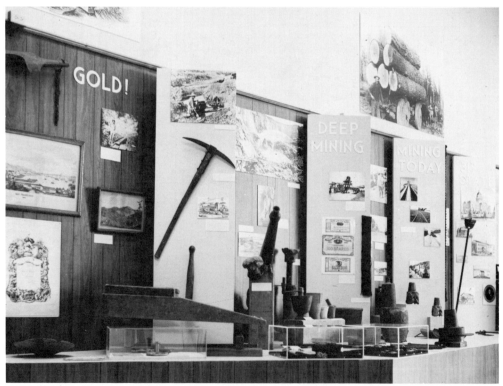

8. Early photographs and engravings combine with actual artifacts to trace the development of mining in California. Vertical triangular panels provide good visual break between sections of story as well as space for main labels. (Pioneer Museum, Stockton)

1. This reconstructed "wet larder" in one of the buildings at Lower Fort Garry National Historic Park (Canada) could also be reproduced "as is" within a case.

G-2—G-9: "The Farmer's Year" sequence at the Farmer's Museum, Cooperstown, is a clean, handsome display. Short, interesting labels are designed, produced and installed for ease of reading. Natural dried materials are combined with the tools in this elegant presentation
(Photos by Milo Stewart, New York State Historical Association.)

THE FARMER'S YEAR
a seasonal account of Yorker farm life in the early 1800's.

G-2 The Farmer's Year

G-3 Introductory label

G-4 March

G-5 April

G-6 August

G-7 October

G-8 November

G-9 February

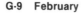

Photographs of early Sacramento newspapermen Dr. John F. Morse and James McClatchy and a college of newspapers dating from the Gold Rush era comprise the exhibit on "Early Newspapers" in the Sacramento City and County Museum in Sacramento, California.